FIRST CONTACT

———

CULT OF PROGRESS

ALSO BY DAVID OLUSOGA

A House Through Time
Black and British
The Kaiser's Holocaust
The World's War

CIVILISATIONS

FIRST CONTACT

—

DAVID OLUSOGA

—

CULT OF PROGRESS

P

PROFILE BOOKS

This paperback edition published in 2021

First published in Great Britain in 2018 by
Profile Books Ltd
29 Cloth Fair
London EC1A 7JQ

www.profilebooks.com

Published in conjunction with the BBC's *Civilisations* series
'Civilisations' Programme is the copyright of the BBC

1 3 5 7 9 10 8 6 4 2

Designed by James Alexander at Jade Design
Printed and bound in Italy by L.E.G.O. S.p.A.

The moral right of the author has been asserted.

A CIP catalogue record for this book is available from the British Library.

ISBN 978 1 78125 998 6
eISBN 978 1 78283 419 9

For Susanne

CONTENTS

FIRST CONTACT

———

CULT OF PROGRESS

PREFACE

With the fall of Rome in the fifth century, Europe entered a new age of relative isolation. The mobility that had been a feature of Rome's vast and intercontinental empire fell away, and grasses grew between the stones of the roads that her legions had cut across Europe. Then, in the seventh century, the rise of Islam created a south-eastern border to Christendom. Later, as the Arab tribes crept along north Africa, conquering Egypt and then the Berber kingdoms to the west, they furthered the encirclement of northern Europe. The conquest of Morocco by the Safavid empire created the bridgehead for the later invasion of the Iberian peninsula in the early eighth century, and the formation of the Islamic kingdom of Al-Andalus.

The conquest of Constantinople by the Ottomans in 1453, seven centuries later – a catastrophic blow to the Eastern Orthodox branch of Christianity – presaged the advance of Islam into the Balkans, on Europe's south-eastern flanks. It was around that moment, in the middle of the fifteenth century, that Christian Europe began to

break out of her near-millennium of isolation. A series of advances in maritime and navigational technology, fused with the residual spirit of the Crusades and a hunger for wealth and trade, inspired European explorers to break out of the confines of Europe and the Mediterranean Sea. The fall of Constantinople re-ignited hostility between the Islamic and Christian worlds, but, rather than reinforce a sense of encirclement, it added further impetus to the European desire to seek sea routes to new markets and new peoples, who might be persuaded to become partners in profitable trade. Some, perhaps, might even enlist as allies in the struggles between Christendom and Dar al-Islam.

We often think about what became known as the 'Age of Discovery' solely from the European perspective. This, in one sense, is understandable. It was Europeans who took to ships and set sail across the globe, and often Europeans who left us the most comprehensive accounts. Yet the real civilisational story of the period between the late fifteenth century and the early years of the eighteenth is one of contact and interaction. It was an era in which civilisations from across the world encountered each other for the first time. When Europeans landed in the New World, societies that had not even been aware of one another's existence found themselves in sudden contact: contact which, in the case of the Mexican and Inca empires, proved nearly fatal. Yet, while the fifteenth, sixteenth and seventeenth centuries

were unquestionably an era of conflict and plunder, and in southern and central America an age of calamity, in most cases and in most places Europeans were not in a position to conquer or colonise, no matter how much they might have wished to do so. The catastrophic conquests that took place in the Americas were the exception rather than the rule. The kingdoms and empires of Africa and Asia did not suffer the same fates as those which befell the peoples of Mexico.

The Age of Discovery was, above all else, an age of trade and broadened horizons. Part of what made those centuries so profoundly different from the era that had preceded them was the availability of new products and a deep and growing fascination in Europe with newly encountered cultures and societies from beyond its shores. The cultural exchanges that had taken place after 1300, when the spices of Asia had begun to flow into the Mediterranean, carried across Asia on the legendary spice road and on the ships of Italian merchants that plied the Mediterranean, had already sparked a profound change in European tastes. In the Age of Discovery new luxuries, even more exotic and desirable, arrived from lands even stranger and more distant, and became increasingly available to ever greater numbers of people.

The art of this age records how these new luxuries seeped into the lives of the wealthy and the aspirational, and how discoveries of new lands and contact with previously

unknown people fired their imaginations. These products, and the new wealth generated by their trade, added to the vibrancy and the variety of everyday life. They became the symbols of modernity, and eventually, as is often the case with new commodities, they went from being exquisite luxuries to being regarded as staples of middle-class life.

Within the art of the fifteenth, sixteenth and seventeenth centuries is a visual record of the excitement and dynamism of what we might regard as the first 'age of globalisation'. Art frequently hints at how civilisations viewed one another and changed one another. Yet the imprint of globalism is often overlooked or rendered invisible. For when we imagine the art of the Dutch Golden Age of the seventeenth century, or the masterpieces of Japanese art created during her long age of isolation from the 1640s until the 1850s, we naturally presume that such works are definitively Dutch or quintessentially Japanese. That, as well as being beautiful, what they primarily convey to the observer is the inner essence of those societies at that particular moment in time.

It's the same when we think of the art of India during the last years of the Mughal empire, before British 'company rule' spread beyond her trading factories on the east coast, and perhaps most of all when we think of the art of Africa, which we so often consider as being 'authentically' African: a distillation into form of the energy and inner spirit of the people of Africa. While much African art is, of course,

fundamentally an expression of the African societies that produced it, within the so-called Benin Bronzes and other works also lies the evidence of Africa's outward gaze and her centuries of contact and trade with the outside world. Something similar is true elsewhere, because, hidden within the paintings of the Dutch Golden Age, or the Japanese prints from the age of the Tokugawa emperors, or the so-called 'company paintings' of late Mughal India are strands of artistic and cultural DNA drawn from other cultures which we shall explore in Part One: First Contact.

During the latter decades of the eighteenth century this era of first contacts and artistic borrowings began to give way to a new age of empire. Fired by a new self-confidence born of the rationalism of the Enlightenment, Europeans came to regard their civilisation as exceptional. As a result of the Industrial Revolution a huge gulf opened up between European technologies and those available to Asians, Africans and others. The nineteenth century, the era of the European empires, thus became the age shaped by a cult of progress, one in which artists struggled to make sense of vast and transformative changes – the rise of the factory, rapid urbanisation and the subjugation of other peoples. We look more closely at artistic innovations and individual artist's responses to post-industrial modernisation in Part Two: The Cult of Progress.

1

FIRST CONTACT

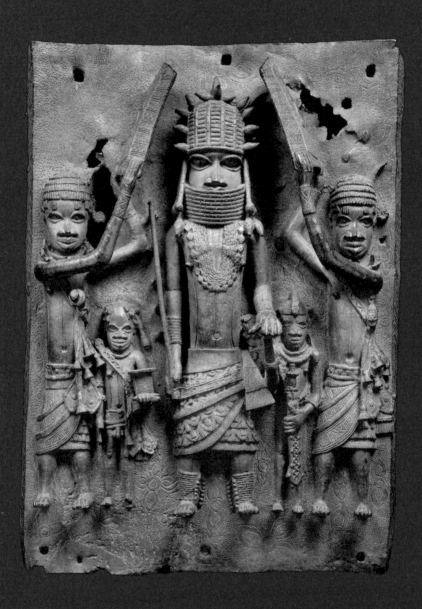

VICTORIAN DISBELIEF

In September 1897, the year of Queen Victoria's Diamond Jubilee, hundreds of carved ivory statues and brass plaques were put on display at the British Museum. Alongside the statues and plaques were ceremonial heads and animal figures, all intricately cast in a copper-rich brass alloy. Together they were exhibited in a room normally reserved for public lectures. Although makeshift and temporary, the exhibition was hugely popular, in large part because it allowed the Victorian public an opportunity to encounter the greatest treasures of an ancient and once mighty civilisation that had recently been the focus of a huge amount of press attention. The faces depicted in the plaques and sculptures were those of its kings and queens, and around them were arrayed images of soldiers, traders and hunters, along with the symbols of a complex pagan faith.

1. One of the thousands of brass plaques looted from the royal palace of Benin in 1897. This plaque, now in the British Museum, shows the Oba (king) with four of his attendants.

To educated Europeans of the late nineteenth century, steeped in classical learning, antique sculptures and reliefs such as these, the artistic fruits of a highly sophisticated casting technique, were hallmarks of a true civilisation. However, what instantly troubled the public who came to view these treasures, and the reporters who were dispatched to the British Museum from both national and local newspapers, was that these stupendous works of art had been generated by an African civilisation, and in the late nineteenth century almost everyone in Europe believed that Africans lacked both the cultural sophistication to appreciate great art and the technical skills required to create it.

The Benin Bronzes, as they became known – despite being made from brass – arrived in London as the booty of war. Eight months earlier, a British military force, 1,200-strong, had invaded the ancient west African kingdom of Benin, home of the Edo people, and besieged then sacked their capital, Benin City. Ostensibly, the invasion had been launched to avenge the lives of British soldiers and officials who had been killed during an ambush of an earlier expedition. In reality this was merely the pretext. Underlying the decision to attack Benin were British ambitions to control the trade in palm oil and other commodities as London extended control over what was then the British Niger Coast Protectorate, part of modern-day Nigeria.

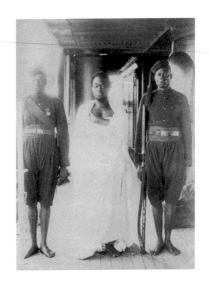

2. Oba Ovonramwen in chains on the deck of the British ship HMS Ivy. He was never to return to his kingdom, dying in exile in 1914.

After the fall of Benin City, the expeditionary force – which was largely made up of troops from the Royal Marines – looted the royal palace. Later, the palace, other public buildings and a great many private homes were destroyed by a fire that may or may not have been started accidentally. Also lost to the flames were sections of Benin City's once imposing defensive walls. Oba Ovonramwen, the king of Benin, whose predecessors are the central subjects of the Benin Bronzes, was deposed and arrested.

Photographed on the deck of a British warship, the Oba casts a steadfast gaze, his look of steely defiance sadly undermined by the chains and manacles that can be seen coiled around royal ankles. Oba Ovonramwen was held responsible for the deaths of the Britons killed in the earlier expedition and put on trial by the British colonial authorities. Although he was (rather inconveniently) found innocent, Ovonramwen was nonetheless sent into exile, like so many

African leaders who confronted European powers during the so-called 'Scramble for Africa'. Indeed, the deposing of Ovonramwen and the British raid on the kingdom of Benin were unexceptional events in the late nineteenth century. Numerous African city states whose leaders had rejected the overtures of encroaching European powers had also been subjected to similar attacks: 'punitive expeditions', in the terminology of the time. What was exceptional about the 1897 Benin expedition was not the level of violence used against the Edo people, or the wholesale destruction of their ancient capital, but the fact that quite by accident the expedition delivered some of west Africa's greatest cultural treasures into the hands of Europeans. This had never been an objective of the expedition, and yet it is the reason the Benin expedition, of all Britain's 'small wars' from the age of empire, is still remembered today.

The looting that followed was not wild or inchoate but systematic and deliberate. Over a number of days the treasures of the royal palace were removed. Ceremonial heads were taken from around thirty royal shrines, dedicated to Obas of the past, and thousands of brass plaques were ripped from the walls and roofs. In all there were around 4,000 'bronzes', as well as hundreds of ivory tusks and carvings, many of which was piled up in the courtyards of the now ruined royal palace. There, photographs were taken of British officers posing among the loot, which they

dismissed in their correspondence as 'Benin curios'. Amid the booty, with crossed arms and fixed expressions, their gaze is every bit as defiant as that of Oba Ovonramwen.

The plaques, statues and ivories were then packed up and transported to the coast on the heads of the thousands of indigenous carriers hired by the British. At the port, the fruits of several centuries of cultural output by the craftsmen of the Edo people were loaded into holds and shipped to Britain. To defray the costs of the raid, the bronzes were to

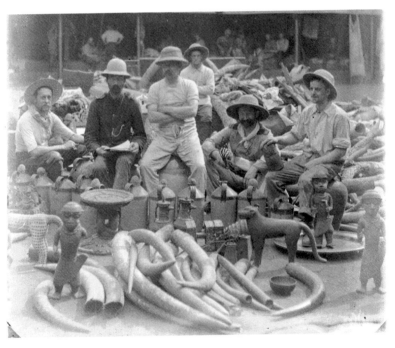

3. *Troops from the British Punitive Expedition posing in the grounds of the Oba's palace amidst the loot; piles of ivory, brass plaques and cast brass figures can be seen.*

be auctioned off in London, sold to collectors and museums across Europe. It was in advance of this colonial fire sale that the temporary makeshift exhibition at the British Museum was organised. The objects presented to the public that autumn were thus not the property of the British Museum but merely on loan to the institution from the Admiralty, who had taken possession of the artefacts on their arrival. Other bronzes and ivories personally looted by the British officers who had taken part in the punitive expedition were

4. Today the vast majority of the art treasures of Benin are held by museums in Britain, Germany and the United States. The collection at London's British Museum is the largest in the world.

regarded as their share of the spoils and excluded from the auction.

When the exhibition at the British Museum opened, it was an immediate sensation. Memories of the first expedition against Benin earlier in the year were still fresh in the public mind. Then the newspapers had exhaustively reported on the supposed 'savagery' and 'barbarism' of the Edo people. The *Illustrated London News* had published a special supplement, and one writer had dubbed Benin the 'city of blood'. Nine months later, the same publications were equally keen to report on the art captured during the successful British expedition. It was at this juncture, however, that both the popular press and the more learned journals encountered a difficulty, as they struggled to reconcile the dazzling art on display with the image of Benin as the kingdom of 'horrors' and 'savagery' that they themselves had helped create. Charles Hercules Read, the curator who persuaded the Admiralty to loan the bronzes to the museum for the exhibition, spelt out the contradiction when he wrote:

It need scarcely be said that at the first sight of these remarkable works of art we were at once astounded at such an unexpected find, and puzzled to account for so highly developed an art among a race so entirely barbarous.[2]

The German anthropologist Felix von Luschan, assistant to the director of the Königliches Museum für Völkerkunde in Berlin, lavished similar praise upon the bronzes and effusively compared the metal-casters of Benin to one of the greatest artists of the Italian Renaissance. Writing in 1901, he suggested that

These works from Benin are equal to the very finest examples of European casting technique. Benvenuto Cellini could not have cast them better, nor anyone else before or after him, even up to the present day. Technically, these bronzes represent the very highest possible achievement.[3]

Yet in the late Victorian imagination the people of the so-called 'Dark Continent' were thought to be incapable of creating true works of art or of incubating that thing called 'civilisation'. According to the prevailing theories, Africa was one of those regions of the world unconnected to the 'golden thread' of western civilisation, which stretched, supposedly unbroken, from classical antiquity through the early Church, the Renaissance and the Enlightenment, linking the cultures and societies of contemporary Europe to ancient Greece and Rome. Adrift, outside of that tradition, Africans were, in the minds of many, not only an uncivilised race but a people without a history. In Africa, it was said, time had passed, but, as progress had

not been made, there had been no true history to record. Yet in 1897 the thousands of plaques and statues gathered together in the centre of London were not only evidence of a sophisticated civilisation but were in themselves a form of historical record. The brass plaques from the palace walls had been cast in order to memorialise the reigns and great military victories of the past. They recorded the rituals that punctuated each year and the festivals in which the power and grandeur of the Obas was put on public and ceremonial display. The Obas were depicted at the physical centres of many plaques and were central to the concept of Edo cultural life. Larger than those around them, they were surrounded by their retinues, the symbols of their gods and the symbolism of their own god-like powers. Similar historical narratives had been carved in the ivory tusks that were also captured.

The art of Benin was so challenging, so sophisticated and complex that many people, in both academic circles and the popular press, were unable to accept that the treasures could have been produced by Africans. They confected theories to explain how it was that highly ornate, intricately cast brass plaques in high relief and perfectly proportioned sculptures of the human form could have been found in a forest empire of west Africa.[4] One suggestion was that the Portuguese, the first Europeans to have traded with the Edo people starting in the late fifteenth century, must have either taught local

craftsmen how to produce this art or had themselves cast the bronzes for the Obas of Benin. Another theory suggested that some unknown white civilisation could have produced the bronzes that had later been merely inherited by the people of Benin – this, despite the fact the faces depicted were clearly those of west Africans. Others suggested that this art form must have been transmitted to Benin from ancient Egypt.[5] A later theory had it that somewhere in west Africa or off her coast was the site of the lost Greek city of Atlantis, and that a band of wandering Greek artists had created the art. But there were experts, including Augustus Pitt Rivers, one of the fathers of archaeology, who rejected all such conjecture and snobbery, and concluded that the Benin bronzes were indigenous masterpieces of African origin. But that position was far from universal.

What was largely overlooked in the newspaper reports of 1897, although not in the scholarly debates, was that the people of late Victorian London and the men who had attacked and destroyed Benin City were not the first Europeans or even the first Britons to lay eyes on Benin's artistic treasures.

In the early decades of the European Age of Discovery, adventurers from Portugal and Tudor England had seen the same plaques, in situ, on the walls of the Oba's palace. The first of those English expeditions, led by the merchant Thomas Wyndham in 1553, had included among its crew

the young Martin Frobisher, who would later lead his fellow countrymen into battle against the Spanish Armada alongside Francis Drake. Wyndham and his crewmen had travelled inland and been highly impressed by the architecture of Benin City. They were further astonished to discover that the Oba 'could speake the Portugall tongue, which he had learned of a child'. Other accounts by European traders who visited Benin were similarly awed by this west African super-state – highly organised, centralised and militarised, a kingdom confident of its own power and determined to trade with Europeans as an equal partner. In 1668, a century after Wyndham's expedition, the Dutch writer Olfert Dapper penned a description of Benin City and the palace in his compendium travel narrative *Naukeurige beschrijvinge der Afrikaensche Eylanden* (*Accurate Descriptions of the African Regions*):

The king's palace or court is a square and is as large as the town of Haarlem and entirely surrounded by a special wall, like that which encircles the town. It is divided into many magnificent palaces, houses, and apartments of the courtiers, and comprises beautiful and long square galleries, about as large as the Exchange at Amsterdam, but one larger than another, resting on wooden pillars, from top to bottom covered with cast copper, on which are engraved the pictures of their war exploits and battles.[6]

When Thomas Wyndham set sail on his journey to Benin in 1553, the site on which the British Museum would later stand was open pasture north of London, near the village of Tottenham Court, so named after a local manor house, Toten Hall. The notion then that the treasures of any great African kingdom might one day be housed there, on the rural fringes of the English capital, would have been unimaginable. Adventurers, traders and merchants of the Age of Discovery set off not on missions of colonial conquest but in the hope of trade with peoples of distant lands. Only in southern America and on tiny Asian islands did the prospect of conquest present itself. African and Asian spices, some of which were literally worth more than their weight in gold, yielded astronomical profits in the markets of Europe and justified the extreme dangers of long-distance missions; indeed, Thomas Wyndham and many of his crew succumbed to fatal tropical fevers while trading with Benin in the 1550s. Three centuries before the punitive expedition of 1897, neither the Portuguese traders nor the English adventurers had had any difficulty in understanding what their nineteenth-century descendants struggled to accept – that Benin was a complex and sophisticated civilisation capable of creating wondrous art.

Not only had those fifteenth- and sixteenth-century encounters been profoundly different from that which took place in 1897, but evidence of that earlier contact can be

found in the Benin Bronzes themselves. In the collection at the British Museum – a small fraction of the thousands of pieces auctioned by the Admiralty – is a small brass statue of a Portuguese soldier, quite possibly a mercenary in the service of the Obas. He has his musket raised to his eye and wears European armour. Other pieces show the faces of Portuguese traders, their European features rendered exaggeratedly long and thin, with long noses and beards, marking them as incomers. But their place within the art of Benin speaks of their place within the royal court, and the culture and power politics of Benin in the fifteenth and sixteenth centuries: Europeans had been the suppliers of the precious raw material required for their creation.

In a number of the Benin plaques Portuguese traders are shown holding manillas, the curved bars of solid brass that were the unit in which the metal was traded. These manillas themselves eventually became a form of currency and a symbol of Benin's trading links with the growing Atlantic world.

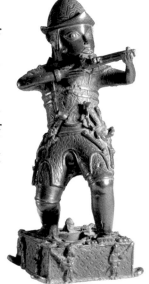

5. This intricately detailed brass figure of a Portuguese soldier, with his musket raised, was cast by the metal craftsmen of Benin in the seventeenth century.

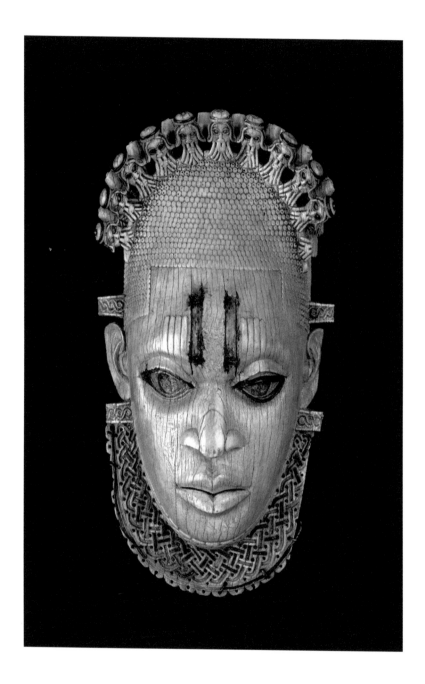

In what is perhaps the most stunning of all Benin's art treasures, the two pectoral masks believed to show the face of a sixteenth-century queen mother known as Idia, further evidence of Benin's relationship with its Portuguese trading partners can be seen. Believed to have been the work of the same artist, the two surviving near-identical masks depict the queen mother with a highly naturalistic expression of effortless authority.[7] Idia had been a powerful political figure who had emerged following a period of civil war. The peak of Queen Idia's ivory crown consists of a row of tiny bearded faces, those of Portuguese merchants, partners in trade and further evidence of Benin's fruitful relationship with Europeans, heralding the age of globalism.

6. One of two near-identical sixteenth-century ivory masks of a Benin queen mother known as Idia. She has become one of the cultural emblems of modern Nigeria. Note the Portuguese sailors carved into her headdress.

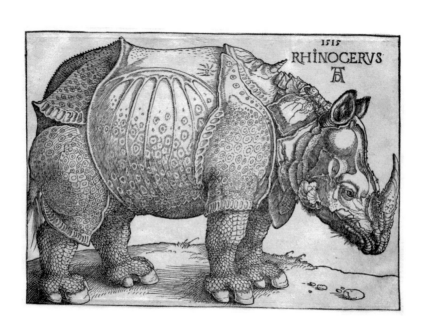

A MARINER NATION

If the story of a global phenomenon can ever truly be said to have a single point of origin, then for the Age of Discovery that site would be Lisbon. There are many reasons why it is the faces of Portuguese traders – rather than Spanish, French, Dutch or English – that can be seen on the Benin Bronzes and ivories. First, there were geographical factors that help explain why the Portuguese became the great mariners of the fifteenth and sixteenth centuries. Portugal's coastline faces not the safe, well-charted waters of the Mediterranean but the apparently endless and forbidding expanses of the Atlantic. This orientation almost urged Portugal's mariners out into the deep ocean, and encouraged its kings to speculate as to what riches and trades might be found beyond, if the great distances could be crossed.

7. *Albrecht Dürer's famous 1515 woodcut of Ganda the Indian rhinoceros provided the conventional European image of the species right until the arrival of live rhinoceroses in the eighteenth century.*

Technological advances in the sixteenth century, in the mariner's craft and in the sciences of navigation and cartography, all assisted the Portuguese in mastering the art of long-distance travel. One critical development was provided by the shipwrights of Lisbon. Through ingenuity, and trial and error, they designed a vessel ideally suited to long-distance trade and exploration: the small, highly manouverable caravel. And more prosaically, an important reason why it was Portugal, rather than one of her wealthier, more powerful competitors, who came to dominate the age's seafaring: Portugal needed money. The kings of this small realm were so poor they were unable to mint their own coinage, and Portugal was rightfully wary of the burgeoning power of neighbouring Spain, recently united by the royal marriage of Ferdinand of Aragon and Isabella of Castile in 1469. Thus the compelling dream of trading for gold in Africa, or navigating around Africa and trading for spices with the peoples of India, animated successive generations of Portuguese explorers.

Portugal's first foothold on the African coast was the city of Ceuta, now an autonomous city of Spain. From there the caravels inched along the north African coast. Expedition after expedition, each ventured a little further south, then east. By the 1430s the Portuguese had managed to pass Cape Bojador, a headland beyond which, it had been believed, no ship could find winds to return to Europe. Later that

same decade they reached the Bay of Arguin in what is now Mauretania. By the 1460s they had reached the coastline of west Africa and erected a fort, the oldest European building in Africa. From that bridgehead they were able to tap into the flow of Africa's gold at source. That one trading post, the fortress of Saō Jorge da Mina, doubled the income of the monarchy. Little wonder that in 1580 the kings of Portugal added the title 'Lords of Guinea' to their growing list of royal titles and honorifics. The wealth of Saō Jorge da Mina helped fund further expeditions, and by 1498 their ships reached India, and in 1500 they discovered Brazil.

The factors that had made all this possible were not products of European thinking but innovations born of the synthesis of knowledge and technologies. The Age of Discovery famously brought about a flurry of cultural fusion; less well understood is that it was itself only made possible by a similar coming together of ideas. Many of the advances in cartography and astronomy that made it possible for the earliest expeditions to cross featureless seas had been pioneered by Iberian Jewish mapmakers, who drafted the charts that these expeditions relied on. Added into this mix were Genoese financiers and bankers who helped organise the building of ships and the victualling of expeditions. The mariners who led those missions also adopted new navigational knowledge gleaned from Islamic sailors.

When Vasco da Gama reached India in 1498, his great feat of navigation had, in its final stages, been achieved with the assistance of an Arab navigator. Hired at the port of Malindi, on the coast of modern Kenya, this unknown Arab mariner used the stars and his charts of the Indian coast to guide da Gama to Calicut two months later, having harnessed the monsoon winds. Port side in Calicut, da Gama, on this auspicious and long-dreamed-of moment, was met not by an Indian delegation but by an Islamic merchant from Tunisia who cursed them in Spanish for having broken into a trade previously dominated by Arabs and north Africans.[1] The Portuguese were late. The first age of globalisation had been under way in Asia long before Europeans began to stake their claims.

Contact with and exploration of the distant lands beyond Europe transformed the economy and culture of Portugal from the second half of the fifteenth century onwards. Long-distance trade, the wealth it garnered and the new worldliness it conveyed upon the people of Portugal, and Lisbon in particular, changed not just their economy but also the way the Portuguese viewed themselves. Around 1515 the Portuguese built the Tower of Belém, which still stands guard over Lisbon harbour. It was erected to celebrate the nation's new discoveries and her growing wealth, and in acknowledgement of the centrality of overseas trade to the Portuguese economy. Within the stonework of the tower

was set a carving of an Indian rhinoceros. As any sixteenth-century visitor to Lisbon would have known, the carving was not merely an image of what a rhinoceros might look like, based on travellers' tales or amateurish drawings: the depiction was derived directly from experience and was of a specific creature.

Despite 500 years of weathering and erosion, the rhinoceros can still be made out at the base of the tower on the landward side. It shows an animal that arrived in Lisbon in 1515. The creature in question had originally been a diplomatic gift to Afonso de Albuquerque, governor of the Portuguese trading posts in Goa, from Muzaffar Shah II, the Sultan of Gujarat. But Albuquerque passed the rhinoceros on to his monarch, King Manuel I 'The Fortunate'. On 20 May 1515, after 120 days at sea, the poor animal, known by his Gujarati name of Ganda, finally landed at the docks near the Tower of Belém, then still under construction. Although rhinoceroses and other exotic animals had been brought to Europe during the Roman empire, the creature that landed in Lisbon harbour was the first of its species to have been brought alive to Europe since the fall of Rome, and in the intervening millennium such beasts had become almost mythical in the minds of isolated Europeans. As all that was known of these animals in Europe came from the writings of ancient authorities, the Portuguese court turned to Pliny the Elder's discussion of the nature of the

rhinoceros for information on their habits. Thus in June 1515 King Manuel had the recently arrived rhinoceros fight a young Indian elephant that was already in his menagerie, in order to test Pliny's assertion that the rhinoceros and the elephant were natural and eternal enemies. The rhinoceros is said to have won on the grounds that the elephant fled the field of combat before any fighting had actually taken place.

The arrival of an Indian rhinoceros – enormous, alive and animated – astonished the people of Lisbon, and its fame spread rapidly beyond the borders of Portugal. So quickly did the creature's celebrity spread that within a few months a simple woodcut print by Giovanni Giacomo Penni had appeared in Rome. Shortly afterwards the German artist Hans Burgkmair produced a far more elaborate and anatomically accurate woodcut print, showing the animal with ropes around its feet. However, it was not until news of the animal's presence in Lisbon reached the German city of Nuremberg that its fame was permanently imprinted on the European memory, becoming not only a symbol of Portugal's global reach but also representing the new age of knowledge and discovery, through the work of one of the greatest artists of the sixteenth century.

Albrecht Dürer never saw Ganda with his own eyes; instead, he relied on a sketch produced or acquired by Valentim Fernandes, a German printer resident in Lisbon.[2] The Fernandes sketch was sent to Nuremberg, and from

that Dürer produced his famous woodcut print of the rhinoceros that was replicated and sold thousands of times over. The woodcut print was fine art's equivalent of the Gutenberg press: a revolutionary technology that made the previously unaffordable suddenly accessible. Thanks to the artist's prodigious talents, and the medium he employed, Dürer's vision of Ganda the rhinoceros entered into the imaginations of vast numbers of people. 'No [other] animal picture,' claims one historian, 'has exerted such a profound influence on the arts.'[3]

While Dürer ensured that the image of Ganda lived on, the creature itself sadly did not. In December 1515 Dom Manuel dispatched Ganda to Rome as a gift to Pope Leo X, who was already the proud owner of an albino Indian elephant. The animal never arrived. The ship carrying the unfortunate beast encountered a storm in the Mediterranean and foundered off the Italian coast. As Ganda was chained and shackled to the deck, he drowned, and never became part of the Medici Pope's menagerie.[4]

While the arrival of exotic beasts caught the attention of Europe's educated elite, and fired both the artistic eye and entrepreneurial imagination of Albrecht Dürer, visitors to Lisbon around the same period were just as astonished by the diversity of human life they found in the city. By the latter decades of the sixteenth century Lisbon had gone from being a backwater on the edge of Europe to becoming

the most diverse and global trading city on the continent. And increasingly Lisbon looked the part. Not only were the goods and spices of Africa and Asia flowing into the city's broad harbour; so, too, were people from across Portugal's constellation of trading partners and trading bases. In the second half of the century Lisbon was home to a large population of Africans, as well as an unknown number of people of mixed heritage. Together they may have made up around 10 per cent of the city's population.[5] During a visit of 1582, Philip II of Spain commented, in a letter to his daughters, that he had seen black dancers on the streets of the Portuguese capital from his window.[6]

Were it not for the devastating earthquake and tsunami of 1755, which all but destroyed the Renaissance city, the evidence of the diversity of sixteenth-century Lisbon would be enormous. That disaster, which razed much of the old city and cost thousands of lives, also obliterated the official records of the Portuguese state and much of the material culture of Lisbon.

Only a handful of paintings of the cityscape survive; among the most stunning is an incredible panoramic painting of the *Chafariz d'el Rey*, (*The King's Fountain*), which once stood in the Alfama district, near the River Tagus. It was painted by an anonymous artist, probably from the Netherlands, some time between 1570 and 1580. What is most striking to the modern viewer is that among the many

figures within this bustling urban scene are a great number of Africans. Another surviving painting of the *Rua Nova dos Mercadores*, again anonymous but probably painted in the period 1570–1619, shows black Lisboeta (residents of the city) of various social classes going about their daily affairs. Around half of the figures in that work are African.

In *The King's Fountain* the ornate public fountain of the painting's title is at the centre of the narrative action. Coming to and from the fountain are *aguaderos*, water carriers. These black Lisboeta were almost certainly slaves, carrying heavy jars of water back to the homes of their masters, many bearing their load upon their heads, west African style. A formal slave trade had begun between Portugal and west Africa in the mid-fifteenth century, but slavery was an older, pre-established institution, and there were white slaves as well as black in Renaissance Portugal, just as there were across other parts of Europe at the time. Furthermore, the records suggest that there were men and women living in states of slavery in late sixteenth-century Lisbon whose ancestry lay not just in Africa but also in India, Brazil, China and Japan.[7] Slavery and blackness were not yet ubiquitous in the late fifteenth and sixteenth centuries – that was to come later. Also, as manumission was common, a number of the black figures in any street scene from the period could have included black freemen and women, as well as those still in bondage. This may well be the case for some of the other

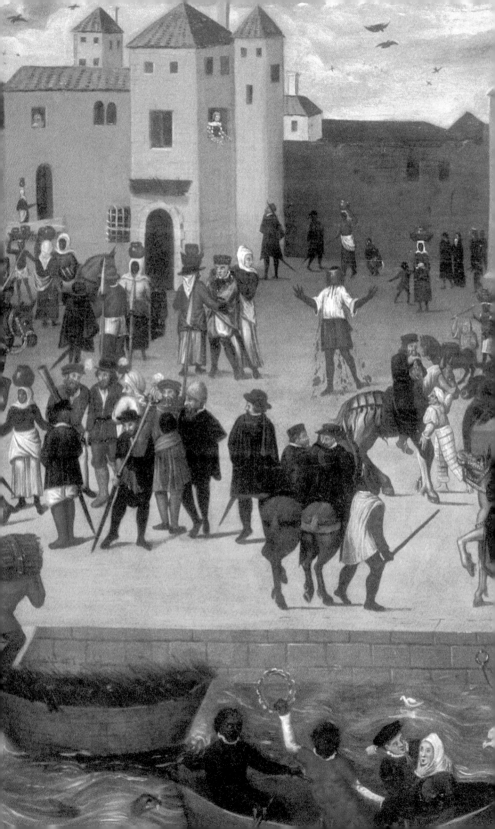

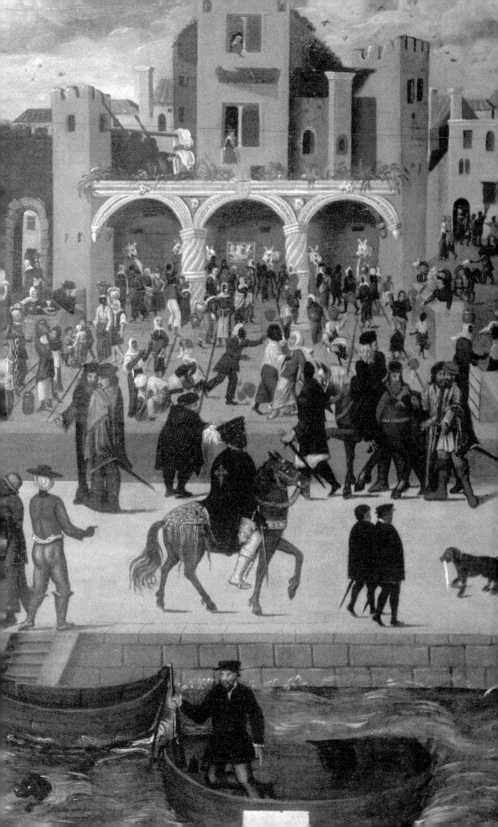

African figures in *The King's Fountain*, such as the ferrymen and street traders. Perhaps the most striking black figure shown is a knight of the Order of Santiago, who appears on his horse with a sword, cloak and other finery. Records from the time confirm that three African men with connections to the court did gain entry into this exclusive order, and the sight of comparatively wealthy and educated Africans on the streets of the Portuguese capital was not uncommon. Among the Africans known to be resident in Lisbon during this period were ambassadors, young aristocrats and even princes from the African societies that had become Portugal's trading partners. The kings of the west African kingdom of Kongo, for example, dispatched younger male relatives to Portugal to be educated in European languages and the Catholic faith.[8]

The strength of the ties between Portugal and her African trading partners can also be seen in the African art that made its way to Lisbon and in the African products depicted as details within Portuguese paintings. Again, such works that exist today – which range from rudimentary trinkets picked up by sailors as objects of curiosity to priceless works of staggering craftsmanship – are rare survivors of the

8. *In* The King's Fountain *Portugal's links to her African trading partners are made clear by the number of Africans, of all social classes, from slaves to a knight on horseback, who appear on the streets of Lisbon's Alfama district.*

calamity that befell Lisbon in 1755. We would know far more about them, their origins and their place within Portuguese society had the Casa da Guiné – which held the records of Portugal's trade with Africa – not been obliterated by this almost biblical catastrophe.[9]

Among the more valuable and intricate works of art are those that were dispatched to Lisbon as diplomatic gifts from the kings of Benin, Kongo and the region that is today Sierra Leone. The most exquisite of those works that have survived tend to be carvings in ivory, produced to exceptionally high standards by skilled craftsmen. Benin ivory, both in its raw state and worked by such artists, was one of the artistic products offered in exchange for brass manillas and other European goods. As the work generated by Benin's guild of metalworkers was exclusively reserved for the court of the Oba, and the export of brass plaques, heads and statues explicitly prohibited, ivory carvings were luxury items that the craftsmen of the Edo people were able to produce for European customers. The prohibition against the export of brass partially explains why the astonishing technical quality and artistic flair of the Benin Bronzes came as such a shock to the art establishment and public of late Victorian Britain.

Benin's ivory-carvers, along with those of Kongo and Sierra Leone, appear to have regarded the new globalism of their age as a business opportunity. To maximise profits,

they began to diversify and produce carved ivory objects specifically designed for export to Portugal. These works of art in African ivory were created by skilled craftsmen who had never set foot in Europe but who were able deliberately to reflect European tastes. The carved figures that appear in salt cellars from the period are European not Africans, as their clothes and facial features demonstrate. They wear Christian crosses and have long beards. The designs of these ivory goods appear to have been copied from illustrations brought to Africa by the Portuguese themselves. Some west African craftsmen were so well attuned to the tastes and culture of their Portuguese customers that they incorporated Portuguese symbols and insignia into their designs. Ivory horns, known as oliphants, from sixteenth-century Benin and Sierra Leone were often engraved with the coat of arms of the Portuguese royalty, the House of Aviz.

Among the many Renaissance Europeans who owned works of art and craft created by Africans was Albrecht Dürer, a man endlessly enthused by the growing understanding of the world that was a hallmark of his era. Well travelled within Europe and personally committed to

9. An intricate and wonderfully playful ivory salt cellar: made by Benin craftsmen but depicting Europeans and the sailing ships that made trade between Europe and west Africa possible.

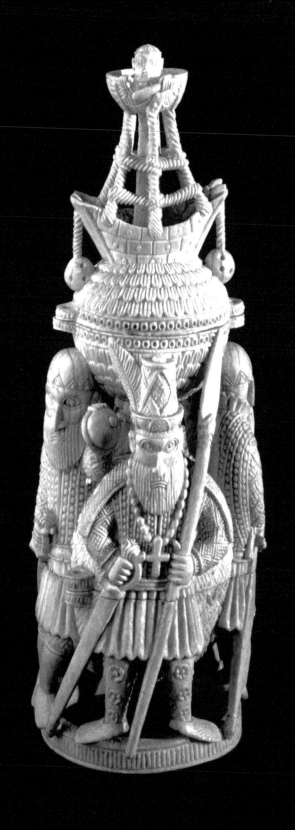

re-imagining what the role of the artist might be, Dürer was magnetically drawn to the visual imagery of other cultures. He may not have visited Ganda the rhinoceros in Lisbon himself, but he did possess goods that might well have been brought into Europe via the Portuguese capital. Among the artefacts known to have been owned by Dürer were a number of ivory salt cellars, which, although now lost, are believed to have been made by highly skilled guilds of ivory-carvers from Sierra Leone.[10] It seems possible that Dürer may have bought these objects on a trip to Antwerp in 1519.

INVADERS AND LOOTING

Four years after Ganda the rhinoceros took his first steps on the harbour side in Lisbon, a Spanish expedition landed on the beaches of the Yucatán peninsula in southern Mexico. The encounter that followed was one of the most cataclysmic events in history.

Spain's defeat of the Mexica civilisation – known as the Aztecs – has traditionally been viewed through the self-serving, self-mythologising accounts of events written by the Conquistadores themselves in the 1520s.[1] Now much criticised and the subject of considerable re-evaluation, the story of the conquest as described by Hernan Cortés and the Conquistadores is likely to have been much embellished, exaggerating the courage, dynamism and tenacity of the Spanish invaders, and is wilfully blind to the resourcefulness with which the Aztecs attempted to defend their world. The traditional account also overstates the degree to which the culture of the Aztec people was erased during the conquest itself and in the years that followed, when an army of Spanish colonists and friars

of the monastic orders arrived in Mexico. While there is no question that few encounters in world history were as devastating as that which took place between Spain and the Aztec empire in the sixteenth century, even here there was some degree of cultural survival and synthesis. Reports of the deaths of great civilisations are always exaggerated.

A century earlier, in 1402, another conquest had taken place, with the Castilian invasion of the Canary Islands.

10. A drawing by Aztec artists recounting the landing of the Conquistadores in 1519, produced decades after the event and taken from Book XII of the Florentine Codex.

That series of landings, battles and consolidations lasted for almost the entire fifteenth century. Thousands of the indigenous Guanche people were killed or enslaved. Others fought on in a long and ultimately futile war of resistance against Castilian arms, but many succumbed to European diseases. Comparable events took place in the 1490s and the first decade of the sixteenth century, when the Spanish conquered the Caribbean islands of Cuba and Hispaniola. Again, the indigenous people were enslaved and subjected to extraordinary levels of violence and brutality. Spanish settlers of the conquered lands – the Canary Islands, Cuba and Hispaniola – were among the first colonial settlers in the modern sense: men who had learned that their fortunes could be made and their positions within their home society radically rewritten through the acquisition of land and forced labour in far-off colonies. In the Canary Islands, and on the island of Madeira, which was colonised by Portugal in the 1450s, sugar-cane was introduced. African slavery followed, and the system that was to shape the futures of huge swathes of the New World began to evolve. Spain's Caribbean colonies were kept financially buoyant not just by cultivation of cash crops but also by the discovery of gold in Cuba. This stroke of fortune enabled the Spanish to use their Caribbean holdings as a bridgehead between the Old World and the New, the jumping-off point for a new wave of conquest on a continental scale.

The first step came in 1517, when Diego Velázquez de Cuéllar, the Spanish governor of Cuba, granted Francisco Hernández de Córdoba permission to embark on an expedition from the Spanish West Indies to the Yucatán peninsula. During their travels, a fleeting but violent encounter between the Spanish and the Mayan civilisation occurred. The Córdoba expedition was not intent on invasion or conquest; its aims had been to capture local people, who were then to be shipped to Cuba as slaves. In that sense, it was a continuation of Spanish policies in the Caribbean, and not a break with the past. But ominously, de Córdoba did take the opportunity to claim the Yucatán formally for Queen Juana of Castile and her son, King Carlos.[2] Christopher Columbus had done the same on 12 October 1492, when he first made landfall on the island of Guanahani in the Bahamas, the royal flag fluttering over the heads of the small Spanish party.

In 1518 Velázquez de Cuéllar dispatched his nephew Juan de Grijala on a second, more heavily armed, expedition to Mexico, but again the mission was partly motivated by the demand for slaves to work the plantations of Spanish Cuba. De Grijala and his men landed at Cozumel and there saw evidence of the developed local civilisation – stone buildings and depictions of animals in stone and terracotta. The Spaniards were now convinced that the lands west of Cuba and Hispaniola were not islands but part of a great

continent. Elsewhere de Grijala's men made contact with the coastal Totonac people, who revealed themselves to be the subjects of an imperial power known as Mexico. Both de Córdoba and de Grijala returned to Cuba with small quantities of gold. The following year Hernan Cortés, the son of a minor Spanish noble and a professional soldier, set sail on what had become a private mission to see the Aztec empire. He had no official sanction, and his expedition was in direct defiance of governor de Cuéllar, who, just too late, had got the true measure of Cortés.

Although the legend of Cortés has to be treated with great caution – much of it having been carefully fabricated by Cortés himself – it is safe to regard him as one of the greatest gamblers to have ever lived: the man who invaded an empire of millions with 600 men, fourteen horses and fourteen cannon.[3] Both Cortés and his mind-set were products of the successive waves of expansion and ceaseless warfare that stretched back through the brutal subjugation of Cuba and Hispaniola, the invasion and colonisation of the Canary Islands and back to the Reconquista of Spain itself. Cortés was shrewd, duplicitous and ruthless beyond measure. The culture that had spawned Cortés and many of his men had imbued them with a strong sense of their own superiority as Christians over pagan peoples, whether island tribes on tiny Caribbean islands or the populace of a vast continental empire. Cortés landed in the Yucatán not

on a slave-raiding mission or to reconnoitre a little-explored shore but to invade.

The eleven ships that carried Cortés and his expedition arrived in February 1519, landing near the site of what became the city of Veracruz. The men spent three months encamped on the coast gathering information. They learned that inland lay a great city that was the centre of a great empire. They also heard about the emperor, Moctezuma (as they named him). Like Juan de Grijala before him, Cortés made contact with the Totonac people, from whom he learned more about the Aztec empire. Within weeks, representatives of Moctezuma arrived at the Spanish camp tasked with checking out the outsiders and their intentions. Painters from the imperial capital – known as *tlacuilos* in the Aztec language, Nahuatl – were dispatched with instructions to depict the incomers and their equipment, along with the animals they had brought with them. The Aztecs lacked an alphabetic form of writing, instead using images in the form of glyphs which were incorporated into folded scrolls and books known as codices. A key form of cultural expression, these documents in themselves could be an embodiment of the divine in the complicated belief system of the Aztecs. In 1519 this highly sophisticated artistic tradition became an interface between two civilisations on the verge of catastrophic conflict.[4]

In August the Spanish marched inland towards the

11. The Taking of Tenochtitlán by Cortes, *a rather exaggerated impression by an unknown seventeenth-century artist, depicting one of the most catastrophic conquests in history.*

Aztec capital of Tenochtitlán. As Cortés drew closer the Aztec people had no reason to suspect that their empire was under threat. Theirs was an intricate civilisation of rich artistic output and enormous architectural achievement. Society moved to the rhythms of a complex calendar and an intricate, if bloodthirsty, religion, through which they attempted to make sense of the universe and their place within it. Famously, the Aztec had never developed the wheel and had no beasts of burden, but what left them

acutely vulnerable to Cortés was the structure of their empire.

In the early sixteenth century the Aztec empire was still young – just a century old. But Moctezuma, the ninth emperor, ruled over a number of dissatisfied subject peoples, some incorporated into the empire relatively recently and still resentful of their overlords. The fragile conglomeration of disparate peoples was held together by a bi-annual tribute system that stoked further resentment. The lack of real bonds between these subject people and their emperor was a profound weakness that the Spanish exploited with merciless precision. The most resentful of these sullen tribes were the Tlaxclalans, not formally subjects of the Aztecs but traditional enemies, whose territory was surrounded by that of Moctezuma. After having at first fought the Spanish, the Tlaxclalans, to their eternal regret, entered into a alliance with them against the Aztecs. His ranks enormously swollen by the armies of his new allies, Cortés reached Tenochtitlán on 12 November 1519.

Built at the centre of Lake Texcoco, the districts of Tenochtitlán were linked to one another and to the mainland by a network of man-made causeways. Home to around 200,000 people, it was probably larger than any European city of the time. The only traces of it that remain are in the accounts of Conquistadores and a handful of

Aztec voices that were later recorded by the friars of the Franciscan order. The ruins and relics of what had been the most wondrous pre-Colombian metropolis now lie flattened under the gargantuan concrete footprint of modern Mexico City.

It was on one such causeway that Cortés and Moctezuma finally met. The Spanish numbered somewhere between four and five hundred; behind them were around 6,000 Tlaxclalans and a few hundred Totonacs. It was at this moment that Moctezuma and his inner circle saw the glint of Castilian swords and the gleam of steel armour. They were reportedly awed above all by the horses on which the Spanish rode, although some accounts suggest they were just as amazed by the sight of the fighting dogs – probably some form of mastiff – that also accompanied the Spanish. During the strange period that followed, the Spanish were treated as honoured guests and lavished with gifts; anything of value that was not offered to them was simply stolen. Having been invited to lodge in the royal palace, Cortés and his men took Moctezuma hostage and for almost half a year the empire was ruled by an emperor who was the prisoner of the invaders.

In April 1520 a second Spanish expedition arrived in Mexico, causing an internal struggle among the Spanish and forcing Cortés to leave Tenochtitlán. In his absence, the remaining Conquistadores massacred leading Aztec

families during a ritual at which human sacrifices were offered. When Cortés returned, Moctezuma was deposed and finally killed, although the circumstances of his death are impossible to determine. Attempting to escape from Tenochtitlán, the Spanish and their allies were ambushed. Many of the Spanish dead drowned in Lake Texcoco, dragged to the bottom by the weight of the looted gold concealed in their pockets. Six months later the Spanish and their Tlaxclalan allies returned to besiege the city. By this point resistance was already being undermined by the effects of the diseases the Spanish had introduced. By the time Tenochtitlán fell it had already been partially destroyed and as many as 100,000 bodies littered its streets. In the wave of looting that followed, many more of the city's inhabitants were put to the sword.

The armies of Moctezuma had faced the Spanish with swords whose cutting edges were made from chipped stones. Their arrows were tipped not with tempered metals but with wood hardened by fire. At first they had attempted to fight the Spanish through their own ritualised form of warfare, but this was no answer to the mounted Conquistador, the sixteenth century's equivalent of the battle tank. Yet even with all these military disadvantages, their sheer weight of numbers should have made the conquest impossible – even with the Tlaxclalans marching under the banner of Cortés. What tipped the scales was the sheer cultural shock of the

conquest and the calamitous impact of western diseases, the most significant being smallpox, a common enough virus in Europe but against which the Aztecs could offer no resistance.

The man who is believed to have unknowingly transmitted smallpox from the Old World to the New was himself a product of the growing age of globalism. Francisco Eguía, an African slave, made landfall on the east coast of the Yucatán peninsula in 1520 and is thought to have died from smallpox soon after. The disease he had harboured began to spread uncontrollably among a people utterly devoid of immunity. Both Spanish and later indigenous chroniclers left shocking accounts of the decimation of Aztec people. One Spanish friar who witnessed the event wrote:

> When the smallpox began to attack the Indians it became so great a pestilence among them throughout the land that in most provinces more than half the population died ... they died in heaps, like bedbugs. Many others died of starvation, because, as they were all taken sick at once, they could not care for each other, nor was there anyone to give them bread or anything else. In many places it happened that everyone in a house died, and, as it was impossible to bury the great number of dead people they pulled down the houses over them in order to check the stench that rose from the dead bodies so that their homes became their tombs.[5]

Animated by their desire for gold, Cortés and his men showed little interest in the suffering of the Aztec people. Nor did they seek to understand the culture and art of the civilisation they had overwhelmed. During the siege and conquest of Tenochtitlán, and the destruction that followed, vast amounts of indigenous artefacts were looted and much of the city destroyed. Growing and genuine Spanish abhorrence at the widespread Aztec practice of human sacrifice encouraged a greater sense of religious mission among the Conquistadores, turning them towards greater acts of religiously motivated destruction. Cortés did, however, recognise how the art of the Aztecs might be used as exotic props in his ceaseless campaign for greater wealth and personal recognition. In order to win support and praise from King Carlos V, he dispatched three shipments of Mexican art, and other items of ceremonial and everyday life, to Europe. One collection was viewed by Albrecht Dürer, who, perhaps more than any other artist of

12. *The Aztec Stone of the Five Eras. Intricately carved with various glyphs and icons, it is one of the most significant Aztec artefacts to have survived the conquest. Its religious and cultural functions are not fully understood.*

his age, possessed a curious eye and an open mind. In his diary entry for 27 August 1520 Dürer wrote:

> I saw the things which have been brought to the King from the new land of gold, a sun all of gold a whole fathom broad, and a moon all of silver of the same size, also two rooms full of the armour of the people there, and all manner of wondrous weapons of theirs, harness and darts, very strange clothing, beds, and all kinds of wonder objects of human use ... All the days of my life I have seen nothing that rejoiced my heart so much as these things, for I saw amongst them wonderful works of art, and I marvelled at the subtle Ingenia of men in foreign lands. Indeed I cannot express all that I thought there.[6]

Dürer's astonishment at the wondrous nature of the objects he viewed in Antwerp, and his praise for the creativity of the Aztec people, flowed from his artistic sensibilities, but, as for all those who encountered them, the sense of wonder they inspired arose from the realisation that they had been produced by a people whose existence had been entirely unknown just two years earlier. To early sixteenth-century Europeans the objects on display were truly the artefacts of an alien civilisation, a people from a continent about which both the scriptures and the ancients had been entirely silent. Even for the victorious Spanish, their encounter with the great civilisations of the New

World was enormously disruptive to established systems of belief and accepted knowledge.

Most of the objects Dürer viewed are now lost. The survival rate for Aztec art and artefacts has been tragically low. The feather mosaics, fruits of what may well have been among the most highly evolved of the Mexican art forms, had little chance of survival, but thousands of other less fragile objects were lost in other ways. Items made of precious metals were frequently melted down and precious stones removed from their original mountings. One remarkable survivor is the so-called double-headed serpent, today

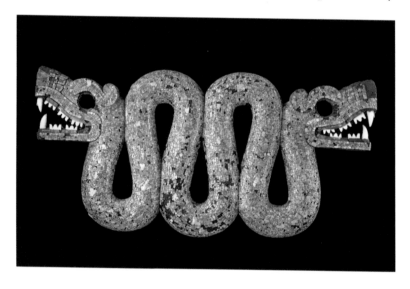

13. The double-headed serpent. One of the greatest surviving treasures of the Aztec civilisation. Carved from wood and covered with mosaic made of turquoise, it might have been one of the gifts Emperor Moctezuma gave to the Conquistador Hernán Cortés.

held in the British Museum. It consists of a carved wooden body on to which tiny, cut pieces of turquoise have been meticulously fixed using plant resins. Minute fragments of brilliant white sea shells have been used to form the serpent's teeth and pieces of red thorny oyster shell frame the two mouths. Some 2,000 individual planes of turquoise completely cover the body, creating a shimmering effect as light reflects off each tiny shard, resulting in an illusion of movement.[7] The survival of the double-headed serpent may well be due to the fact that turquoise, although valued more than gold by the Aztec, was of little interest to the Spanish.

The original religious and ceremonial functions of the double-headed serpent, the only one of its kind to have survived, are today uncertain. Perhaps it was part of the ceremonial dress of Moctezuma himself, worn on the chest, attached by cords. Alternatively, the serpent could have been carried in ceremonies on a staff. But, however it was worn or presented, its symbolism would have been powerfully obvious to all who saw it. The object was loaded with the dualism that was a central feature of the Aztec belief system: not only does the serpent have two heads and multiple symbolic meanings; it may also be a hybrid creature – a serpent-bird, a feathered snake, the symbol of the Aztec god Quetzalcoatl, the deity of whom Moctezuma may, disastrously, have believed Cortés to have been an incarnation.[8]

Mexico – renamed Nueva España (New Spain) – was brought under the rule of the kings of Spain and into the embrace of the Catholic Church. Almost immediately Cortés began rebuilding Tenochtitlán as a Christian capital, effectively obliterating Moctezuma's realm. On the site of the main temple complex that had stood at the centre of the city, the Spanish cathedral was built. Those who survived the conquest and smallpox epidemics – their numbers can only be speculated at – were now subject to a second, spiritual and cultural conquest. Spain's grip on the region tightened further when, after the initial flood of looted gold began to slow, the silver mines of Zacatecas were discovered. The wealth drawn from the mines, from the 1540s onwards, sparked migration from Spain and increasing investment in the territory by the Spanish Crown. The mineral wealth of New Spain thereby funded the administration of Mexico, which in turn assisted the monastic orders to embark on the wholesale conversion of the conquered people and the establishment of the Catholic faith.

Efforts to obliterate Aztec religion were carried out with incredible zeal, by both the Conquistadores and the friars of the Franciscan, Augustinian and Dominican orders, who flocked to Mexico. Within a decade of the conquest 2,000 idols had been toppled and 500 temples destroyed.[9] New churches were built on temple foundations, sometimes using the same stone. And cast on to the fires were the

codices, the books of glyphs that had recorded Aztec history and transmitted its culture. To complete the process, the schools from which the *tlacuilos* painters and the priestly classes operated were shut down.

The conversion of the peoples of Mesoamerica in the sixteenth and seventeenth centuries was regarded as one of the great triumphs of Catholic evangelism. So great was the harvesting of souls that the new converts could not all fit into the new churches that were rapidly built with local labour and decorated by local painters schooled in European design. To draw the whole of the Aztec population to the new faith, the friars concentrated first on converting members of wealthy and aristocratic families, the people who had the greatest influence among their people. But they also focused on the young, who were regarded as ripe for conversion, having not been raised in the traditions of their parents.

Many of the Franciscan, Augustinian and Dominican friars, the spiritual Conquistadores of New Spain, were astonished by the ease of their task. The Aztec appeared remarkably willing to accept the new faith – although there were concerns that internally, behind closed doors, the new converts were secretly faithful to the old gods. Some friars came to believe that the majority of conversions were insincere. They noted that traditional healers and prophets still operated, especially in the remote rural areas far from

the centres of Spanish influence. In order to erase the last traces of the Aztec religion and drive out the pagan gods, the friars had first to develop the capacity to determine which indigenous practices and traditions were idolatrous – in Christian terms. This required them to acquire a greater understanding of the religion and the cultural practices they were seeking to eradicate, and by the 1530s the more astute friars, particularly the Franciscans, had come to realise that the codex books that had been destroyed had been the key to understanding Aztec religion. Surviving codices were closely examined, Aztec priests were questioned and the *tlacuilos* were called upon to explain and decipher the images and symbols of codices.[10]

Among the Franciscans who came to New Spain was Friar Bernardino de Sahagún. In 1536 he helped found the Colegio Imperial de Santa Cruz de Tlatelolco, an institution dedicated to the study of the Nahuatl language and the training of indigenous men to be priests. Sahagún learned Nahuatl and embarked on a series of expeditions to the provinces to live among the local people and increase his knowledge of Aztec culture. He also recruited a number of indigenous artists and translators with whom he set about creating a written and pictorial record of the Aztec culture. The resulting works was the vast, twelve-volume *Historia general de las cosas de Nueva España (General History of the Things of New Spain)*.

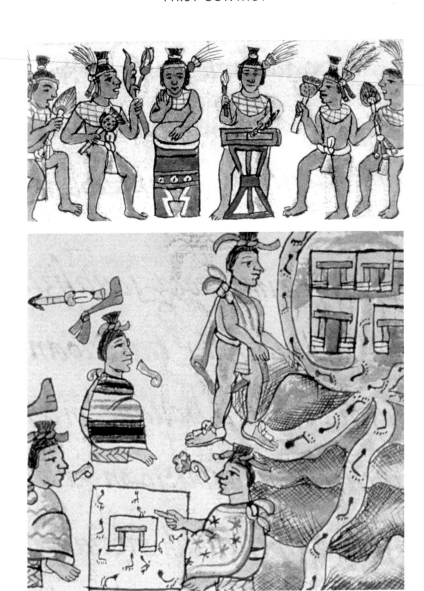

14, 15. *Images from Book IX of the Florentine Codex show Aztec musicians performing and the consultation of maps. The images were created by Aztec artists who worked alongside the Franciscan friar Bernardino de Sahagún.*

As the best-known extant version is today held at the Laurentian Library in Florence, Sahagún's *Historia* has come to be known as the Florentine Codex. This vast work contains descriptions and paintings of the beliefs, gods, customs and world-view of the Aztec people, before and during the conquest. The text appears in both Spanish and Nahuatl, although not consistently. The first volume is a compendium to the twenty-one gods of the Aztec, a subject

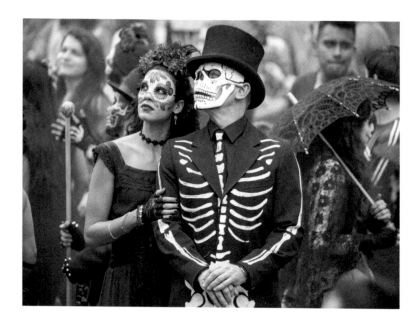

16. *The Day of the Dead and the* calavera, *the stylised representation of the human skull, are now internationally recognised emblems of modern Mexico – here portrayed by James Bond in the opening sequence of* Spectre *– but the origins of the festival stretch back to the religious beliefs of the Aztecs.*

the Spanish found extraordinarily difficult to comprehend. Each deity is described and painted. Subsequent volumes deal with the ceremonies and rituals, the origin stories of the gods, the role of omens and superstitions, the forms of government that had prevailed before the coming of the Spanish and the customs and pastimes of the nobility. Volume XII is an account of the conquest as seen from the Aztec perspective, based on a series of accounts gathered by Sahagún himself between 1553 and 1555. Although mediated by Sahagún, the Florentine Codex does attempt to give voice to a people rendered mute in Cortés's dubious and selective account. And that indigenous voice is often at its most vivid when delivered through the paintings that are the most striking and beautiful feature of this and other codices produced in the sixteenth century.

The destructiveness of the conquest and the decades that followed is undeniable, but, as the codices reveal, there was some degree of dialogue and accommodation between the European and Aztec cultures that found themselves in sudden and close proximity. The most dynamic and visible element of Aztec culture that survived was their festival to the goddess of death. This tradition was kept alive by fusing it with the Catholic traditions of All Saints Day and All Souls Day. It lives on today as the Day of the Dead, a modern, nationwide Mexican festival that remains partially pre-colonial and pagan in nature. The celebration of the

spirits of lost ancestors, the symbolism of the skull, the offering of food and flowers to the spirits of the dead are not Catholic traditions but living echoes of Aztec belief systems, kept alive for five centuries by their descendants. The skull mask, the *calavera,* has become the ubiquitous symbol of the Day of the Dead and is fast becoming an internationally recognised icon of modern Mexican culture.

JUSTIFYING CONQUEST

There was no society where the victim or victor that emerged from the age of exploration remained unchanged. Spain too was transformed. Vast amounts of silver and gold seized from the New World made her the richest nation in Europe. The brutality of the conquests were justified, it was argued, because they spread Christianity. Although the purity of Spain's Catholic faith was ruthlessly defended by the Inquisition, the exchange of ideas and culture was unstoppable.

However, Spain's aggressive exporting of her culture and her faith to other parts of the world didn't render her immune to the inflow of cultural influences from abroad. In Toledo, the spiritual heart of the Spanish church, cultures met and mixed and, in doing so, some of the very greatest European art of all time was created. Take, for example, the work of a visionary, a man whose style and intensity was centuries ahead of its time. Born in Crete as Doménikos Theotokópoulos, he was known in Spain as El Greco, the Greek. El Greco used the artistic traditions of Greek

orthodoxy, as well as the strange distortions of Italian mannerism, and his great achievement was combining those influences in a way that expressed the fanatical intensity of the religious culture of sixteenth-century Toledo. In 1596 he began work on a dramatic view of the city. It is starkly lit beneath a stormy sky, a vision of a holy citadel where God's authority was made manifest to the Spanish church. Rising up from the skyline is the spire of Toledo cathedral. It was for this cathedral that El Greco painted one of his greatest masterpieces.

El Greco's painting still hangs in the space for which it was created, the cathedral sacristy where the priests put on their robes before performing mass, so it is fitting that El Greco chose as his subject the disrobing of Christ. What we see is the moment Christ's cloths are ripped from his body before the crucifixion. No other artist more vividly captured Catholic Spain's intense fascination with the brutal horror of Christ's sacrifice. While there is no blood in this painting, we are symbolically reminded of the violence that is to be done to the body of Christ through the deep, intense red of the robe. It reminds us that the crucifixion was a blood sacrifice, a strange echo of the human sacrifices that were at

17. In stark colours and with exaggerated proportions, El Greco places Christ, isolated and tormented, against a storm-riven sky. In the background stands Toledo where Greco spent forty years of his life.

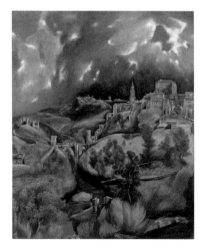

18. One of only two surviving landscapes by El Greco, his View of Toledo *reorders and reimagines the city as a divine Christian citadel and hints at the fervent religious atmosphere that pervaded the city in the early seventeenth century.*

the heart of the religion of the people who Spain had conquered, the Aztecs. El Greco made that sacrifice explicit when he painted Christ's battered, distorted body hanging on the cross, his blood trickling down towards not a view of the Holy Land, but of Toledo, the beating heart of the Spanish empire.

But Spain's conquests in the New World were not the norm in the sixteenth century. They were, in a sense, the exception. When European explorers reached the shores of more powerful empires like India and China, they found themselves marginal players and in Japan they encountered a feudal society too robust to be conquered.

KEEPING AN EYE ON CULTURE

The Portuguese of the sixteenth century were wisely secretive about their trade networks and the extent and nature of their contacts with other nations. As a result, the details of when and how the European Age of Discovery arrived in Japan are vague. While there may possibly have been earlier arrivals, what is known is that in 1543 a Chinese junk, on which two or three Portuguese merchants were travelling, was driven by a storm on to the shores of Tanegashima island, today part of the Japanese prefecture of Kagoshima.

According to an account of that encounter, the first Japanese to arrive at the remote cove in which the ship had come to rest were peasants from a nearby village who were intensely curious about the stranded Europeans. With no shared spoken language, the captain of the Chinese ship and the leader of the local Japanese village conversed using Chinese characters drawn into the sand of the beach using sticks. Through this medium the captain was questioned about the strange white-skinned men with bizarre clothes

and unfamiliar facial features who were among his crew.[1] Just as exotic and fascinating were the objects the Europeans carried. The local lord, Tanegashima Tokitaka, met with the men from Portugal soon afterwards and, after an impromptu demonstration, purchased two arquebuses (an early form of matchlock musket).[2] Tokitaka gave these weapons to a master swordsmith named Yasuita Kinbei Kiyosada, who began work replicating the weapons, thus beginning the introduction of firearms into Japan. The muskets the Japanese blacksmiths devised were called *tanegashima*, after their place of introduction.

The following year more Portuguese arrived, this time in their own vessels, and the men who had been driven on to Tanegashima island were reunited with their countrymen. Rapidly, as further ships arrived and goods traded and exchanged, the two parties began to learn more of one another.[3] Marco Polo had described Japan in his accounts as an island of gold, and in late Renaissance Europe Japan was recognised as the most distant of all known civilisations. What was clear to the Portuguese traders was that in Japan – as in most of Asia – they simply did not have the option of behaving aggressively, as the Spanish had in Mexico and the Caribbean. Sixteenth-century Japan was a demographic superpower, with a population probably in excess of 12 million, many times the size of Portugal herself and far larger than most European states; she was wealthy, highly

organised and militarily formidable.

The Japanese emperor was little more than a symbolic, ceremonial figure, and so the nation was divided between numerous competing local rulers, the *Daimyo*. Despite being in a phase of internal strife and warfare, sixteenth-century Japan displayed none of the fragilities that had left Moctezuma's Mexico so vulnerable to Cortés. The pattern of conquest and domination that characterised Europe's contact with the civilisations of the Americas was not to be repeated in Asia, and the encounter between Japan and Europe was one the historian Holden Furber described as the 'age of partnership': an era of collaboration and interaction that has defined relationships between Asians and Europeans through to the early modern era.[4]

Trade was the only option available to the Europeans who came to Japan. And the attractions of such a trade were obvious and multiple. The Japanese themselves produced numerous products that were desired both in Europe and in other parts of Asia where the Portuguese also had trading bases. But, more significantly, they had the wealth to buy large quantities of the goods that Europeans were seeking to sell. Their wealth was in the form of silver. After Spain, with its recently acquired territories in Mexico and Peru, Japan was the biggest producer of silver in the world. By the start of the seventeenth century perhaps as much as a third of the world's silver was mined in Japan.[5] This precious metal was

the commodity Europeans needed more than any other in order to trade with China, during an age economic historians call the 'silver century'.[6] Indeed, the interconnections and globalism of the early modern age can be partly understood through the global flows of silver. The bulk of that precious metal, whether mined in the New World or extracted from the volcanic rocks of Japan, was exported to China and used to purchase Chinese commodities. China was in many ways the centre of the first age of globalisation. Her share of the global population in the sixteenth century stood at around 25 per cent, a greater proportion than today, and she produced many of the most treasured commodities of the age – silks, fine porcelain, pearls and lacquer ware. The trade that developed between the Portuguese and the Japanese was in large part a Chinese trade. An old Ming Dynasty law prohibited Chinese merchants from trading directly with Japan, thereby allowing the Portuguese to act as middlemen, using New World and Japanese silver to buy Chinese silks, which were then sold to the Japanese for yet more silver. Then, returning to China, the Portuguese would trade Japanese silver for Chinese gold, at generous rates of exchange, and also purchase greater quantities of Chinese luxury goods which they then sold back in Europe at enormous profit.

The Japanese called their part in this global exchange the 'Namban trade'. The name derives from a Sino-Japanese

term that in its new context came to be applied to the Europeans. Rather unflatteringly, Namban meant 'southern barbarians': southern because the Europeans tended to arrive from the south, having travelled from their trading bases in China (Macao) and India (Goa); and barbarians because the Japanese were appalled by European standards of hygiene and etiquette. They were even more horrified by European table manners.

There was, however, another commodity within this trade that was little discussed in the centuries that followed: a slave trade. Japanese people, mostly poor peasants, were sold into slavery. The most valued were young girls, who were bought and sold for sexual purposes. It is probable that the first Japanese ever to see Europe arrived in Lisbon as slaves. There is also evidence that Africans and Malays, who laboured for the Portuguese on their ships and in the trading fort in Macao during the sixteenth and seventeenth centuries, and who were themselves enslaved, became the buyers and owners of Japanese women peddled to them by the Portuguese.[7]

During the seventeenth century the Portuguese traders were joined in Japan by merchants and sailors from Spain, Italy, the Dutch Republic and England. The Japanese dubbed the Dutch and the English *kōmōjin* – red hairs. The Europeans introduced new technologies, new forms of art and new foods, some of which, such as sweet potatoes,

were produce of the New World and therefore relatively novel even to the Europeans. Watermelons made their first appearance in Japan at this time, as did bread, but the most significant culinary innovation of the age was the Portuguese recipe for egg-and-flour fried batter, which after some adaptation became Japanese tempura.

This era of trade and encounter between Europeans and the Japanese was depicted in a popular new Japanese art form, *namban-byobu* – large, multi-panelled, folding painted screens. The work of the master artists of the Kano, Tosa and Sumiyoshi artistic schools, they are strikingly beautiful, abounding with detail and renowned for their lavish use of gold-leaf paints. The tradition of screen painting stretched back centuries; the screens were used to divide rooms in Japanese homes. They came in a range of sizes, with the numbers of panels ranging from two to six, though only around ninety *namban-byobu* from the sixteenth and seventeenth centuries have survived.[8] Little known outside Japan today, they are exquisite representations of a largely forgotten phase of sixteenth-century globalisation, seen from the perspective of the Japanese.

The screens depict the arrival of Portuguese traders on the Japanese coast, in their black ocean-going ships – black because they were painted with pitch. It is probable that none of the artists who painted the screens ever saw the Portuguese ships with their own eyes. Some may have

based their paintings on depictions of ships that appeared as details in European maps that had begun to circulate among the Japanese elite.[9] But many of the most interesting and appealing *namban-byobu* depict the unloading of goods from the Portuguese trading ships. Wrapped bolts of Chinese silk are shown piled on the decks of the ships or being lowered into small boats and ferried ashore. Other goods lie in neat piles on the beach. The traders are shown parading through the streets of settlements, past the homes and the eyes of admiring locals. They carry with them Chinese furniture, exotic animals in cages or on leashes, and yet more silk. In a *namban-byobu* attributed to the painter Kanō Naizen, a camel is shown being led away from its place of landing, while a group of Portuguese and African sailors struggle to subdue two Persian horses. In another, peacocks and even Bengal tigers are shown arriving. While the Europeans provide the novelty and the narrative on the beach, awaiting them are Japanese officials, calmly interacting with their new trading partners.

What is apparent is that to the Japanese artists who produced them, and their fellow countrymen who bought their work, the crews of the Portuguese vessels were just as fascinating and exotic as the cargoes they carried – all the more so, as Japan's encounter with the Portuguese inevitably entailed an encounter with the many and varied peoples of the Portuguese trading empire. On board the

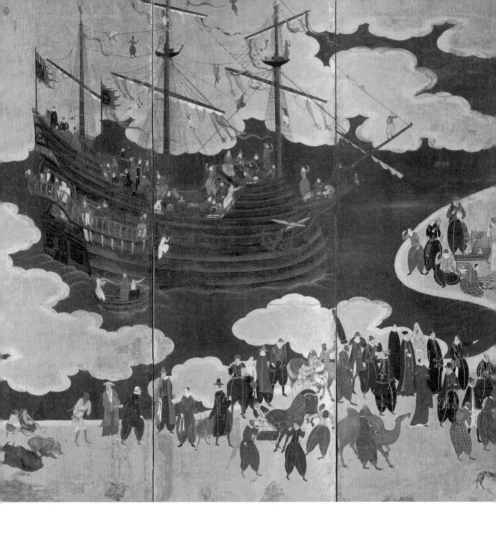

19. A namban-byobu screen by the Japanese artist Kanō Naizen
showing the arrival of a Portuguese trading ship. Among the exotic
goods being unloaded are camels and horses from Arabia. Namban,
the term the Japanese gave their European trading partners, meant
'southern barbarians'.

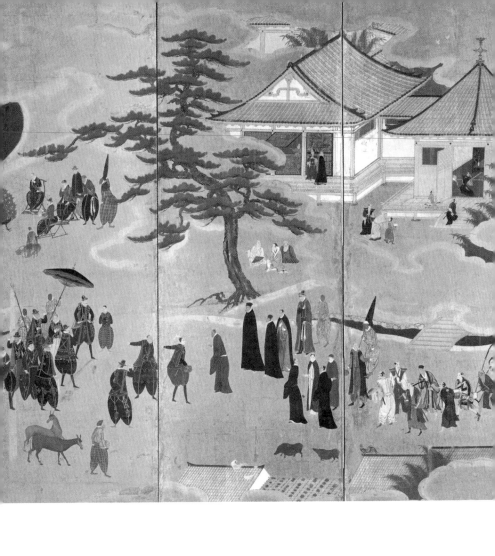

Portuguese galleons and caracas, and carefully portrayed by the *namban-byobu* artists, are Africans – both enslaved and free – Indians, Malays and Persians. *Namban-byobu* capture that moment when the Portuguese, then the most travelled and worldly nation on earth, encountered the relatively isolated Japanese. Here, magically preserved on the surviving screens, is what it looked like from sixteenth-century Asian eyes when the great circus of global trade and inter-civilisational contact came to town.

While the subject matter of *namban-byobu* is the arrival of outsiders, the artistic style is indigenous. Within the more playful *namban-byobu* there is even a sense of the Europeans being gently ridiculed. The loose *bombacha* trousers that travellers from Europe and her empires wore to protect themselves from mosquitoes are rendered comically baggy. European noses, which appeared prominent and extended to the Japanese, are exaggerated, and occasionally accentuated with a rakish moustache. Yet for all the frenetic activity and the observed novelty and exoticism of the scenes they depict, there is a stillness and calm to the *namban-byobu*. This, perhaps, hints at the sense of equanimity with which the Japanese regarded the arrival of Europeans: confident of their capacity to control the incomers, and focused on their own internal politics and power struggles. The Chinese translator who had interpreted for the first Portuguese arrivals at Tanegashima

in 1543 was perturbed that the Europeans appeared to lack 'a proper system of ceremonial etiquette', and was appalled to see that they 'eat with their fingers instead of chopsticks', 'show their feelings without any self-control' and 'cannot understand the meaning of written characters'. Yet summing them up, and reflecting on what their sudden arrival might mean, he concluded, 'they are a harmless sort of people'.[10]

Events would prove the interpreter of 1543 wrong. The introduction of the arquebus radically interfered with the power balance of sixteenth-century Japan and played a key role in the Sengoku period, also known as the Age of the Warring States, in which Japanese armies equipped with domestically produced copies of European firearms fought for control and ultimately for unification.

Within many *namban-byobu* are depictions of another group of Europeans who were to unleash an equally destabilising force on Japanese society, one that would demand the Japanese to rethink their categorisation of Europeans as harmless. The figures in question can usually be found on the shore or in the waterside settlements. Already resident in Japan, they are shown waiting to greet the new arrivals from the Portuguese empire. These figures, the Jesuits, are at other times shown near their churches, built in the local Japanese style. For the Portuguese, the conversion of the Japanese was a mission of enormous importance. Arriving from a Europe torn apart by religious

conflict and the Protestant Reformation, the Jesuits were determined to spread their faith to this most distant of nations, thereby bolstering the strength of the Roman Catholic Church, both literally and symbolically. So successful were the Portuguese missionaries in their task that the historian C. R. Boxer described the period (1549–1639) as Japan's 'Christian century'.[11] In 1550 only around a thousand Japanese people had converted to the new faith.

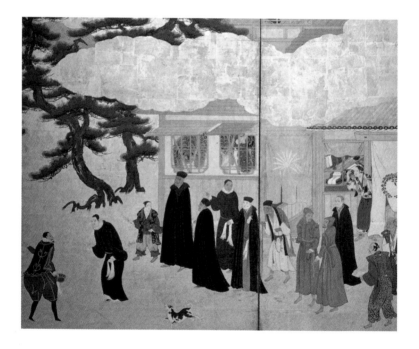

20. *Newly arrived Portuguese traders are greeted by some Jesuits, the Catholic missionaries whose success at spreading the faith among the Japanese would ultimately lead to the expulsion of all Europeans from mainland Japan.*

By 1580 that figure had reached about 150,000. By the end of the sixteenth century there were around 300,000 Japanese Christians; soon after that, half a million.[12] The spread of the new faith was fastest in Kyushu, the most southerly of Japan's three main islands, where a number of the local *Daimyō* had converted and were actively assisting the Jesuits in their work.

This wave of conversion was well under way in 1603, when the chaos of the Sengoku period came to an end. The arquebus, the weapon that the Portuguese had unintentionally introduced into Japanese warfare, had ensured that military victories were more decisive and complete than had been the case before the advent of firearms. The end of the Age of the Warring States was brought to a conclusion by the final rise to power of the dynasty that was to turn against both the Portuguese and their faith. The Tokugawa Shoguns, who were to rule Japan until the 1860s, developed a deep distrust of the Jesuits. And in the last years of the sixteenth century Japanese observers noted the bitter rivalries that existed between the Franciscan and Dominican orders. Disputes between the Europeans were increasingly conducted openly as the rival orders denounced one another and their motives to their Japanese hosts.[13] The Tokugawa became more suspicious still as they came to understand what the Spanish had done to the Aztec people, and learned that the calamity that

had befallen Mexico had been repeated some years later during the conquest of Peru and the destruction of the Inca Empire. The Japanese were similarly disturbed by the invasion and gradual conquest of the Philippines by Spain over the course of the late sixteenth century.

Shōgun Ieyasu, the first of the Tokugawa, was a strong proponent of foreign trade and tolerated the missionaries. During the early years of his reign the number of Christians began to rise rapidly however, and in 1614 he issued a Christian expulsion edict. In 1623 the second Tokugawa, Ieyasu's son Shōgun Hidetada, executed fifty-five missionaries in Nagasaki (some of whom were symbolically crucified) and drove out the Jesuits. Japanese converts were brutally repressed, and all Japanese were prohibited from practising their faith, and sentenced to death if they refused to denounce Christianity. Churches built by the Jesuits were demolished. Between 1633 and 1639 the Tokugawa issued a series of so-called seclusion edicts, and Namban trade, which had begun in 1550, was halted. Tokugawa Shōgun Iemitsu declared a new era of 'sakoku' (isolation), in which Japan, in theory at least, was to be cut off from the rest of the world. The Japanese were forbidden to leave their country, and the construction of ocean-going ships was prohibited. All foreigners, not just the missionaries, were expelled, and foreign ships refused permission to enter Japanese ports. The sakoku era was to last 215 years. However, Japan's

isolation was never complete, and it is perhaps better to think of the *sakoku* era as a period of controlled contact – managed globalism – rather than of complete isolation. Japan's window on the wider world was Dejima, a purpose-built artificial island in Nagasaki harbour. Access from the island to the mainland was strictly and easily controlled, allowing the Japanese to enjoy the benefits of foreign trade while ensuring that Europeans were not able to spread their faith or smuggle missionaries into the country. From Dejima the ships of the Chinese were permitted to trade, as were those of a single European nation, the Dutch Republic.

Why the Dutch? As Protestants, men more interested in profit than proselytising, the Dutch were more trusted than the Catholic Portuguese, although the Dutch were constantly questioned about their faith by their Japanese trading partners. It is also said that the Japanese preferred the company of the Dutch, who, like them, were enthusiastic consumers of strong alcoholic spirits, unlike the pious and often abstemious Portuguese. Yet drinking habits and religious confession cannot fully explain why the Dutch were able to find favour with the Tokugawa rulers of Japan. Part of their success was due to their ability to master the necessary diplomatic skills needed to win the trust of the Japanese.

At the centre of the story was the Verenigde Oost-Indische Compagnie (VOC), the Dutch East India

Company. Established in 1602, it was the first multinational corporation and the first to allow the public to buy and sell company shares and bonds. These were innovations perfectly suited to a state formed from seven separate, quasi-independent provinces and home to people whose Calvinist ethic encouraged them to save and accumulate capital. The principle behind the formation of the company was simple. The various pre-existing Dutch trading companies were compelled to join forces and merge into the new VOC, which was given monopoly rights over trade with the East Indies, thereby preventing Dutch companies from wastefully competing against one another.

Within the Dutch factory on Dejima, the VOC learned to play the game of local politics. The company operated under terms dictated by their host, with little room for manoeuvre, in a constrained and clearly defined role. Not only this, but the privileges the VOC enjoyed came with obligations and responsibilities with which they had no choice but to comply – these duties included making themselves available for military service to the Shōguns. The Dutch operated in an environment in which the power of the Shōgun was unassailable, impervious to whatever displays of military power the Dutch might contemplate, and in order to survive in that environment they allowed themselves to be incorporated into the power structure of Japan. They were, in effect, domesticated.[14] Like all

other vassals, they were expected to demonstrate their subservience and submission lavishly, theatrically and regularly. Each year the company's representative made the long journey to the capital Edo (Tokyo) to prostrate himself before the Shōgun. One governor-general wrote in 1638:

> The Japanese must not be troubled. You must wait for the right time and opportunity and with the greatest patience to obtain something. They will not suffer being spoken back to. Therefore the smaller we make ourselves, pretending to be small, humble and modest merchants that live because of their wishes, the more favour and respect we can enjoy in their land, this we've learned from long experience ... In Japan you cannot be too humble.[15]

The Dutch were not simply the European nation with favoured nation status in Japan; they also acted as 'merchants of light', suppliers of advanced western technology and information, about events and developments in Europe and beyond. New ideas in the sciences and the arts reached Japan through the portal of Dejima, carried on the ships of the VOC. Through Dejima trickled the fruits of the European Enlightenment – clocks, maps, microscopes, celestial and terrestrial globes, eyeglasses and medical instruments. Telescopes, too, were imported, but eventually, like the arquebus before them, indigenous manufacturers learned how to replicate them.

In the later, more proactively inquisitive stages of the *sakoku* era, an earlier prohibition on western books was lifted and thousands of European texts containing developments in medicine, chemistry and philosophy were imported through Dejima. These books were translated by a hereditary caste of linguists from a handful of Nagasaki families, who passed their skills through the generations. They became the first link in a chain of what became known as *rangaku* (Dutch learning), a term that was deployed to describe all knowledge imported from the West, no matter what its origins.

One popular scientific curiosity imported through Dejima was to have an unexpected impact on Japanese art.

The Japanese called them *nozoki-karakuri,* or Dutch glasses. This simple optical device consisted of a convex lens fixed into a wooden box, in front of which were

21. A wood block print by Suzuki Harunobu shows two young Japanese women with a stereoscopic picture viewer – a device known as Dutch glasses. This fashionable European import made specially created images appear more three-dimensional.

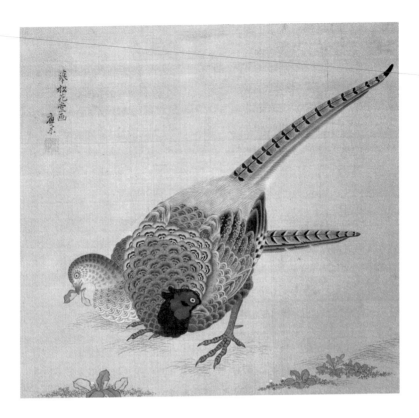

22. *A pair of pheasants by the Kyoto artist Maruyama Ōkyo shows the fusion within his mature work of influences from both East and West.*

placed printed landscapes that had been painted using European rules of perspective. The result was a convincing three-dimensional effect. The impact was all the greater for the Japanese, who were accustomed to the flat, decorative style of their nation's dominant, state-sanctioned school of art.[16] One of the artists who created images to be used in

nozoki-karakuri was Maruyama Ōkyo. One of his earliest jobs had been painting faces on to dolls for a Kyoto toy merchant. Moving on to painting scenes for the Dutch glasses, Ōkyo studied vanishing-point perspective. His innovation was to apply his new understanding to revered Japanese subjects, such as the medieval Hollyhock Festival, infusing them with a previously unknown sense of depth.

One of his masterpieces, *Cracked Ice*, is a low two-fold painted screen (*furosaki byōbu*) of the type used in the tea ceremony. It shows a sheet of ice, presumably on a

23. *One of Maruyama Ōkyo's most celebrated works,* Cracked Ice. *Painted on to a two-fold paper screen designed as backdrop for use in the traditional tea ceremony it applies western vanishing-point perspective to a traditional Japanese subject.*

lake, through which run a series of broken, jagged cracks, which disappear into the mist. The resulting effect is of a seemingly three-dimensional space, subtly governed by the rules of perspective. While a product of cultural synthesis, *Cracked Ice* remains fundamentally Japanese, displaying a

philosophical contemplation of two concepts fundamental to Buddhism, imperfection and impermanence: imperfection in the form of the jagged, uncontrolled and irregular lines; impermanence in the subject itself, winter ice that will soon melt.

EMBRACING THE NEW

Dejima was just one node in the intercontinental empire of the Dutch, a profoundly different entity from the empire the Spanish had created in the Americas. Unlike the Spanish, the Dutch were a people little interested in religious conversion of non-Europeans, and they largely kept their Protestant faith to themselves. Although they travelled the world heavily armed, and could be utterly ruthless if the need arose, they were only keen on conquest if it could be done at a profit. Fundamentally this was an empire of traders, not Conquistadores. Their watchwords were profit, stability and toleration, a reflection of the pragmatism that remains a feature of the Dutch national character to this day.

Here were a people who, in a literal sense, had built their nation, reclaiming great swathes of land by waging a ceaseless, inter-generational battle against the sea. Their weapons in that conflict were dykes, levees and the thousands of windmills that drained Dutch fields: machines that became the unofficial symbol of the country. Dutch

pragmatism was hard-headed and hard-nosed, focused on the bottom line, when it was not forced to focus on war. This was a nation committed to the art of making money, seizing from the Italians the mantle of being Europe's great financial innovators. For money was not just spent in the Dutch Republic; it was recycled. The Dutch effectively invented the modern stock exchange, the engine that has helped propel capitalism ever since. Amsterdam's exchange, the Bourse, enabled the Dutch to buy and sell shares and bonds in the Republic's global trading companies, making Amsterdam the Wall Street of seventeenth-century Europe. Although the Dutch did succumb to bubbles and speculation – as the legendary tulip mania of the 1630s revealed – at heart they remained merchants, committed to the real-world business of buying and selling.

Dutch traders grew rich by providing their European neighbours with essential goods: grain, fish and finished cloth were the core commodities fuelling the Dutch economy. But greater riches and greater excitement came through long-distance trade. As we have seen, much of that wealth was earned by playing the role of middlemen and shippers in the trade between Asian nations. But the Dutch seaborne empire also introduced the citizens of the Dutch Republic to a large number of new and exotic foreign goods. The VOC and the republic's other trading companies enabled a tiny nation – only 1½ million citizens

packed into just 60 square miles of territory – to become briefly the great global trading nation.[1]

Historians have spent the past 300 years trying to work out how they did it. Again and again they point to the Dutch talent for co-operation and capacity for pragmatism. These virtues were not, perhaps, an innate feature of the Dutch national character, which was itself not fully formed even at the creation of the Dutch Republic. For the Dutch, whose nation was born from the fires of religious conflict, pragmatism was a trait willingly acquired and perfected. The Eighty Years War (1568–1648), fought by the provinces of the Netherlands – at first for religious toleration but eventually for independence from Catholic Spain – consumed most of the first half of the 'golden' seventeenth century, with only a short truce between 1609 and 1621. The Spanish were able to afford such expensive and devastating military campaigns against the Netherlands, in part because of the vast bullion wealth that flowed into their realm from the silver mines of Zacatecas in Mexico and Potosí in Peru (now Bolivia). The conquest and domination of the New World and the religious wars that ravaged the old were, in this way, intimately interconnected.

The seven northern provinces – Holland, Zeeland, Friesland, Utrecht, Gelderland, Groningen and Overijssel – emerged from the Spanish conflict and joined together to form the Dutch Republic.[2] While these provinces

had much in common, their path towards nationhood had been neither obvious nor irresistible, and forms of provinciality and urban patriotism lingered on throughout the seventeenth century. Yet with so much blood having been spilt and treasure spent, the new state was strong on toleration and desperate for stability. A third of the population had remained dedicated to the old Catholic faith, and the same tendency towards pragmatism that had led the Dutch merchants to throw in their lot with the VOC encouraged each province to tolerate the disparate faiths in its midst. The Dutch Republic thus became a land of 'hidden' Catholic churches as well as counting houses and merchants' chambers.

At the centre of this apparently fragile nation – an oddity whose structure and form of government bemused both contemporaries and later historians – lay the city of Amsterdam. It was upon that metropolis that the great network of trading bases and web of shipping routes converged, allowing the city to usurp Antwerp as northern Europe's most important trading port. The Amsterdam of the Golden Age was a city of warehouses, a place of import and export in which anything and everything could be bought. The philosopher René Descartes – a Frenchman who lived much of his adult life in the Dutch Republic and served in a Dutch army – described the Amsterdam of 1631 as 'an inventory of the possible'.[3] 'What place on earth,' he

wondered, 'could one choose, where all the commodities and all the curiosities one could wish for were as easy to find as in this city?'[4] Whereas the Tokugawa rulers of Japan attempted to finely calibrate their nation's exposure to the wider world, the Dutch embraced their new-found globalism wholeheartedly, revelling in the excitement and novelty of it all. The merchants of the Dutch Republic may have built their grand canal-side villas in the restrained and sombre styles of the Dutch Baroque, but they filled them

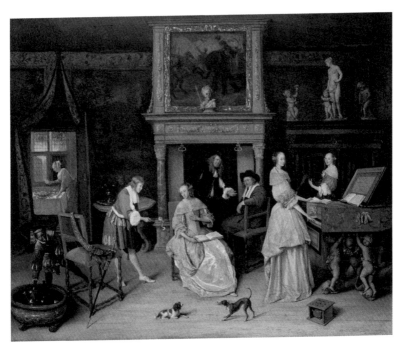

24. *Among the commodities traded by the Dutch were enslaved Africans, some of whom were brought to the Netherlands to work as exotic servants, as depicted here in this family parlour scene.*

with the lavish and exotic fruits of global trade – blue and white Chinese porcelain, Japanese lacquer ware shipped from Dejima, silk from Persia, spices from the East Indies, pepper from Africa and Turkish carpets from the Ottoman Empire. The silverware on the tables of these merchant dynasties was exquisitely crafted by local craftsmen, but the metal itself came from Peru or Mexico. And to serve their fine wines the Dutch trafficked enslaved African boys, who became one of the great 'fashions' of the age among the rich. Their forlorn faces stare back at us from the margins of numerous Dutch portraits of the period. For, like the British, the Dutch liked to celebrate their own unique freedoms while growing fat on the unfreedom of Africans.

The frenzy of trade, money-making and almost conspicuous consumption that characterised the Golden Age was reflected in Dutch art. The economic booms of what has been called the 'Dutch miracle' created the necessary conditions for a surge in artistic production and expenditure. It can be argued that the modern art market was invented, or at least given its first trial run, in the Netherlands of the seventeenth century. The accumulated wealth acted as the flame that drew artists from other regions of Europe, and in particular from the southern Flemish provinces that had remained under the control of the Spanish Habsburgs. It was the urban merchant class, rather than the rural aristocrats, who had the money, and

it was they who became the principal patrons. What they wanted was a new kind of art – free from the flamboyance of the Catholic faith. They sought paintings that offered a reflection of themselves: proud republican Calvinists who had worked hard for the wealth they now enjoyed. Dutch art of the seventeenth century reflects their character and that of the new nation they dominated.

From out of the shadows of Rembrandt van Rijn's famous *Militia Company of District II under the Command of Captain*

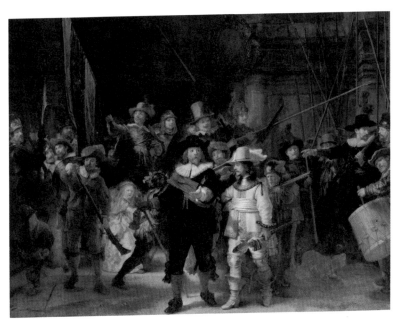

25. The art of the Dutch Golden Age was created for the proud and wealthy citizens of the Republic. Its patrons were also its subjects, as here, in Rembrandt's celebrated The Night Watch, *which depicts the men of an Amsterdam citizen's militia.*

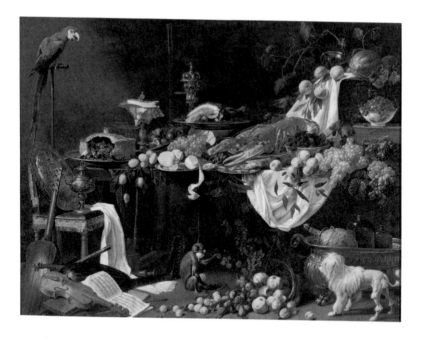

26. *The abundance of exotic foreign goods and luxury foods (available to the wealthy) is here celebrated in a flamboyant still-life painting by Adriaen van Utrecht.*

Frans Banninck Cocq (often known as *The Night Watch of 1642*) emerge the faces of the men who commissioned that gargantuan canvas; the citizen militia of Captain Banninck Cocq who stood ready to defend their city. In Bartholomeus van der Helst's *Banquet at the Crossbowmen's Guild* of 1648 we see the men of the guild celebrating the signing of the Treaty of Münster, which brought to an end eighty years of war with Spain and proffered the possibility of retirement from active service. In Rembrandt's near-

miraculous portraits of the Dordrecht merchant Jacob Tripp and his wife, Margaretha de Geer, from around 1661, we are presented with the thin, pallid faces of the oligarchs who helped make the Dutch so wealthy.

Less familiar, but just as eloquent, are the many still-life paintings from the period, a favourite among Dutch patrons and a speciality of Dutch and Flemish artists. At one end of the spectrum were the reserved *banketjestukken* (breakfast pieces), depictions of simple Dutch food, artfully composed into paintings of austere beauty.[5] At the opposite end were the *pronkstilleven,* often translated as ostentatious still-lifes. These paintings of sumptuous consumption, produced by artistic pioneers such as Jan Davidszoon de Heem, Adriaen van Utrecht, Willem Kalf and Frans Snyders, present the viewer with the many wonders and luxuries that had entered the lives of the Dutch merchant classes, thanks to their nation's seaborne empire. Arrayed on linen-covered tables are rich cuts of meat and bounteous mountains of fruits, casually arranged in bowls of blue and white porcelain. Among the luxurious foods were scattered ornate silver platters and examples of Venetian glassware. The true stars of the *pronkstilleven,* though, were the nautilus cups, made from the pearly inner shells of the chambered nautilus, which had been plucked from the beaches of the Pacific and Indian oceans and transformed by local goldsmiths into flamboyant drinking vessels.[6]

A still-life of 1644 by Adriaen van Utrecht, who worked not in the Protestant Dutch Republic but in Catholic Antwerp, to the south, shows a series of small tables each of which literally overflows with luxurious fruits, meats and pastries. Nearby are scattered a selection of musical instruments and books, symbols of the leisure that prosperity enabled. A South American parrot eyes up the fruits, and a pet monkey picks a berry. The whole scene is rendered hyper-real by the application of multiple layers of glaze.

In the seventeenth century *pronkstilleven* sat uncomfortably with the sombre Calvinism of the urban merchant class and spoke of a tension that ran through the Golden Age. One-time English consul in Amsterdam William Carr, the author of a guidebook to the Dutch Republic, was of the opinion that the Dutch character had been radically altered by the nation's new-found prosperity:

> The old severe and frugal way of living is now almost quite out of date in Holland … there is very little to be seen of that sober modesty in apparel, diet and habitations as formally. Instead of convenient dwellings the Hollanders now build stately palaces, have their delightful gardens, and houses of pleasure, keep coaches, wagons and sleighs, have very rich furniture for their houses, with trappings adorned with silver bells.[7]

The moral hazard of increasing wealth and rampant consumption could – at least in the case of the *pronkstilleven* – be managed through a subtle form of double-think. The wealth displayed on the canvases of van Utrecht, de Heem, Kalf and Snyder could be interpreted as the rewards of hard work and thrift, rather than the trappings of sinful ostentation. The *pronkstilleven* also carried within them elements of the symbolic and allegorical language of the *Vanitas* painting, a genre that reminded patrons of the fragility of personal fortune and the transience of life. The fruits in the expensive Chinese bowls were in the process of decay, and the arrangements of flowers – always a favourite motif – would eventually wither, just as human beauty fades and human life comes to an end. This rationale enabled the Dutch elite to celebrate their wealth and enjoy the excitements and novelties of global consumption while showing obeisance to the strictures of their faith, allowing them to have their Calvinist cake and eat it.

The new products that flooded into Amsterdam changed Dutch tastes and fashions, and not just for the wealthy. Yet another instantly recognisable symbol of Dutch culture is the blue and white glazed Delftware pottery that can even now be found on the walls of thousands of Dutch homes. Some of the original seventeenth-century Delftware manufacturers are still in business producing plates and crockery. Cheap imitations of their work are on sale in every

tourist trap in the modern Netherlands.

Although the origins of this tradition stretch back beyond the seventeenth century, Delftware was inspired by Chinese Kraak porcelain, made especially for export and shipped to the Dutch Republic in vast quantities by the merchant fleet of the VOC, often carried as ballast. Some of the earliest Chinese porcelain to reach the Dutch market arrived in the holds of two Portuguese ships, the *São Tiago* and the *Santa Catarina*, that were captured in 1602 and 1603 respectively, the latter in Nagasaki harbour.[8] Indeed, the term Kraak is believed to be a Dutch corruption of the word 'caracas' –

27. *Delft tiles depicting the trading ships that helped make the Netherlands so wealthy. Delft pottery was a domestic imitation of the blue and white Kraak pottery that was one of the most popular global imports.*

after the Portuguese ships captured. Delftware, produced by the potters of the city of Delft, was a cheap, earthenware imitation of the Chinese Kraak porcelain, which remained an expensive luxury only within the reach of the very wealthy, and a feature in many *pronkstilleven*. Affordable and fashionable Delftware was an invention of an age that was increasingly about the interaction between cultures, not merely borrowings between them. The patterns that came to adorn Delftware plates and bowls reflect this growing synthesis. Evolving over time, they incorporated both Chinese and Japanese motifs as well as scenes of Dutch life; trading ships of the VOC in full sail, arrangements of tulips and the omnipresent windmill.

The food that was consumed from Delftware plates and bowls in the seventeenth century was also changed by long-distance trade. New tropical ingredients – pepper, cloves and nutmeg, all available in increasing quantities – became important flavours in a changing national cuisine, at least temporarily.

Behind the confident facades of the Baroque buildings and the broad, well-fed faces of the men in Rembrandt's group portraits was another reality of the period. While it is true that the Dutch were the great innovators and risk-takers of the seventeenth century, what is often forgotten is that they had little choice in the matter. Theirs was a nation in which everything appeared to hang by a thread. Its conflicts

with Spain, Portugal and Britain (there were three Anglo-Dutch wars in the seventeenth century) were relentless, and the Dutch trading empire that was the source of so much wealth was forged against the backdrop of ceaseless war. This meant that the nation could lose trading bases and trading partners just as easily as it could create them. The Dutch grip on its empire and her fortune at times appeared tenuous; factories were besieged and bombarded, invaded and traded away at the negotiating table. In 1664 the Dutch famously lost their settlement of New Amsterdam on the southern tip of Manhattan island to the British, who renamed it New York after James, Duke of York, the future King James II. The coat of arms that had been designed and proposed for New Amsterdam included two beavers, as the economic viability of this North American colony rested so heavily on the fur trade.

The number of Dutch paintings from the Golden Age that depict shipwrecks and losses at sea hint at another aspect of national fragility. Personal fortunes and the prosperity of companies could be wrecked in an instant. Long-distance trade was always high-risk trade. Tropical storms, interceptions at sea by the ships of rival powers or pirates could ruin families as easily as trade could make them. Even the principle of risk-sharing, which was one of the central functions of the joint stock company, could not save the over-exposed from bankruptcy. And even Rembrandt, the

artistic star of his day, lost his home and much else when his creditors called time on his debts in 1656, during the depression that cast a shadow over the 1650s.

In multiple ways, the seaborne empire changed the material aspects of life in the Netherlands; what is difficult to ascertain, however, is the extent to which ordinary Dutch citizens felt connected to and invested in the imperial project. The strongest links were familial. It has been estimated that over the course of the Dutch Republic's existence around a million men and women set sail for Asia and Africa on the ships of Dutch trading companies. Disease ensured that the majority never returned, and their graves can be found in abandoned cemeteries everywhere from Kolkata to Guyana. This extraordinary level of global mobility reflected the marked increase in the scale of trade and the level of contact between Europeans and the people of Asia, Africa and the Americas in the seventeenth century. The mode the Portuguese had pioneered in the latter decades of the fifteenth century had been enormously expanded by the Dutch, yet, for all this, many Dutchmen never left their native soil. One of those who stayed, even when family members departed to find their fortunes in the empire, was Johannes Vermeer.

Vermeer was born and died in the little city of Delft, where the producers of Delftware had established their factories. As far as we know, he never left the Netherlands. Most of

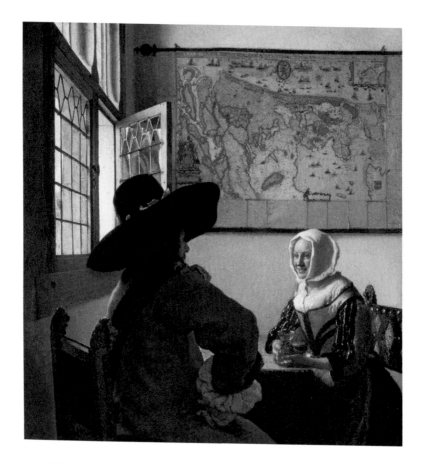

28. Although apparently insular and domestic, many of Vermeer's paintings hint at the new globalism of the Dutch Golden Age: the map on the wall, the hat made from North American Beaver fur, reveal the impact of trade on Dutch life in the seventeenth century.

the surviving documents that tell us anything about the life of Vermeer are records of his life in that one small town. Johannes Vermeer is an enigma; a man about whom art

historians know just enough for the gaps in their knowledge to be acutely frustrating. His output as a painter was modest – there are only about thirty-five surviving paintings – and most are famously intimate; simple scenes set within the neat, ordered, almost claustrophobic world of the Dutch interior. He is not known for wide horizons or panoramic vistas; indeed, his celebrated *View of Delft* (1660–61) is one of only two known landscapes. What Vermeer mastered, perhaps more than any other artist, was capturing on canvas the fleeting moments of everyday life and the seemingly inconsequential: a girl laughing as an officer leans towards her *(Officer and Laughing Girl* (1660s))*; a music teacher and his student standing together at a virginal, at the far end of a formal room *(Lady at the Virginals with a Gentleman* (*c.* 1662–4))*; a young woman alone with her thoughts as she reads a letter *(Young Woman Reading a Letter at an Open Window* (1657–9))*.

29. *In* Young Woman Reading a Letter at an Open Window *Vermeer leaves the interpretation open. But an era marked by long-distance trade was inevitably one of long absences and separations. Is the writer of the letter her lover in a faraway land?*

Each depicts an enclosed room that is bathed in delicate light from a side window. We are reminded that the rest of the world is just out of sight. However, within the details of these famously internal scenes, among the objects on the tables and the maps on the walls, are the signs that Vermeer's domestic world was infused with the globalism of the Dutch Golden Age and the interactions that typified the seventeenth century.

In *Officer and Laughing Girl* the officer wears a broad felt hat, made from the fur of beavers trapped in the Great Lakes region of North America, where, at the time, European traders – with the French in the lead – were engaged in an often violent struggle against the elements, and with one another, for access to beaver pelts.[9] The indigenous native American nations were happy to trap beavers and trade their pelts in return for European goods, especially firearms, but those weapons were often used against them. When the French missed out on an opportunity to extend their activities into the area around Lake Superior, the English stepped in and established the Hudson Bay Company, with a string of trade forts. It was the struggles over the fur trade that led to the Dutch loss of New Amsterdam at the end of the second Anglo-Dutch War in 1664. Conflicts between Englishmen, Dutchmen, Frenchmen and federations of Native Americans all lay behind the fashionable hat worn by Vermeer's officer.

Young Woman Reading a Letter at an Open Window is set in the same room. Its subject is the same woman, very possibly Vermeer's wife, Catharina Bolnes.[10] Again this apparently inward-looking, domestic scene carries the imprint of seventeenth-century global trade. On the table a Turkish rug is draped, an object far too valuable to be placed on the floor. Resting on the rug is a Chinese Kraak porcelain dish, in which an arrangement of fruit is jumbled, echoing the many *pronkstilleven* that were produced in the same years. The young woman's expression leads us to imagine that the letter is from a lover far away, perhaps in a Dutch trading factory in Asia or the Americas. Vermeer is exploring the emotional phenomenon of relationships fractured by great distance.

Like most artists of his age, Vermeer remained in Europe, where his skills were valued, although in the end not enough to stave off penury. One of his late-life contemporaries, a very different type of artist, did travel abroad, and did so on the ships of the Dutch East India and West India Companies, though she was not Dutch by birth. The astounding rise of the Dutch Republic was partly made possible by the freedoms it offered its citizens, a breed of men and women who refused to bow to monarchs and were disdainful of those who did. There was freedom of religion and the freedom to trade and to travel. In 1610 the Dutch became the first people in Europe to end prosecutions

for witchcraft. Accordingly the Dutch Republic thus attracted the freedom-loving and the persecuted from other states – branches of English Protestantism, Sephardi Jews from Spain and Portugal and their Ashkenazim co-religionists from Eastern Europe (although a great number of restrictions remained in force to limit the freedoms of Dutch Jews). The long lists of immigrants from disparate backgrounds, faiths and nations goes some way to explaining why the seventeenth century was a golden age for Dutch science and philosophy, as well as the arts.[11] For women, doors that remained resolutely shut in other parts of Europe were opened, just a little, in the Dutch Republic. The belief that a woman's sphere was the home prevailed, but Dutch women enjoyed rights their sisters elsewhere were denied. The right to inherit property was key and, as Vermeer's paintings wonderfully demonstrate, the courtship that led to marriage had become a form of flirtatious negotiation between prospective partners, rather than a financial transaction between prospective fathers-in-law.

One of those drawn to such new freedoms was the German-born artist and naturalist Maria Sibylla Merian, who settled in Amsterdam in 1691 with her two daughters. Merian had previously been living in a religious commune in the north of the country, part of a pious, utopian sect known as the Labadists. The commune had supported

30. *Maria Sibylla Merian's watercolour of the lifecycle and metamorphosis of the Carolina Sphinx Moth. The insect is depicted alongside the plant upon which it relies, the Peacock Flower.*

Merian as she sought to bring an unhappy marriage to an end. They also supported her work, studying the life-cycles of caterpillars and butterflies – an unusual pastime for a woman of the time. She had inherited her passion for insect life from her father, Matthäeus Merian, and acquired a love of painting from her stepfather, Jacob Marrel. While still a child growing up in Frankfurt, she learned to draw and paint in watercolours, specifically choosing that medium as women were prevented from selling paintings executed in oils in many German cities.

Her ambition was to produce paintings and books that were simultaneously works of both science and art, and her great innovation was to paint caterpillars and butterflies alongside the plants on which their life-cycles depended, showing the symbiotic relationships in nature. Through empirical study she was one of the first to confirm that insects emerge from pupae rather than through some form of spontaneous generation, as had been previously presumed.

In Amsterdam, Maria Sibylla Merian had the freedom to run her own business, publish her books and expand her studies. She executed paintings for collectors and researchers and was granted access to Amsterdam's scholarly elite. In those circles she was able to view the preserved animals and insects held within the cabinets of curiosities that were a feature of the homes of the wealthy and educated

across Europe. Many of these creatures had been trapped in the Dutch colonies and shipped home by men working on the ships of the VOC and the Dutch West India Company. After eight years in Amsterdam, and tantalised by the prospect of studying these creatures in their natural habitat, Merian and her youngest daughter, Dorothea Maria, set sail for South America. The two women headed for the Dutch colony of Suriname on the tropical Caribbean coast, settling at a plantation on a tributary of the River Commewijne, where they began their work.

Suriname was dominated by Dutch-owned sugar plantations, and enslaved Africans from the plantations assisted the Merians in their work. To some extent they were complicit in the great sin of the Dutch Republic, but Merian learned the local creole, Negerengels (Black English), learning of their customs and traditions in the process. In the annotation to her beautiful watercolour of the peacock flower of Suriname (*Poinciana pulcherrima*) Merian explained that the enslaved African women of the colony used the plant to induce abortions, refusing to give birth to children destined to lives of slavery, in an act of defiance and resistance.[12] Knowledge of the plants' properties may well have been passed on to the enslaved women by women from the indigenous Amerindian peoples. Later the naturalist Hans Sloane, while working as a physician in Jamaica, learned that the enslaved women of

that British slave colony used the same plant for identical reasons.

On her return to the Netherlands, Merian began to collate her research into a book, *Metamorphosis Insectorum Surinamensium* (*The Metamorphosis of the Insects of Suriname*), which was published in 1705 to rapturous acclaim across Europe. Her reputation blossomed. In the nineteenth century, however, her work was disparaged, and her research discredited, due in part to the fact that it had been based to some extent on information gleaned from interviews with Amerindians and enslaved Africans, people deemed by nineteenth-century snobberies to be unreliable and uncivilised. It is only latterly that her place in the histories of art and science has been rediscovered and her reputation rehabilitated. In Germany, the land of her birth, Merian has appeared on postage stamps and formerly on the reverse of the 500 Deutschmark note. Her scientific work has recently been translated into multiple languages and made the subject of symposia. Her paintings have been republished in book form as well as being gathered together for exhibitions. Perhaps most significantly of all, Merian's enormously influential role in entomology and the development of scientific illustration has been posthumously recognised and celebrated.

ACTS OF EMPIRE

In July 1783 the German-born artist Johan Zoffany arrived at the Indian port of Madras (now Chennai), on board a ship of the British East India Company. Until the last years of the 1770s Zoffany had enjoyed a glittering career, painting the great and the good of Georgian London and travelling to Italy to undertake choice commissions. Then, in 1777, he fell out of favour with Queen Charlotte, wife of George III. The queen had taken umbrage at Zoffany's flamboyant *The Tribuna of the Uffizi*, painted to her commission between 1772 and 1777. The offending work depicts a group British connoisseurs revelling in the art of Renaissance Italy and classical antiquity at the Uffizi gallery in Florence, while on the Grand Tour. As the art historian Jonathan Jones has noted, the painting rather gives away the fact that the eighteenth-century Grand Tour was as much about social indulgence as about artistic appreciation: the Georgian equivalent of the gap year for the sons of the wealthy. *The Tribuna of the Uffizi*, one of the most complicated paintings Zoffany ever attempted, is a masterful example of the

conversation piece, one of the genres in which he excelled. But it met with royal disapproval because among the British connoisseurs shown ogling the masterpieces of the Uffizi were a number of men who had paid Zoffany to have their likeness included. The artist and diarist Joseph Farington recorded in 1804 that the queen was so offended by this lapse in protocol that she 'would not suffer the picture to be placed in any of her apartments'.[1] Despite having produced earlier, successful royal commissions, Zoffany never received another.

Out of favour and out of work, Zoffany eventually decided to travel to India, having been informed that Warren Hastings, the first governor-general of Bengal, was a commissioner and collector of fine art. In the India of the British East India Company, Zoffany imagined that his fortunes could be revived and his reputation rebuilt. As one contemporary said, Zoffany's ambition was 'to roll in gold dust'.[2] He may well have been attracted to India having heard reports of other artists, such as the painters William Hodges and Tilly Kettle, who, with the help of well-placed patrons, had enjoyed successful sojourns in the subcontinent. No matter that he might have wished to pretend otherwise, the fact that his new clients were the administrators and soldiers of the East India Company, rather than the aristocrats of London and the crowned heads of Europe, represented a lowering of status. The prospect of painting

new subjects and taking part in the adventure of travelling to the frontiers of British global power could also have been a deciding factor. But he had travelled his whole life and had previously considered sailing on Captain Cook's second voyage to the South Seas in 1771, although that opportunity had evaporated due to Zoffany's then precarious finances. He was to spend the next six years in India.

After arriving in Madras, Zoffany gravitated to Calcutta (now Kolkata), the centre of the East Indian Company's operations in Bengal. The city had been founded in 1686 as the company's base in the region. There, on a bend in the Hooghly river, the company built a small factory in 1696. The site had not been well chosen as it was prone to periodic flooding, and the small streams that flowed down to the Hooghly spawned mosquitoes, although the British worried far more about the miasmas (noxious gases) that they erroneously believed were the cause of malaria.

The Honourable East India Company was an enterprise born of the same impulse as the VOC. Established on 31 December 1600 by the, by now elderly Queen Elizabeth I, its full title was The Company of Merchants of London Trading to the East Indies. Its task was to emulate the successes of the Portuguese and steal a slice of the trade in Asian pepper and spices. Like the VOC, it was granted a monopoly in return for developing trade between Asia and England. The English faced competition from the Dutch,

Portuguese, Danish, Swedish and French, all of whom were attracted to India by the availability of spices, silks, cotton, opium and other commodities, but also by the growing weakness of the Mughal empire.

By 1647 the East India Company had established twenty-three trade factories, and had largely displaced the Portuguese. By the end of the century it was dominant in Bengal, and the trade in Indian cotton and silk began to transform the wealth of the company and the fashions and domestic lifestyles of the British public. Following the British victory at Plassey over the Nawab of Bengal and his French allies in 1757, the company's domination of Bengal was complete. The wealth of one of India's most dynamic regions poured into Britain, much of it siphoned through Calcutta and carried home by the returning 'Nabobs' (a British corruption of the Indian word Nawab), successful merchants who had made vast fortunes both for the company and themselves in India.

The Calcutta that Zoffany experienced in 1783 was relatively large by eighteenth-century standards, with a population of well over 100,000. It had grown rapidly and chaotically. The British merchants, soldiers, accountants and apprentices who had done well for themselves built villas on the outskirts, surrounded by lush gardens. Meanwhile another city, Calcutta's necropolis, expanded at a similarly frenetic pace. For hundreds, a plot in South Park

31. A so-called Company painting from around 1850 by the Indian artist Shiva Dayal Lal shows women selling food in the market.

Street Cemetery was the only Calcutta property they ever secured. Most of the eager young men who left Georgian Britain for India never returned; the majority were dead within two years of arrival.[3] Like the sailors and traders of the VOC, they fell victim to tropical disease or were lost at sea during the treacherous five-month passage around the Cape of Good Hope. The presence of death, coupled with the enormous opportunity for self-enrichment, created a frenetic boomtown atmosphere. Here the British elite, and Europeans drawn from across that distant continent, lived in a whirl of socialising, gossip and heavy drinking, incongruously set amid Georgian town houses that would

not have looked out of place lining the thoroughfares of London or Edinburgh.

In Calcutta Zoffany was able to purchase all the artistic materials that he had been unable to bring with him. But, more importantly, there he was able to find the patrons wealthy enough to afford his exclusive services, including Warren Hastings himself. The culture of the British contingent in the India that Zoffany got to know was in part a creation of Hastings.

In Calcutta both seasoned company men and teenage writers newly arrived from Britain revelled in their growing wealth and the exoticism of the cultures they found. There was also a real willingness to explore those cultures and adopt local customs. Company men smoked hookah pipes, chewed betel nuts and wore Indian clothes. Cohabitation between European men and Indian women was common, although only a small proportion of these relationships became formal marriages. Perhaps as many as half of all male British residents – including Zoffany – took Indian mistresses, then termed *bibis*, with whom some fathered children. Between 1780 and 1785 a third of the wills of company men, filed in Calcutta, made mention of Indian *bibis*. In the same period half of the children baptised in St John's Church, Calcutta, were illegitimate.[4] (Upon his return to Britain, Zoffany arranged for a friend to manage the care of his abandoned Indian family.)

In other ways, too, Zoffany became an 'Orientalist', in the original sense of the word. In the age of gentleman amateurs, the Orientalists were men engaged in the study of India's cultures and languages, men of the European Enlightenment committed to inquiry and drawn to the intricate beauty of Urdu poetry, the study of ancient Hindu legal codes or the elegant subtleties of Sanskrit. It was men such as these who formed the Asiatic Society of Bengal, founded the year after Zoffany's arrival in Calcutta and dedicated to the better understanding of Indian history, languages, faiths and cultures. Its membership included the pioneering linguist Sir William Jones, as well as both Zoffany and Warren Hastings, who was made honorary president. The governor-general was himself a student of Indian languages and literature as well as an enthusiastic collector of Indian art and artefacts. More than mere hobbyists, the members of the Asiatic Society translated books, manuscripts and legal documents and sought to acquire knowledge that enabled them to know, and ultimately rule, India and her people better. What marked them out from later generations was their willingness to concede that certain aspects of Indian culture were equal, and even superior, to those of Europe. Sir William Jones felt able in 1786 to describe Sanskrit as 'more perfect than the Greek, more copious than the Latin, and more exquisitely refined than either'.[5] As we'll see, later generations of British

administrators adamantly refused to regard even the most sophisticated manifestations of Indian culture as being comparable to the fruits of European civilisation.

Zoffany also travelled repeatedly to the city of Lucknow, where he established a temporary studio and painted portraits of leading company figures and members of the local elite. Lucknow was one of the cultural centres of another India. This extraordinarily cosmopolitan Mughal city was semi-autonomous but caught between the declining power of the Mughal emperor in Delhi and the rising strength of the East India Company in Bengal. Its ruling dynasty were of Persian descent, its population a mixture of Hindus and Sunni Muslims, British soldiers and officials and men like Zoffany himself, from other parts of Europe. In Lucknow Zoffany lived in the house of Claude Martin, a Frenchman in the employ of the local ruler who had settled into a comfortable and classically Orientalist lifestyle, collecting Indian manuscripts and living with his Indian wives. Martin purchased paintings from Zoffany, as did another wealthy Lucknow resident, Antoine Polier, a Swiss engineer who, like Martin, delighted in the cultures around him and cohabited with his Indian *bibis* and their children.

It was in Lucknow that Zoffany found the subject for the most famous of his Indian paintings, and one that reflected the unique world of late Mughal Lucknow. *Colonel*

Mordaunt's Cock Match, now at Tate Britain in London, was commissioned by Warren Hastings and is a depiction of an actual event: a cock fight laid on in April 1784 by Colonel John Mordaunt, a representative of the East India Company. The man for whom this conversation piece was painted does not appear, but Hastings is known to have been at the fight itself. At the centre of the painting, and the centre of the action, stand two men: John Mordaunt, the illegitimate and reputedly illiterate son of the Earl of Peterborough, and Asaf-ud-Daulah, the Nawab of Oudh. Mordaunt was colonel in Asaf-ud-Daulah's personal bodyguard, a courtesy the British provided the Nawab in return for his general co-operation, which had been easily acquired. There is some reason to suspect Colonel Mordaunt may also have acted as a spy for the Company. His official responsibilities, in addition to protecting the Nawab, included laying on lavish and often raucous entertainments for the court, such as cock fights, employing specially imported British cockerels against local fighting birds. In the painting the Nawab and Mordaunt stand behind the cocks, their arms outstretched towards one another.

Asaf-ud-Daulah had moved his court to Lucknow after the death of his highly respected father, Shuja-ud-Daula, in 1775. He had also handed over much of his political power to the devout and serious-minded bureaucrat Hasan Reza Khan and his deputy Haldar Beg Khan, both of whom were

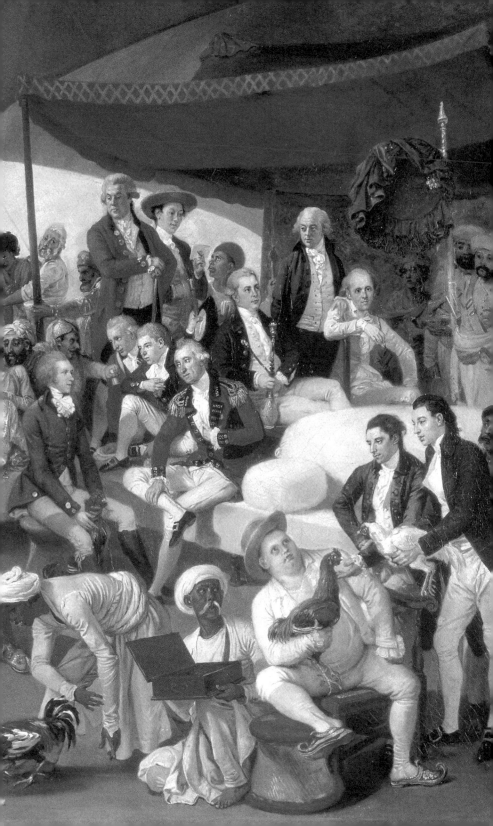

painted by Zoffany.[6] Soon after, the Nawab signed a treaty
with the East India Company by which he ceded territory
and awarded the company the right to collect revenue
and maintain a military presence. The fact that the British
cock, to the right in the painting, appears to be dominating
the Indian bird to the left, hints at the direction in which
Zoffany thought the relationship between the Company
and the Nawab was heading. Stripped of real political power,
for which he appears to have cared little and which he seems
to have surrendered readily, the Nawab had descended into
a life of decadence slipping rapidly into one of debauchery.
Warren Hastings, who had been quick to exploit the coming
to the throne of a weak and uninterested Nawab, described
the Lucknow of Asaf-ud-Daulah as 'a sink of iniquity' and
'the school of rapacity'.[7]

Although his personal life was one of infamous excess,
Asaf-ud-Daulah was a passionate and serious patron of
architecture and a genuine connoisseur of poetry and
painting. Fabulously wealthy, despite the abandonment
of political power and the forfeiture of half his income to
the British, he commissioned numerous buildings and
shrines in Lucknow and the painting of miniatures in the

32. *Johann Zoffany's celebrated painting of a cockfight held at the court of
the Nawab of Oudh in 1784. A witty and subversive commentary on Anglo-
Indian relationships during the age of the East India Company.*

33. A painting thought to be by the late Mughal artist Ghulam Ali Khan commissioned in the 1820s by the Anglo-Indian cavalry officer and collector James Skinner.

late Mughal style flowered under his rule. Mughal artists who were struggling to find commissions in Delhi, the imperial capital, were drawn to Lucknow by tales of the Nawab's wealth and generosity. The Nawab's patronage of new architectural projects added glamour to Lucknow, which accentuated the allure of the city. There, as in other Mughal cities, a cultural and artistic renaissance overlapped, disconcertingly, with an age of political decline, as the increasing power and presence of the East India Company undermined indigenous authority and independence.[8]

As the lavish detail in *Colonel Mordaunt's Cock Match* suggests, Zoffany revelled in the atmosphere of Lucknow and did not miss the opportunity to bring all of the subversive minutiae of court life together in the painting. There are unsubtle references to the Nawab's reputed homosexuality, and his rumoured impotence, and

indications of the gambling and revelry that characterised his court. What is perhaps most striking is the general sense of informality. Everywhere there is easy mixing between Indians and the British.

Cock fights were not rare events in Lucknow: they were part of a constant pageant of grand feasts, blood sports, hunts and other revelries that punctuated the unreal life of the Nawab and his entourage. As well as seeking to capture the dynamism of the event, Zoffany included a number of identifiable individuals – the same sin that had excommunicated him from royal favour back in London. All the key figures, both Indian and European, were known to the artist, the commissioner Warren Hastings and the two central protagonists, Colonel Mordaunt and the Nawab. Among the Europeans were Zoffany's friend Claude Martin, the English artist Ozias Humphry and a number of well-known Company officials; among the notable Indians was the Nawab's chief minister, Hasan Reza Khan. Zoffany humorously includes himself in the painting, sitting with his paint brush under a green canopy. The women who appear are not just ladies of the court, or the wives of the allegedly homosexual and impotent Nawab, but also *bibis*. European women are conspicuously absent, although there were a number of British women within the European contingent resident in Lucknow at the time.

Colonel Mordaunt's Cock Match can be, and has been,

interpreted as an Orientalist (in the modern, post-colonial sense) composition, in which Indian vices and moral failings are contrasted with European vigour and pragmatism, thereby justifying British rule over an Asiatic people. Yet what it also demonstrates is that in late eighteenth-century Lucknow elite Indians and Europeans did interact and socialise with one another. Despite some disturbing undertones, what is absent from the canvas are manifestations of the distrustful, highly racialised relationship between Britons and Indians that would emerge in the nineteenth century. As the historian Maya Jasanoff and others have noted, the painting also appears to show the impact that Indian art had on Zoffany. Through its somewhat flattened perspective and its wealth of detail, the influence of the Mughal miniature painting tradition has been detected.

A later painting reveals not the influence of Indian art but the artist's lingering sense of mischief. The painting in question is an altarpiece of the Last Supper for St John's Church, the city cathedral modelled on London's St Martin-in-the-Fields. Zoffany completed the painting in 1787. St John's had been paid for by subscription raised from the British population of Calcutta, and it was not just a place of worship but also a statement of the British presence in the city. Zoffany's painting was to be the centrepiece. As church attendance was virtually compulsory for East

India Company servants, Zoffany knew that all the eyes of Calcutta would be on his work. And what he delivered was – on the face of it – everything that had been asked of him: a skilful rendering of one of the great subjects of European art. The painting followed a conventional composition, with the Apostles all arrayed along one side of a table, allowing the viewer to take a place opposite Jesus. Zoffany also included all the conventional accoutrements: the chalice, the bread and the wine. Judas is fittingly wracked with guilt, clutching a bag of silver, his payment for the betrayal of Christ.

When it was installed, the clergy were extremely pleased with Zoffany's work. But soon there were murmurings

34. *Johann Zoffany's* Last Supper *still hangs in the space for which it was painted, St John's Church in Calcutta. The unveiling of the painting in 1787 caused a minor scandal within the city's European population.*

and whispers in the congregation. Without their consent, Zoffany had used various notable members of Calcutta society as models for Jesus and his disciples. And not all who could recognise their faces on this canvas were happy. There are conflicting reports, but the rumour was that Judas had been given the face of one Mr Paull – a company official with whom Zoffany had been having a bitter dispute. St John had the face of Mr Blaquire, a Calcutta magistrate noted for his hostility to the Christian faith, and for his cross-dressing, which is why Zoffany has painted him in an extravagantly effeminate manner. Another unhappy figure was Mr Tuloch, a Calcutta engineer who was said to have been so angered that there was talk of his taking legal action against Zoffany.[9] The same sense of mischief that had forced the artist to flee Europe had re-emerged in what was supposed to have been a serious and solemn commission for the respectable members of Calcutta society. This famous celebrated London artist had come into their midst and delivered to them not a brilliant rendition of a classic subject but a slap in the face.

* * *

In 1784 Parliament passed the India Act (also known as Pitt's India Act), which sought to enforce greater governmental control overseas and largely curtailed the East

India Company's expansionist tendencies. Consolidation of British interests in India and the promotion of trade were the new priorities. However, when Richard Wellesley, the older brother of the future Duke of Wellington, arrived in India as governor-general in 1798, to the frustration of the men of Leadenhall Street, the London headquarters of the company, it transpired that he was not very interested in consolidation. He sought territory, not markets, and hungered for glory and power more than profit.

The invasion of Egypt by Napoleon and the armies of revolutionary France in the summer of 1798 had shaken the nerve of politicians in London, who were temporarily receptive to Wellesley's argument that what was needed in India was not consolidation or accommodation with the Nawabs and princes but empire. Although Wellesley probably knew that the notion of a French invasion of India was far-fetched, it was a useful nightmare with which to alarm his critics and subdue his detractors. From the start, Wellesley was unambiguously and unashamedly an empire-builder. He was determined to end French intrigue and influence on the subcontinent, and willing to crush any Indian princes who received French aid or stood in the way of Britain's ambitions. One such was Tipu Sultan, the defiant ruler of Mysore. Tipu, also known as the Tiger of Mysore, actively fought against British imperialism, making himself Wellesley's prime target. Provoked into war, the

Tiger of Mysore was killed in battle in 1799 at Seringapatam.

But the new governor-general also had an obsession for order and a determination to sweep away the excesses of the India that Zoffany had known. The culture of hard drinking, gambling and cohabitation with Indian women was to be stamped out and replaced with a new ethos of Wellesley's making: one focused on military service and devotion to duty. Wellesley disapproved of close relationships between the colonised and coloniser, whether sexual or platonic.

Like the palace of the Nawab of Oudh in *Colonel Mordaunt's Cock Match*, factories were the epicentres of European activity in India, places of business and pleasure in which buyer and seller met. Under Wellesley's new strictures, such activity was to be short-lived. The factories were a far remove from the clubs that were to become a feature of British life in India in the decades ahead. New lines were to be drawn between the British and the Indians. East was to become East, and West was to become West. Racial mixing was to give way to racial hierarchy. Relations between company men and Indian women were suppressed, or at least driven underground or to the brothels. Perhaps as many as 50 per cent of European men had maintained relations with Indian women in the 1780s, but by the first years of the nineteenth century the practice was in decline. The wills of company men from 1805 to 1810 reveal that only a quarter made provisions for Indian mistresses,

down from a third twenty years earlier. Similarly, baptism records suggested that fewer than one in ten of the children christened in the British churches had Indian mothers.[10] In the coming decades the word 'nigger' began to appear in the diaries of British men in India, a sign that the pathological racism born of the Atlantic slavery and the efforts to defend it from Abolitionism were being transposed on to British interactions with the people of the subcontinent.

Austere, Anglo-centric, hyper-masculine and somewhat joyless, the new culture was to be reflected in architecture as well as in everyday life and the structure of imperial society. The governor-general didn't just want the British to build an empire in India: he wanted that empire to look the part, and he set about the physical architectural transformation of the city of Calcutta, a project that began literally at home, with the rebuilding of his official residence. The result

35. Government House in Calcutta, the vast neo-classical palace built by Richard Wellesley, Governor-General of Bengal, in 1803, was the seat of British hegemony in India at the height of the East India Company's power.

was Government House, today called Raj Bhavan. It was intended to be a symbolic realisation of Britain's power in India and was designed by an engineer rather than an architect: Charles Wyatt, the nephew of the architects James Wyatt and Samuel Wyatt, both masters of the neo-classical style. Inevitably Government House, the seat of power for a governor-general who had at one time been a classical scholar, harked back to the styles of Rome.

The inspiration for the new residence was Kedleston Hall in Derbyshire, the ancestral seat of the Curzon family and the work of Samuel Wyatt and the great Robert Adam. Numerous elements of Kedleston were incorporated into the new building by the Hooghly river, including its basic layout with sweeping corridors and its four separate wings. But to build a stately home like Kedleston Hall in the British countryside merely asserted that the family who resided there were respectable, well educated and had good taste. To build an enormous neo-classical palace on Indian soil said something completely different. Although made of the same Jodhpur marble as the Taj Mahal and adorned with some minor orientalist flourishes and details, Government House, with its portico and Greek columns, both Ionic and Corinthian, was intended to signify that European reason had triumphed over what the British increasingly regarded as Oriental corruption and despotism. But, more than that, the building was intended to convey a sense of authority

and permanence. If empire is as much about theatre as about force, then in India the British had built the perfect stage set. Visitors for the next century were stunned by the scale and splendour of the building, as had been Wellesley's intention.

Less impressed were the court directors of the East India Company, who had to foot the bill. When the costs of the land, building, access roads and furnishings were added up, the project had cost around £179,000. When Wellesley was attacked for his expenditure, he replied: 'I wish India to be ruled from a palace, not from a counting-house; with the ideas of a Prince, not with those of a retail-dealer in muslins and indigo.' Having increased the company debt by two-thirds during his term in office, and seemingly constitutionally incapable of controlling his urge to build or his lust for war, Wellesley was recalled in 1805.

His replacement was also his predecessor, Lord Cornwallis, who now returned to Calcutta for a second term. Less flamboyant but with just as closed a mind, Cornwallis set about finishing what Wellesley had begun, erasing the last vestiges of the cosmopolitan India that Zoffany had encountered. It was the beginning of the end for the Orientalists. India was to be ruled and subdued and her culture understood only as much as was needed to assist the task of imperial control. The British in India were to remain British in manners and customs, and the

Orientalist curiosity of Warren Hastings and Sir William Jones denounced and disavowed. In the decades that followed, the organisations created to facilitate such study and inquiry were starved of funds or marginalised. The young company writers were to learn Indian languages, but only so much as was required to aid efficient rule. Men like Cornwallis, and the historian Thomas Babington Macaulay, who was appointed to the Supreme Council of India in 1834, convinced themselves and their political masters that there was little the British could learn that could be taught in Sanskrit or Persian. 'Who could deny that a single shelf of a good European library was worth the whole native literature of India and Arabia,' blithely claimed Macaulay, while simultaneously admitting his ignorance of those very languages.[11]

Henceforth the ancient civilisations of India had nothing to teach the British – if indeed they were civilisations in the true sense. The neo-classical columns and portico of Government House were a physical manifestation of a growing idea that what would later be called western civilisation was part of a distinct teleology that could trace its roots back to Rome and Greece. In such a world-view, cultures that did not share such a lineage could not truly be considered civilised, no matter how sophisticated their laws and customs or how intricate and beautiful their art. In this world-view, the source of western civilisation had first

emerged in Greece, then been given voice and muscularity by Rome, transposed into the Christian tradition by the early Church, to then flower in the Renaissance, which in turn had brought forth the Enlightenment. Early nineteenth-century Britain and her empire were said to be the inheritors of that cultural treasure. In India men like Macaulay, an avid reader of the classical texts, believed the British had found a set of Asiatic cultures that in contrast had 'degenerated'. The same degeneration argument was to be used later by the Africa 'experts' of 1897 when seeking to explain how the supposedly barbarous people of west Africa had created the fabulously beautiful Benin Bronzes.

The belief in the singularity of western civilisation both explained and justified British expansion in India and elsewhere, providing the moral underpinning and self-rationalisation for new forms of paternalist imperialism. The imperial mission was also to be a 'civilising mission', through which barbarous peoples were to be guided towards eventual self-government, equipped along the way with the intellectual and cultural gifts of western civilisation. Neo-classicism, the architecture that made solid the links – both real and imagined – between nineteenth-century Europe and the classical civilisations, was to play a key symbolic role in this venture. What has been called the 'age of partnership' in Asia was, in the case of India, metaphorically buried under the foundations of Government House.

2

CULT OF PROGRESS

THE LURE OF THE PHARAOH

Two days after Richard Wellesley landed in Calcutta to take up his post as governor-general of Bengal, a French invasion fleet left Toulon and sailed out into the Mediterranean.[1] Joined by vessels that had set off from other ports, the combined armada eventually consisted of around 335 ships, making it the largest fleet to have sailed the Mediterranean for centuries. Landing in Malta, the French defeated and deposed the Order of Saint John, the knights who had ruled the island since the early sixteenth century. From Malta the invaders headed south to the ancient Egyptian port of Alexandria. After a difficult disembarkation, a force of 25,000 was assembled, and Alexandria was swiftly captured. The French then began a gruelling march across the desert towards Cairo. On 21 July they approached the village of Embabé, on the western bank of the Nile, around nine miles from the pyramids, and there, despite being exhausted, they fought one of history's most decisive battles.

The French infantry – formed into squares – faced the

legendary cavalry of the Mamelukes, the military caste that ruled Egypt. At the critical moment thousands of Mameluke horsemen rushed headlong at the infantry squares bristling with muskets and bayonets. The Mamelukes thundered forwards through fields carpeted with clover, firing their pistols at the invaders in what one historian described as 'the last great cavalry charge of the Middle Ages'.[2] When they were within yards of the squares the French opened fire. In just two hours the Mameluke cavalry, the force that had defeated the Mongols in the thirteenth century and saved Europe from encirclement, was decimated. Wave after wave

36. For the French, the invasion of Egypt was not just colonial expansion but an attempt to take possession of the ancient land from which, many Europeans believed, 'civilisation' itself had first sprung.

of horsemen were instantly obliterated by concentrated volleys of short-range musket fire. The Mameluke dead may have numbered 6,000. The French lost twenty-nine men. In the wake of this extraordinary victory a French army, led by a twenty-nine-year-old general, marched into Cairo.

Napoleon Bonaparte had been a relatively late convert to the obsession with Egypt that had gripped the minds of French thinkers and writers for over a century. In the 1670s the philosopher Gottfried Wilhelm Leibniz had attempted to induce King Louis XIV to launch an invasion of Egypt, presenting the king with an enormously detailed plan for conquest and colonisation. In the eighteenth century numerous thinkers and travellers had debated in print the benefits that might flow from the conquest of Egypt.[3] The Enlightenment philosophers Montesquieu, Turgot and Voltaire had added their voices to the conversation.

To Europeans, Egypt was a land both familiar and unfamiliar, a biblical realm but also the nation from which civilisation itself was said to have emerged, that 'golden nugget' later being passed on to the Greeks, Romans and ultimately Christian Europe.[4] Yet, despite its critical role in that civilisation story, this antique land had thus far resisted the inquiring gaze of the European Enlightenment. Although the pyramids were known to Europeans, much of the rest of the kingdom of the pharaohs remained lost to legend and buried under shifting sands. So much of Egypt's

past glory was yet to be unearthed – both metaphorically and literally. The tombs of the pharaohs lay undiscovered, and the hieroglyphs remained undeciphered – and this was almost a standing insult to the age of inquiry. In 1787 the philosopher and historian Constantin de Volney had published his travel account *Voyage en Syrie et en Égypte, pendant les années 1783, 1784 et 1785,* in which he warned starkly of the multiple risks and dangers that any invading force would face, but simultaneously presented his readers with a tantalising vision of the cultural and economic rewards that would flow from a successful conquest.

In theory, Egypt in the 1790s was a province of the decaying Ottoman empire. In practice, it was ruled by the Mamelukes, a caste of warriors of Circassian and Georgian origin who perpetuated their reign through the purchase of slave boys, who were converted by force and inducted into their ranks (a system that European observers viewed with a mixture of confusion and consternation). The multiple factions within the Mamelukes were constantly vying for influence. To French scholars such as Volney and Sonnini de Manoncourt (author of the influential *Voyage dans la haute et basse Égypte* (1799)) Egypt was a land burdened by what Enlightenment thinkers called 'Oriental despotism'. As such it was a land ripe for liberation from Mameluke overlordship and the backward-looking superstition that such misrule was said to perpetuate. Mameluke rule

was said to have led to an ossification of politics, arts and sciences, and modern Egypt could be rescued from this lethargy by European invasion and exposure to science and rationalism. In the minds of Volney and others the French conquest of Egypt could be considered a benevolent act of liberation.

Louis-Alexandre Berthier, one of Napoleon's generals in Egypt, described the purpose of the invasion as being to 'tear Egypt from the despotism of the Mamelukes'.[5] In

37. *The trade in enslaved women and the mysteries of the harem were favourite tropes of European Orientalist painters, as here in Jean-Léon Gérôme's imagining of a slave market in an unspecified Islamic city.*

the year of Napoleon's invasion Joseph Eschassériaux, the French legislator who was then leading a commission tasked with exploring the feasibility of France acquiring new colonies in Africa, described Egypt as a 'half-civilised' land. Its conquest, he believed, would be a fitting triumph for the idealistic France that had emerged from the Revolution. 'What finer enterprise' could there be, he asked, 'for a nation which has already given liberty to Europe [and] freed America than to regenerate in every sense a country which was the first home to civilisation and to carry back to their ancient cradle industry, science and the arts, to cast into the centuries the foundations of a new Thebes or of another Memphis?'[6] As with all colonial conquests, there were also less prosaic or idealistic considerations. Egypt was a tantalising colonial prospect, a territory that could provide France with both raw materials and new markets and become a bridgehead from which to threaten British interests in India. Intellectually, emotionally, ideologically and geo-strategically the case for conquest stacked up.

Napoleon, despite his general interest in the Orient and his deep fascination with Alexander the Great, was initially little moved by such arguments.[7] His attention was focused on other opportunities for glory and advancement, and on his brooding dissatisfaction with the Directory that then ruled revolutionary France. The driving political force, whose energies transformed Enlightenment theorising

into national policy, was Foreign Minister Charles Maurice de Talleyrand. It was only after it had been decided by the Directory to put Talleyrand's proposals for an invasion of Egypt into action that Napoleon became the man of the hour. Once his formidable mind and colossal ambition were focused on Egypt, Napoleon set out to harness Enlightenment idealism in order to win greater public support for the expedition, and to disguise the cold geo-politics that underpinned the Directory's decision. Napoleon's invasion was thus presented to the nation as a mission not simply to conquer Egypt but to remake her in the image of revolutionary France.

To begin this gargantuan task, and convince 3 million Egyptians that such a radical remaking was necessary and desirable, Napoleon included within his invading army not just soldiers but also scientists, writers, artists and philosophers. They were formed into what historians have called a 'legion of culture': 167 men from the various branches of new learning, all of them dedicated to recording, comprehending and unearthing the ancient land whose ruins and relics lay hidden beneath the sands, and in reforming contemporary Egypt. Among these children of the Enlightenment were the great mathematicians Jean-Baptiste Joseph Fourier and Claude-Louis Berthollet. There was Nicolas-Jacques Conté, the inventor and a pioneer of the hot-air balloon, and Vivant Denon, the

celebrated engraver. They were joined by the celebrated inventor of descriptive geometry Gaspard Monge and the brilliant geologist Déodat de Dolomieu, after whom the Dolomites mountain range is named. Portentously, the legion also included Mathieu de Lesseps, father of Ferdinand de Lesseps, the man who – a generation later – would build the Suez Canal. Despite the more troubling and ruthless aspects of his character – many of which were to emerge for the first time during the Egyptian campaign – Napoleon was always skilled at finding and promoting youthful talent, and many of the men he persuaded to travel with him to Egypt went on to perform great tasks for France.

In addition to studying Egypt – ancient and modern – these savants were tasked with disseminating the fruits of Enlightenment thinking and science among the Egyptians. The Egyptians themselves were to be beneficiaries of their own conquest: to be liberated from Mameluke rule (against whom there were genuine and justified grievances), to be instructed in the new sciences, and to be presented with the forgotten glories of their ancient past. Despite the propagandists' motivations, there was a genuine mission and a sense of sincere, if paternalistic, idealism. Yet Napoleon, for all his sophistication when in the company of artists and intellectuals, spoke to his troops not of knowledge and progress but of loot and plunder.

In August, just weeks after entering Cairo, Napoleon established the Egyptian Institute, which consisted of four sections: one each for the study of mathematics, political economy, physics and the arts. The geological survey of Egypt's ancient sites was begun with studies made of the pyramids and other archaeological sites. Vivant Denon was dispatched to draw the temples and monuments of the ancients and record their architectural achievements and the mysterious hieroglyphs. Napoleon himself travelled with members of the Egyptian Institute to the site of the ancient Suez Canal built by the pharaohs. In keeping with their more idealistic ambitions, the institution welcomed Egyptian visitors to the confiscated Mameluke mansion in which the new organisation and its expanding library were housed. The men of this legion of culture also founded hospitals and established a system of quarantine. They began work on a new sewage system for Cairo and looked at how street lighting might be introduced. Printing presses, the first in Egypt, were also imported and two newspapers established.

In 1798, on the banks of the Nile, Enlightenment theory was to be put into practice. Egypt was somehow to be transformed into a secular state organised around rational and scientific principles. Yet this nation was a complex, deeply religious and profoundly conservative society, one that the French only dimly understood. Although Napoleon

seemed aware of how dangerous it was to interfere with Islamic practice in Egypt, with characteristic paternalistic arrogance he still set about proposing and implementing secular reforms. His proclamations assuring the Egyptians that France was the defender of Islam, issued in poorly structured Arabic littered with errors, did little to convince local clerics that the French had any genuine respect for their faith.

Napoleon and his army of philosophers and scientists further aimed to create equality before the law, improve agricultural yields and build the irrigation system on which the whole nation relied. While some of these aspirations may have improved the lives of some Egyptians, they were imposed by outsiders who had little comprehension of the nation they had invaded and a paternalistic overconfidence in the manifest superiority of their civilisation. The behaviour of French troops and the aggressive methods deployed in the gathering of taxes further antagonised the Egyptians. Unsurprisingly, the people and the clerics refused to embrace European culture or see it as being superior to their own. The deep and long-running opposition to Mameluke rule that the French might have exploited was set aside as the French occupation became ever more bitterly resented and actively resisted.

The Ottoman Sultan in Istanbul, the ultimate ruler of Egypt, issued a firman declaring war on the French. When

revolt broke out in Cairo in October 1798, just six months after Napoleon's arrival, the results were almost disastrous. The French garrison was attacked, and a general who had been mistaken for Bonaparte was lynched by a mob. Over two days of violence 300 Frenchmen were killed. Napoleon restored order by unleashing his artillery upon the rebellious parts of the city. Ten times as many Egyptians died in the retribution.

Despite increasing opposition to their presence, Napoleon's men continued with their efforts to dazzle the Egyptians. In November, Nicolas-Jacques Conté launched one of the most spectacular wonders of the age: a hot-air balloon. It was only fifteen years since the Montgolfier brothers had invented the balloon and flown over Paris, and Napoleon had insisted that one be brought to Egypt. When that balloon was destroyed, along with much of the French fleet, when it was attacked while at anchor off the coast of Egypt, a new balloon was constructed. Determined to impress the people of Cairo, the French appear to have exaggerated the balloon's capabilities, telling those who would listen that it was a ship of the sky that could carry men across countries and oceans. As the huge balloon – painted in the red, white and blue of the French tricolour – rose into the sky above Ezbekiyah Square, the people of Cairo were momentarily astonished. Here was the great demonstration of Enlightenment learning, European science and the fruits

38. The Description of Egypt *was intended to be encyclopaedic, a drawing-together of all knowledge on contemporary Islamic Egypt as well as the ancient pharaonic land. Here, a weaver's workshop from a section on the arts and trades.*

of progress that Napoleon and the savants had envisaged. But as it climbed higher, the balloon caught fire – and crashed down to earth. One Egyptian witness took this disaster as proof that the balloon was not a ship of the air but 'just a kite like our little boys fly at weddings or festivals'.[8]

None of the ambitions that had led the French to Egypt were realised, although there are direct links between the expedition and the later construction of the Suez Canal. But there were real long-term effects of Napoleon's invasion for France, Egypt and the wider Islamic world. The engraver Vivant Denon had spent his time in Egypt drafting sketches of the sites of upper Egypt and the Nile valley. In 1802 he

published his book *Voyage dans la basse et la haute Égypte pendant les campagnes du Général Bonaparte*, which included drawings of the architecture of ancient Egypt along with engravings of the designs of the temples and tombs of the pharaohs. The book became a source of the so-called Egyptomania that took hold in early nineteenth-century France and spread to other nations, particularly the United States.

Between 1809 and 1820 the French government published the twenty-four volumes of *Description de l'Égypte*, an archetypical Enlightenment project to catalogue, classify

39. It was the huge number of meticulous, if sometimes romanticised, illustrations of the temples of the Nile Valley for which the Description of Egypt *was best known.*

40. *Art helped establish the legends around which Napoleon's cult of personality was constructed. Here the future emperor is depicted laying his hands upon the sick, in the manner of a medieval monarch.*

and record the architecture, ancient monuments, natural history and culture of Egypt, ancient and modern. The enormous and encyclopaedic *Description de l'Égypte* was hugely influential in Europe. Its impact was felt in French art and architecture. Egyptian motifs became a feature of the so-called 'Empire style' of French decoration and architecture. It also perpetuated the portrayal of Napoleon's invasion as an act of cultural benevolence, down-playing the violence, abuses and resistance. The popularity of *Description de l'Égypte* further conspired to fix Egypt within

the western gaze as a place of conquest, or 'an appendage to Europe', as the influential theorist Edward Said wrote.[9]

Napoleon's invasion also brought forth an engagement with new forms of Orientalist art. Oriental themes and subjects had been present in European art before 1798, just as there had been travel accounts of Oriental lands prior to the Enlightenment. Figures from the Ottoman empire and the Middle East had appeared, for example, in the paintings of Gentile Bellini, who lived in Istanbul between 1479 and 1481.[10] But Napoleon's invasion and the publication of *Description de l'Égypte* enormously increased levels of interest in the Orient, in the people of Egypt and in the wider Islamic world.

Many European artists, however, presented a romanticised view of Napoleon and his armies. Antoine-Jean Gros, a pupil of the master of French neo-classical artist Jacques-Louis David, produced grand history paintings depicting the most significant battles of the Egyptian campaign, all of them sanitised to an almost ludicrous extent. Gros's greatest work was *Bonaparte Visiting the Plague Victims of Jaffa* (1804), a rendition of an event that took place five years earlier, in the latter stages of the Egyptian campaign, and which, by the early years of the nineteenth century, had been fashioned into legend.[11] Commissioned by Napoleon and overseen by Denon, the painting shows the future emperor touching the sores of one of the plague-ridden

men while his fellow officers and military doctors, fearful of contracting the dreaded disease, cover their mouths with handkerchiefs.

Interest in Oriental themes further increased when, in 1830, France invaded and conquered Algeria. In 1834 the artist Eugène Delacroix unveiled his painting *Women of Algiers in Their Apartment,* painted after travelling to Morocco and Algeria while accompanying a French diplomatic delegation. Delacroix had already painted the Orientalist fantasy *The Death of Sardanapalus* (the last king of Assyria), a painting that indulged the European obsession with the idea of Oriental despotism. *Women of Algiers in Their Apartment* was a very different work, depicting a scene of everyday life in contemporary Islamic society, rather than a historical subject. The painting had been inspired by a visit that Delacroix had supposedly made to an Arab household, during which he had been able to quickly sketch the women in their harem – a term that referred merely to the parts of the house occupied by the female members of the family. (As it was highly unusual for a male stranger to be allowed a private meeting with Muslim women, it is possible that the three women Delacroix encountered in Algeria were in fact Jewish.) What is certain is that Delacroix embroidered what he saw, using costumed models to complete the painting when he got back to Paris and adding the figure of a black servant. Nonetheless, Delacroix's subtle use of colour and

41. *Restrained by the standards of his other Orientalists works, Eugène Delacroix's* Women of Algiers in Their Apartment *was inspired by the artist's own travels in north Africa.*

light to evoke an intimate domestic mood inspired other artists to paint scenes from what, to European eyes, seemed an exotic world. But his travels in north Africa, and French expansion in the region, convinced Delacroix that local cultures were at risk of being overwhelmed and thus had to be recorded by artists like himself. Although the painting places the three woman within a European fantasy, the level of realism achieved in *Women of Algiers in Their Apartment* was unusual.

REVOLUTION IN THE MIDLANDS

French historians have frequently proposed 1789, the year of the French Revolution, and 1793, the start of the Reign of Terror, as the end dates for the Age of Enlightenment. That intellectual revolution, from which emerged the ideas of Voltaire, Diderot, Locke, Newton and Rousseau, is said to have begun in 1637, when René Descartes (then happily enjoying the freedoms of life in the Dutch Republic) published his *Discourse on the Method*. If Descartes was the midwife of the Enlightenment, then its undertakers were his fellow Frenchmen Maximilien Robespierre and Napoleon Bonaparte. The Age of Enlightenment burned as brightly in Scotland and England as it did in France and the Netherlands, but the revolution that emerged in Britain in the second half of the eighteenth century was very different from that which had erupted on the streets of Paris.

42. One of Joseph Wright of Derby's 'night pieces', The Iron Forge, casts the founder as a heroic and muscular figure, provider for his wife and children, an embodiment of the Victorian virtues of hard work and honest labour.

Until the middle of the eighteenth century the people of Europe mostly worked in agriculture and lived in the countryside. There were plenty of towns and cities, of course, but most people didn't live in them. In Britain around 77 per cent of the population lived in the countryside; in France it was around 90 per cent.[1] The outlier, once again, was the Dutch Republic, but even there only 39 per cent of the population lived urban lives at the end of the Golden Age.[2]

Despite the advent of global maritime trade during the Age of Discovery, and its extension and amplification in the seventeenth and eighteenth centuries by the merchants of VOC and the East India Company, the fates of even the most advanced European societies still rested on the success or failure of the annual harvests. Across Europe the ownership of land remained the ultimate signifier of status, and wealth drawn from estates was more highly regarded than that derived from trade. The men who accumulated vast fortunes through slavery and sugar in the Americas, or cottons and silks in India, were pioneers in a new globalised economy, but those who could afford it, when they returned home, bought agricultural estates and built grand houses. New money was laundered into old money through neo-classical architecture and strategic marriages into the aristocracy.

Two revolutions – one gradual, the other more rapid –

disrupted those ancient patterns. The first was a revolution in agriculture itself, the beginnings of which stretched back centuries. As farmers had learned to rotate crops, yields had slowly increased. Later, small farms were amalgamated into larger, more efficient estates. Then the selective breeding of animals, new types of plough and better transport infrastructure enabled farmers to increase production further.

The second, more famous revolution was the Industrial Revolution. It began in England around 1750, although it wasn't described as a revolution in Britain until the 1840s, by which time it was half over. Why England and why the middle of the eighteenth century? Britain had some obvious advantages over her competitors. Beneath her soil lay vast stocks of coal and iron ore. Both England and Scotland had developed legal systems that privileged and protected property. The British coastline was studded with ports and intersected by navigable rivers. And by the mid-1700s local producers had enjoyed the benefits of wartime protectionist tariffs. However, many economists argue that what best explains the rise of British industry was the rise of British capitalism. Whatever the reasons for the advent of industrialisation, the aspect of the revolution that led to the most profound changes in the daily lives of millions was the emergence of new and disruptive technologies, the locus of which was the factory.

The word 'factory' had previously been used to describe the fortified trading posts that had been established in Africa and Asia by joint stock companies such as the VOC and the East India Company. In the latter half of the eighteenth century the word began to shrug off that earlier meaning and took on its modern one. When and where the first factory was established is another matter for debate, but there's a strong case for suggesting that Cromford Mill, in the Derbyshire countryside, was the first modern

43. *Richard Arkwright's Cromford Mill by his friend Joseph Wright of Derby. Cromford was the world's first fully fledged factory and Arkwright one of the great pioneers of the Industrial Revolution.*

factory. Built in the 1770s by the entrepreneur Richard Arkwright, it was designed around his greatest invention, the 'water frame', a system that used the power of flowing water to drive spinning machines, which in turn produced cotton thread and yarn. A single water wheel could power whole banks of machines. This meant that work previously done by small groups of pieceworkers in a domestic setting could be done in a factory at enormously higher levels of efficiency, productivity and profitability. Cromford Mill carried many of the hallmarks of the factory, including the extent to which the machinery set the pace, determining the meter of human activities, operating the first recognisable 'factory system'. The workers in Arkwright's factory – who included children – had been drawn to Cromford from miles around. Their ancestors had been agricultural workers whose lives ran according to patterns set by the seasons. Arkwright's factory system demanded that they operate in shifts. The factory clock became a central feature of the lives of millions and part of a revolution in chronology and time-keeping that seeped into almost every aspect of life and commerce.

Arkwright was so proud of his factory that he had his friend paint it. In *Joseph Arkwright's Mill, View of Cromford near Matlock* (1783), the artist Joseph Wright of Derby set the mill in a bucolic landscape; the only human figure is a man leading a horse and cart down a track. There is no hint

of the clanking of machinery or the sheer relentless energy of the factory behind. Paintings of this sort were a form of industrial landscape painting in which factories and mills were dissolved into rustic landscapes or hazy sunsets, as if they were accepted features of the agrarian past, rather than harbingers of a new era that profoundly threatened the existing order.

If Wright of Derby felt the need to understate the impact that Cromford had had on the surrounding countryside, it may have been in reaction to growing disquiet over the effects of industry on the rural landscape. Such opposition, much of it marshalled around the emerging idea of the picturesque, was already vocal by the 1780s, and only intensified in the decades that followed. In his 1794 *Essay on the Picturesque, As Compared with the Sublime and the Beautiful*, the prominent landowner and essayist Sir Uvedale Price condemned the mills around Cromford and Matlock as intrusions into picturesque nature: 'When I consider the striking natural beauties of such a river as that at Matlock, and the effect of the seven-storey buildings that have been raised there, and on other beautiful streams, for cotton manufactories, I am inclined to think that nothing can equal them for the purpose of disbeautifying an enchanting piece of scenery.'[3]

Joseph Wright of Derby had witnessed the rise of industry in the English Midlands. He counted among his friends not

just businessmen and industrialists but also scientists and thinkers – Enlightenment men committed to the principles of rational inquiry and empirical experimentation. What fascinated Wright was not just the vigour and inventiveness of industry but the science that lay behind it. It was when seeking to depict the drama of Enlightenment science that Wright created his greatest work.

In *An Experiment on a Bird in the Air Pump* (1768), a travelling scientific demonstrator (one of a type then referred to as 'natural philosophers') has placed a white

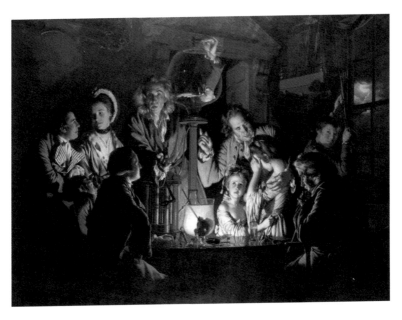

44. *Joseph Wright of Derby's most famous painting has a well-to-do family captivated by a dramatic display of the power of nature and the new sciences, brought into their home by a travelling scientist.*

cockatoo in a glass bell jar and begun to pump out the air. The bird, trapped in the vacuum and deprived of oxygen, is on the verge of suffocation. His audience, made up of various members of a well-off middle-class family in whose home the demonstration is taking place, respond with a mixture of fascination and horror. Their faces are illuminated by the light of a single candle.

Air pumps were not a new technology in the 1760s, but public demonstrations of the power of the vacuum had become infamous for both their theatricality and their cruelty. Wright's atmospheric painting captures both aspects, for while the cockatoo suffers at the bottom of the glass jar, the scientist, dressed in a scarlet robe and staring out at the viewer, has his hand poised on the valve at the top of the jar, able at any moment to save the bird by allowing air to rush back in and revive the poor creature. In strict accordance with prevailing views on the inner nature of the genders, Wright has his male spectators gaze at this dubious experiment with expressions of intent but detached curiosity. The two female spectators, the daughters of the household, are shown standing beside their father, overcome by feminine emotion. Their distress at the suffering of the cockatoo – quite possibly the family pet – is palpable.

In *An Experiment on a Bird* and *A Philosopher Lecturing on the Orrery*, Wright showed how the new sciences were

being brought into the homes of the expanding middle classes, 'new learning' becoming not just theatre but almost a religion, with the literal power over life itself. But in *An Experiment on a Bird in the Air Pump* Wright also perfectly captures the accompanying sense that the new sciences, like the industrial machines housed in those dark satanic mills, were simultaneously regarded as disconcerting forces that challenged the natural order. From the gloom and the tension of Wright's paintings comes the growing sense that progress was uncontrollable and its effects unpredictable, that the wonders of the new age involved a certain loss of innocence.

THE CITY AND THE SLUM

In the penultimate year of the nineteenth century Alfred Russel Wallace, the co-discoverer of the theory of natural selection, published a now largely forgotten book: *The Wonderful Century: Its Successes and Failures*. It was, as the title suggests, a catalogue of the advances that had been made in Britain and her empire during the 'wonderful' nineteenth century. In his final chapters, however, Wallace decried the litany of moral and political failures that, in his esteemed view, tainted the successes of the age. Cited among these failures were the rise of militarism, the late Victorian famines that decimated British India and the 'thinly-veiled slavery' that was taking place across the colonial world. Wallace also listed the living conditions of the poor in Britain's industrial cities.[1]

45. Charles Booth's revolutionary maps used colour coding to denote levels of wealth or poverty for each street of late-Victorian London. The social crisis caused by rapid urbanisation and industrialisation represented a profound challenge to art.

The slums that so appalled Wallace were a product of the rapid and largely unplanned urbanisation that had begun in the eighteenth century. The sheer speed at which Britain's industrial cities expanded in the eighteenth and nineteenth centuries had been both breath-taking and alarming. Higher profits and greater productivity had enabled the owners of factories and mills to pay wages that were considerably higher than those for agricultural work, encouraging migration from rural villages to towns and cities. The enclosure of agricultural land, a feature of the concurrent agricultural revolution, provided further impetus for migration to the cities. Although, like Cromford Mill, the first factories had tended to be built in rural locations, near the fast-flowing rivers needed to power waterwheels, the shift to coal and ever greater mechanisation meant that industrialisation and urbanisation ultimately became synonymous. By the middle of the nineteenth century Britain became the first society in which the majority of people lived in cities.

The poster child for industrial urbanisation was Manchester. At the beginning of the eighteenth century it had been a market town with a population of around 10,000. By 1851 it was home to 400,000 people. Nothing like industrial Manchester had ever existed before. It became the focus of global fascination, a brick-built metropolis that was simultaneously a miracle and a social disaster. Although industrial wages were higher than those on the

farms, increased earning power did not translate into better standards of living in the new cities. Foreign visitors to Victorian Britain were genuinely shocked by the living conditions of the poor. Great plagues of cholera and typhoid periodically swept through the slums, killing thousands. It is no accident that both Karl Marx and Friedrich Engels gravitated to Britain to formulate their ideas about the age of industrial capitalism. Politicians, reformers, philanthropists and philosophers all struggled to find ways to ameliorate the human cost of urban industrialisation, all the while facing huge resistance from vested interests and parsimonious local authorities.

How were artists to make sense of mid-century Manchester and the forces that had given rise to her? What was the role of the artist in a society for which there was no precedent or precursor? From the start, artists struggled to find answers. They were wary of depicting the stark realities of the factory or the social horrors of the industrial city. One, however, was drawn to the new industrial regions of Britain. J. M. W. Turner embarked on a tour of the English north and the Midlands, to make sketches of the main centres of manufacturing. In August 1830 his journey took him to Dudley, an industrial town at the centre of the Black Country, so called because of the enormous clouds of smoke that were constantly vomited into the skies from its factory chimneys and the coals and cinders that covered

the ground around the mines and furnaces. The engineer James Nasmyth described the region as one in which 'The earth seems to have been turned inside out. Its entrails are strewn about ... By day and by night the country is glowing with fire, and the smoke of the iron forges and rolling mills.'[2] Little had changed a decade later, when Charles Dickens, in *The Old Curiosity Shop*, described the Black Country: 'tall chimneys, crowding on each other and presenting that endless repetition of the same, dull, ugly form poured out their plague of smoke, obscured the light, and made foul the melancholy air.'[3]

Turner's painting of industrial Dudley is a pictorial record – albeit a lyrically beautiful one – of the conditions Dickens and Nasmyth attested to. He used delicate watercolours to emphasise the effects of natural light at day's end, and set the old town of Dudley, with its church and the ruins of the eleventh-century Norman castle, high on the hill, pushed into a gloomy, half-lit background. What dominates the scene is industry. Glowing fires from a forge radiate outwards. Clouds of black smoke climb upwards into a darkening sky, and the barges that ferry the raw materials of industry shimmer into indistinct shapes, merging with their own reflections. John Ruskin, who for a while was the owner of Turner's painting, regarded it as a portent of 'what England was to become': a land in which the rise of industry inevitably entailed the loss of the old world, represented by

46. The fires of industry dominate in J. M. W. Turner's rendering of Dudley in the English Midlands. Turner visited the town during the summer and autumn of 1830 while on a tour of England's burgeoning industrial centres.

Turner as the ruined castle and church. The new age, Ruskin predicted, mandated 'the passing away of the baron and the monk'.[4]

In his fascination with industry, iron forges, steam trains and steam-powered tug boats, Turner stands out among his contemporaries. More typical was William Wyld, who – two decades after Turner's tour of the Black Country – produced a watery, anaemic depiction of Manchester. Held in the Royal Collection, Wyld's *View of Manchester from Kersal Moor* was commissioned by Queen Victoria herself, after her tour of the north-west of England in 1851.

Wyld places the great city of 400,000 souls literally on the horizon. In the foreground is a comforting pastoral landscape; goats graze in tall grass, and a resting couple, accompanied by their dog, take in the view. Smoke rises from a line of giant chimneys that puncture the skyline, and the rooftops and church spires of mid-century Manchester can be seen through the haze, but the dirt and energy of the industrial megalopolis, the conditions that had shocked the queen, are lost in the glow of a sunset that is delicately refracted through the smoke of the factories. (As generations of artists were to discover, one of the few redeeming features of industrial pollution was that it created stunning sunsets.) *View of Manchester from Kersal Moor* said more about the influence that Claude Lorrain, the grand master of landscape art, had had on William Wyld than it did about the world's foremost industrial city. With Manchester thrust into the distance, the thousands of families living in damp cellars, the ceaseless noise from machine and factory, the vile smells, fetid gutters, polluted rivers and pitiless, relentless misery of it all are rendered invisible.

It was Britain's novelists who had the most to say about the misery of the industrial working class and the wretched poverty that marred their lives. Writers more than painters were willing to venture into the parts of the Victorian city that the respectable classes preferred to ignore, despite the

47. *William Wyld's view of Manchester keeps the booming industrial metropolis in the far distance. The smoke from the forest of chimneys refracts the light of the setting sun, creating a romantic atmosphere. But the painting has nothing to say about life in a city that was then home to 400,000 people.*

fact that wealth and poverty existed side by side, separated by only a few streets, as the maps of Charles Booth were later to reveal. Dickens had been forced to work in a factory aged just twelve, after his father had been incarcerated in the infamous Marshalsea prison for his debts. The author carried the psychological scars of that experience throughout his life. As a writer, Dickens was constantly fascinated by the plight of the urban poor, or at least those he regarded as the 'deserving poor'. Yet it was perhaps a

generation of women writers who most subtly and movingly uncovered the struggles of the industrial workers, and forced their middle-class readership to confront the social costs of industrialisation and the Victorian cult of progress.

In *Mary Barton: A Tale of Manchester Life* (1848) Elizabeth Gaskell created a fictional portrait of life in the slums of 1840s Manchester, mirroring the journalistic reports of the same neighbourhoods that appeared in Friedrich Engels's *Condition of the Working Class in England* (1845).[5] In perhaps the most powerful passage, Gaskell's characters John Barton and George Wilson venture deep into the abyss of tenements and cellar dwellings on Berry Street, in central Manchester.[6]

It was unpaved, and down the middle a gutter forces its way, every now and then forming pools in the holes with which the street abounded. Never was the old Edinburgh cry of '*Gardez l'eau!*' more necessary than in this street. As they passed, women from their doors tossed household slops of every description into the gutter; they ran into the next pool, which over-flowed and stagnated. Heaps of ashes were the stepping-stones, on which the passer-by, who cared in the least for cleanliness, took care not to put his foot. Our friends were not dainty, but even they picked their way, till they got to some steps leading down into a small area, where a person standing would have his head about one foot below the level of the street, and might at the

same time, without the least motion of his body, touch the window of the cellar and the dump muddy wall right opposite. You went down one step even from the foul area into the cellar in which a family of human beings lived. It was very dark inside. The window-panes where many of them broken and stuffed with rags, which was reason enough for the dusky light that pervaded the place even at mid-day ... the smell was so fetid as almost to knock the two men down. Quickly recovering themselves, as those inured to such things do, they began to penetrate the thick darkness of the place, and to see three or four little children rolling on the damp, nay wet, brick floor, through which the stagnant, filthy moisture of the street oozed up; the fireplace was empty and black; the wife sat on her husband's lair, and cried in the dank loneliness.[7]

THE AMERICAN WILDERNESS

In the last years of the eighteenth century the factory came to America. The rise of industry, combined with rapid population growth and mass immigration, led to the replication in the United States of the social conditions seen in Britain's industrial cities. The lives of those who dwelt in the cellars around New York's Five Points were every bit as bleak as those who lived in the cellars of London's infamous Seven Dials. But in America, beyond the teeming cities of the East Coast, lay a vast continental wilderness of endless acres and enormous potential. The bountiful wealth and sheer scale of the land were taken, by some, as proof of divine providence. American nature appeared pristine and perfect, and the dream of taking possession of this colossal prize rapidly took hold. In 1803 Thomas Jefferson purchased

48. Kaaterskill Falls in autumn as painted by Thomas Cole in 1826. On a ledge above the falls stands a lone figure of a Native American. Both he and the American wilderness, Cole suggests, are threatened by the advance of modernity and the cult of progress.

the territory of Louisiana from the French government for the embarrassingly modest sum of $15 million, and by the 1830s the first of the homesteaders had begun to head westwards on the Oregon trail. By the 1840s the American drive for westerly expansion had a name: 'Manifest Destiny'. America's mission, wrote the originator of that term, the columnist and editor John L. O'Sullivan, was 'to overspread the continent allotted by Providence for the free development of our yearly multiplying millions'. To Sullivan and millions of Americans that mission was unquestionable, sanctioned both by God and by reason.

Nineteenth-century America was a nation of unbridled ambition and vaulting confidence. Yet on matters of high culture Americans were gripped by something akin to an inferiority complex. When it came to the arts, young America deferred to old Europe. An American national style had emerged in the years after independence and the war of 1812. The dominant genre – perhaps inevitably – had been historical painting, but by the 1830s the initial growth pangs of the nation were over and a new generation of American painters went in search of a new subject and a new form of national art. They found that subject not in the heroic deeds of great men but in the empty stillness of the Catskill mountains and along the banks of the Hudson River in New York State. There they stumbled upon a landscape unlike anything that existed in Europe, a landscape that almost

demanded to be painted so that the news of its discovery could be better disseminated.

In the hands of this new generation, landscape painting – traditionally a poor relation among the artistic genres – was elevated as rarely before. It was fêted and empowered so as to play a commanding role in the creation of a new national myth. In this new American art, natural history was to stand in for history itself. Canyons, mountains and waterfalls were to replace the classical ruins of the old world – so beloved by European landscape artists. Thus through landscape and the representation of her nature, America was to find new strands to her emerging identity and reinforce her sense of fundamental exceptionalism. The artists in question became known as the Hudson River School, as it was up that watery highway that they travelled to find their landscapes and escape from urban life and urban subject matter. The work of the Hudson River painters spanned two generations, and the school included women as well as men, but the artist who led the way, becoming America's greatest landscape painter, was Thomas Cole.[1]

British by birth, Cole was from Bolton, in Lancashire, one of the fiery crucibles of the Industrial Revolution. His family moved to Philadelphia in 1818. Like Wright of Derby, the young Cole had watched as industry ravaged the English landscape around him, imbuing a deep reverence for untamed nature and an understanding of its inherent

fragility. In his adopted homeland Cole embarked on a long, difficult and unconventional path towards his vocation. Moving to New York in 1825, he achieved his first successes, winning the admiration and patronage of the wealthy George W. Bruen. With the money from those early sales Cole funded expeditions to the Catskill mountains, painting landscapes that were later sold to influential, old money New Yorkers with whom Cole's ideas as well as his art struck a chord. It was at this time that Cole befriended the artist Asher Durand, who became another of the Hudson River painters.

Cole produced multiple paintings of the Catskill mountains, starting in 1824 and returning to the same landscape and the same themes year after year. The area had been opened up to tourists who travelled up from New York City a few years earlier, but Cole's landscapes, particularly those of the stunning Kaaterskill waterfalls, established the region as America's first natural tourist attraction. Before the national parks, before Yellowstone and the Grand Canyon, it was to the Catskills that Americans came to commune with nature. Those unable to make the pilgrimage were – through the power of art – still able to revel in the knowledge that their nation possessed a natural, God-given beauty like that of no other.

In 1829 Cole returned to Britain, where he studied the works of Turner, once even meeting the great man in his

London gallery. Travelling on, Cole headed to the Continent and embarked upon the customary tour of the galleries, where he saw the works of the old masters and generated hundreds of sketches. It was on his return to America that he became the true and vocal champion of the American landscape, refuting both on canvas and in his writings the then widely held belief that American nature lacked true beauty and the solidity that came through associations with the past – by which was meant a past that Europeans had been present to witness. The American landscape was supposedly virgin and free from the stamp of history. The Native Americans, with all their ancient associations with the land, were unthinkingly discounted. The idea that underpinned much of Cole's work – the idea of the sublime, the involuntary thrill that comes from contact with an untamed landscape – had been imported from Europe. America was by no means alone in the nineteenth century in looking to landscape art and nature in order to forge new forms of romantic cultural nationalism. The work of artists on both sides of the Atlantic imbued nature with a spiritual essence that connected the viewer to God. Whether it was the Hudson River Valley, the English Lake District or the Black Forrest of Germany, the inner spirit of the nation was said to reside somewhere out there, in the wilderness.

Yet in America, despite its vast size, the wilderness was under threat. As the population boomed and progress drew

millions westwards, land was cleared for crops and cattle.
Thomas Cole's paintings preserved on canvas parts of the
American landscape that many felt should be preserved in
reality. In a restless, forward-facing nation Cole's voice was

*49. One of the key painters of the Hudson River School of America,
Frederic Edwin Church produced highly romanticised landscapes on giant
canvases. Like Thomas Cole, he regarded the American landscape as a
divine creation and proof of American exceptionalism.*

important. His paintings and those of his contemporaries provided America with a necessary counterbalance.

Painters, along with poets and novelists, offered a nostalgic call for what had been recently lost and a note of caution as to what appeared threatened. Cole himself was a conservationist in the most basic sense, sceptical of the thrusting abrasiveness of American progress and confident in the belief that a society that loses contact with nature

loses contact with both God and morality. Cole helped ignite a debate about the costs of progress and the value of the American wilderness that was to continue through the work of Ralph Waldo Emerson, David Thoreau, John Muir and all the way up to Rachel Carson's 1962 book *Silent Spring* and the advent of modern environmental consciousness.

Cole was the first among equals within the Hudson River School, but other artists, such as Asher Durand and Frederic Edwin Church, stood with him in their reverence of nature. In 1857 Church painted another of America's national wonders, *Niagara Falls*. The enormous canvas rapidly won national and international praise. So popular was the painting that when it was put on display at a New York gallery a 25-cent charge for admission was imposed. Within two weeks 100,000 people had paid for their chance to view what one periodical descried as 'the finest oil picture ever painted on this side of the Atlantic'.[2] Some visitors viewed the painting through binoculars, as if they were at the falls themselves rather than looking at a painterly rendition of them. Church's masterpiece then toured the nation before crossing the Atlantic to be displayed in London and in Paris at the 1867 Exposition Universelle.

THE COURSE OF EMPIRE

Part of what marked Thomas Cole out from his contemporaries, and other members of the Hudson River School, was that he did not limit himself to landscape. In the early 1830s he began to conceive of an epic series of five allegorical paintings that were to fuse landscape with another genre: history painting. The result, *The Course of Empire,* is more than an allegory; it is a prophetic warning in oil paint.

Like most significant works of art, *The Course of Empire* was a comment on its times, the so-called Jacksonian era. It was impossible, in the 1830s, for educated Americans not to sense that they were living at a time in which the tempo of history, and the rate of change and speed of invention and innovation, appeared to have accelerated. The nation was expanding westwards, and had attained population parity with Britain. The sheer size of America's potential was breath-taking, but the deleterious costs of progress were already being felt. The nation's wilderness, sacred to Cole and to millions who came after him, was at risk of being

50. The Course of Empire: The Savage State.

———————

expunged. Also at risk was the original founding conception of America as a commonwealth of farmers, a pastoral nation of little men, free from the tyranny of monarchs or the yoke of an overbearing state. At this critical crossroads, under the controversial and divisive presidency of Andrew Jackson, Cole produced *The Course of Empire,* which reminded Americans of a simple fact – that empires fall as well as rise. The series was influenced by ideas that were current at the time which suggested that human history moves in cycles, and that there are natural phases in the civilisational process.

Although conveying a message of national importance, *The Course of Empire* was commissioned for the private gallery of Cole's New York patron Luman Reed, a wealthy merchant and enthusiastic collector. Each of the five paintings that make up the series demonstrates a different time of day, from dawn to dusk. Each is set in the same landscape: a natural harbour, with the sea visible in the distance. The mountains that loom over the harbour are unchanging despite the passing of time, while below a great human drama is being played out.

The sequence begins with what Cole titled *The Savage State*. It is early dawn on primordial Earth. A hunter chases a stag across a verdant, untamed landscape. The first light

51. The Course of Empire: The Arcadian or Pastoral State.

of day illuminates the scene, and in the distance a primitive settlement of animal skin tents can be seen. Cole described the painting as showing only 'the first rudiments of society'.[1]

The next painting in the sequence depicts what in some ways was Thomas Cole's ideal. In *The Arcadian or Pastoral State* the nomads trekking with the herds have long gone, for the inhabitants of this fertile Eden have become agriculturalists: a farmer ploughs his field, a shepherd tends his flock. As food is now plentiful, and life has become 'tamed and softened', the elite no longer toil in the fields and have discovered the arts: music, dancing and poetry. In the distance, near where the simple tents of their ancestors

52. The Course of Empire: The Consummation of Empire.

53. The Course of Empire: Destruction.

had been erected, now stands a megalithic temple in which the citizens of this Arcadia worship their gods. In the pastoral state of civilisation, Cole suggests, mankind and nature live in happy equilibrium. But by the waterside stands the symbol of impending change. A longboat is under construction, hinting that the men of this society are destined to venture forth and forge an empire.

The third painting is the literal and narrative centrepiece of this series, and was intended to be hung in the middle position. *The Consummation of Empire,* larger than the other paintings, is set at midday. The once sparsely populated harbour is now lined with classical structures of white

54. The Course of Empire: Desolation.

———

marble – vast temples and huge, gaudy palaces. Every balcony and public space throngs with crowds, and the river bustles with ships of trade and war. What is absent from this urban landscape is nature; all the trees have been eradicated. Here Cole presents an opulent, powerful civilisation at what he called 'the summit of human glory'. Although democracy appears to have developed, there has been no flowering of republican values here. Democracy has been corrupted by luxury and tyranny, as power and wealth have bred decadence and moral decay. At the centre of *The Consummation of Empire* is the emperor, shown marching into his great city ahead of a column of horses

and elephants. Thousands have come out to celebrate the glories of their leader and the power of their civilisation: the scene groans with hubris.

The fourth painting, *Destruction*, depicts the moment the city is overrun by the forces of an unnamed enemy. The bridge across the bay on which the emperor made his triumphal entrance has collapsed, fires have broken out in temples and palaces, and statues of the gods have been toppled. Weakened by luxury and decadence, the populace of Cole's imagined civilisation are no match for hardened, virile invaders.

In the final painting, *Desolation*, it is a melancholy dusk. Centuries have passed. The harbour is moonlit and devoid of human presence. Nature has recolonised the landscape, vines have wound their tendrils around broken marble columns, and saplings have pushed aside blocks of weathered marble to reclaim their territory in an act of re-purification.

The more optimistic and less perceptive reviewers of *The Course of Empire* interpreted the series as an allegory predicting the impending fall of the tyrannies and monarchies of old Europe, and the unstoppable rise of American democracy.[2] Others saw the painting for what it was: a commentary on the America of the Jacksonian era. Many were troubled by Cole's pessimism. Cole himself wrote of his despair at the decline of the 'moral

principle' in America.[3] With *The Course of Empire* he was able to remind the citizens of his adopted homeland of the republic's foundational opposition to centralised power and traditional distrust of luxury and excess. The America of the 1830s, Cole suggested, had wandered from those essential principles. Through carefully staged allegory he warned that America's exceptionalism was not so deep or so profound as to render the nation impervious to the great cycles of history or the immutable forces that he believed propelled them.[4] Cole hammered home his central point in the newspaper advertisements that announced *The Course of Empire,* quoting lines from Canto IV of Byron's epic 1812 poem *Childe Harold's Pilgrimage*:

First Freedom, and then Glory – when that fails,
Wealth, vice, corruption.

THE THEFT OF IDENTITY

Hidden away in the landscapes of the Hudson River painters are tiny human forms, the figure of 'vanishing Indians'. What Native Americans had in common with the landscape over which they roamed was that they, too, in the minds of the adherents of Manifest Destiny, were to be brushed aside by the sweep of progress. Some of the solemnity that flowed from the canvases of Thomas Cole, Frederic Edwin Church and Asher Durand stemmed from the prescient belief that the natural vistas they depicted were destined for destruction. The same was taken to be true of the Native Americans, and art works that depicted them were possessed of the same sense of poignancy.

In nineteenth-century America politicians talked of the 'Indian Problem', and both novelists and poets imagined the final extinctions of Native American nations – the Oneida, the Wampanoag, the Mohicans. Thomas Cole based his wistful 1826 painting *Landscape Scene from 'The Last of the Mohicans'* on a passage in James Fenimore Cooper's famous novel. All sorts of complicated attitudes came into

play when Americans considered the fate of the Native Americans. Enlightenment notions of the noble savage – proud, simple people living a pure life in nature – clashed with emerging ideas of race, and the supposed inferiority of non-white peoples. But there was also an almost religious refusal to permit anyone – even the original possessors of the land – to stand in the way of progress and Manifest Destiny. Parts of the American landscape were eventually saved and transformed into National Parks, while the broken remnants of once proud Native American nations were corralled into native reserves.

In 1830 President Jackson signed into law the Indian Removal Act, which was intended to clear all indigenous peoples from areas wanted for white settlement to the east of the Mississippi. They were to be relocated on federal land to the west of that river. Those who resisted or refused to sign one-sided treaties were forcibly displaced or eliminated. The calamity that followed is known by the Cherokee nation as 'The Trail of Tears'. Those who accepted their fate and survived the death marches to the new reserves often found themselves on the move again the moment their new territories became coveted by white settlers.[1] By the end of the nineteenth century the Native American population of the United States had been reduced from millions to around a mere 250,000.

While some artists depicted the process of ethnic

cleansing solely from the point of view of the white pioneers, the German-born painter Albert Bierstadt depicted Native American settlements in a number of his works. In his 1867 painting *Emigrants Crossing the Plains,* the bleached bones of cattle lie in the wake of a caravan of covered wagons heading west, literally into the setting sun. Almost lost in the haze are the tepees of the Native Americans. The wagons roll inexorably past them towards the Pacific. Literally and metaphorically the Native Americans are being left behind. The painting was inspired by a scene Bierstadt had personally witnessed in Nebraska in 1863, thirty years after the passing of the Indian Removal Act. By then the

55. *The setting sun leads the pioneers of the Oregon Trail ever westwards, in Albert Bierstadt's painting of 1867. Around 400,000 settlers, prospectors and ranchers used the trail in the middle decades of the nineteenth century, helping America to make real sense of 'Manifest Destiny'.*

character of westward expansion was rapidly changing. The pioneers Bierstadt encountered were not refugees from the cities of the East Coast but migrants from north Germany and Westphalia, and highways like the Oregon trail were about to be rendered defunct by the completion of the first transcontinental railroad.[2]

During the period between the passing of the Indian Removal Act and the closure of the American frontier in 1890 there were a handful of artists who focused their attention directly on the Native Americans. The most notable was George Catlin, who saw in the Native Americans what Thomas Cole had seen in the landscape of the Catskills. Catlin was born in 1796, in an America that was only thirteen years old. His mother, who as a child had been briefly taken prisoner by Native Americans, ignited her son's youthful fascination with the multitude of nations

and clans who lived beyond the western horizon. Having trained as an engraver, Catlin

56. With his expeditions to the frontier behind him, George Catlin spent the 1840s promoting his so-called Indian Gallery, taking his vast collection of Native American portraits on tour across the United States and ultimately to Europe.

moved into portraiture, studying at the Pennsylvania Academy of Fine Arts, and by his late twenties could see stretched out in front of him a life of dull, static mediocrity, against which he spectacularly rebelled.

Heading west in 1830, he embarked on a series of expeditions – five in total – to the western frontier, and there he captured in portraits the faces of the Native Americans. In other paintings he recorded their customs, so far as he was able to observe and understand them. Catlin was convinced, as were most of his contemporaries, that his subjects were members of a 'vanishing race', doomed to a rapid and pitiless extinction, and this encouraged him to work with a frantic energy and take extraordinary personal risks. Over the span of nine years he travelled vast distances and painted portraits of some 300 Native American men and women.

By no means indifferent to the suffering of those who appear in his paintings, Catlin went out of his way to name his sitters accurately. In his canvases they appear as individuals, not as 'types', demonstrating to anyone who cared to look that there were numerous, distinct Native American nations, each with its own traditions and cultures, and all under threat as the United States pushed ever westwards. A decade into his mission Catlin lamented the plight of 'the noble races of red men ... their rights invaded, their morals corrupted, their lands wrested from them, their

customs changed'. Catlin cast himself as a saviour figure who, as he himself said, had 'flown to their rescue'. However, it was their memory, not their lives, that Catlin sought to preserve, accepting that the tribes of the west were 'doomed

57–60. Catlin produced some 600 paintings and portraits of Native American subjects. In all he visited forty-eight different ethnic groups on his tours of the frontier. Although today his reputation is mixed, in his portraits he attempted to convey the individuality of his subjects.

and must perish'. Through his work Catlin believed a record of the Native Americans and their culture would emerge and that this pictorial record would permit them to 'live again upon canvas', his paintings standing 'for the centuries yet to come, the living monuments of the noble race'.[3]

Despite being an artist of limited technical ability, Catlin came to regard his paintings as vital to American history, and he spent much of his later life trying to convince others of that assessment. In 1837 he gathered his paintings together to form what he called his 'Indian Gallery', which he toured around the country and later Europe. Although a success with the public, the gallery failed to make Catlin a profit. The viability of his tour of Europe was undermined by his insistence on shipping across the ocean most of his vast collection, a substantial entourage and two live bears. Loaded aboard ship, the 'Indian Gallery' weighed in at a full eight tons. Catlin's lack of restraint and ever mounting debts eventually lead him to a London debtors' prison.

For a man of his age Catlin's genuine passion for the cultures of the Native American nations was unusual. Further redeeming his paintings from the taint of the 'colonial gaze' is the fact that his portrayals of ritual life, hunting parties and other activities that punctuated the lives of the people he painted have become a valuable source to their descendants in the twenty-first century as they attempt to re-assemble lost rites and traditions.

61. *The Native American nations created their own artistic record of the series of wars by which they were driven from their traditional lands. This depiction of the Battle of the Little Bighorn of 1876, a rare victory, was painted on to a buffalo hide by an artist from the Cheyenne nation.*

What is not apparent from the surviving paintings and portraits is that the Plains Indians did not meekly reconcile themselves to displacement or extinction. They fought for their lands and traditions and documented that struggle in their own artistic traditions. Their art – 'ledger paintings' and 'war deeds' painted on calfskins and buffalo hides – shows their battles with the blue-jacketed soldiers of the US army. They are a unique record of Manifest Destiny at work, as seen from the other side of the frontier. It is art that records how the West was lost. A depiction of the battle of Little Big Horn in 1876, painted on an animal hide by people of the Cheyenne nation, is a record of one of the few native American victories in the so-called Indian wars. There were many more images of defeat than of victory.

PORTRAITS FOR POSTERITY

Thousands of miles from the American west another European artist was painting portraits of another indigenous people, on another colonial frontier. Gottfried Lindauer was an ethnic Czech from the city of Pilsen, then part of the Austrian empire. In 1873 he left his home city – largely to avoid conscription into the Austro-Hungarian army – and embarked on a journey that took him far beyond the reach of the Habsburg state. He first gravitated to Germany; then, on 6 August 1874, he landed in New Zealand.

A graduate of the Academy of Fine Arts in Vienna, Lindauer was a talented portraitist. One of his particular skills was the ability to transpose on to canvas something of the realism and directness of gaze seen in portrait photography, accentuating the effect through dramatic lighting effects and glazing techniques (although many subsequent critics have suggested his portraits lack sophistication). Lindauer spent the late 1870s and the 1880s touring New Zealand, setting up his studio and offering his services in each town he

62. Gottfried Lindauer's youthful self-portrait. Migrating to New Zealand, this Czech artist became perhaps the most respected painter of the Māori.

visited. But he had arrived in his new homeland in the latter stages of a long period of warfare.

In 1840, the year of Lindauer's birth, the Treaty of Waitangi had been signed by Māori chiefs and the British. This much-contested treaty, signed under somewhat dubious circumstances, gave Britain sovereignty over New Zealand – the islands Māori call Aotearoa. There had then followed decades of land acquisition and displacement of Māori by British settlers, in a period that was inevitably one of intermittent warfare between Māori and Pākehā – the Māori term for Europeans. As the Pākehā were supported by local militias as well as British troops, the scales were heavily weighed against Māori resistance. Having, in various ways, lost much of their ancestral land, been subject to war, and exposed to European diseases against which they had no immunity, the Māori population declined precipitously. In the same years waves of settlement enormously swelled the numbers of

Europeans. By the end of the nineteenth century, just sixty years after the Treaty of Waitangi, the Māori population had dwindled to a mere 50,000, while the European population approached 1 million.

Gottfried Lindauer's first patrons were wealthy and prominent figures from late Victorian New Zealand society: politicians, diplomats, landowners and merchants. Some, including Lindauer's main patron, the tobacco merchant Henry Partridge, commissioned portraits of Māori as well as of themselves and their families. To men like Partridge, such portraits, and paintings of Māori customs and scenes from everyday life, were intended to fulfil an ethnographic function. Like the portraits of George Catlin's 'Indian Gallery', they were envisaged as nostalgic mementoes of the early years of the colony, a pictorial record of an indigenous people who, it was widely presumed, had no long-term future. The English traveller Edward Markham, who visited New Zealand in the 1830s, before Charles Darwin had developed his evolutionary theories, concluded that a preordained process of displacement and extermination was playing out across the world. Like the Native Americans nations, he believed, New Zealand's Māori population was being pushed towards an inevitable extinction. This bleak, genocidal prospect was seemingly accepted by Markham, and many other nineteenth-century commentators, with calm equanimity.

It seems to me, that the same causes that depopulated the Indian Tribes are doing the same all over the World. In New Zealand the same as in Canada or North America, and in Southern Africa the Hottentots are a decreasing people and by all accounts the Islands of the South Seas are the same. Rum, Blankets, Muskets, Tobacco and Diseases have been the great destroyers; but my belief is the Almighty intended it should be so or it would not have been allowed. Out of Evil comes Good.[4]

Māori society, however, was not on the threshold of some extinction event. By the 1890s the population began to recover, leading to a Māori revival and a reassertion of

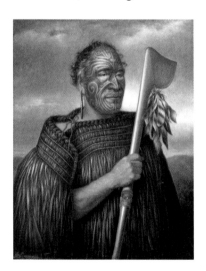

63, 64. Lindauer's portraits of Māori Chief Tamati Waka Nene *(1890), and* Heeni Hirini and Child *(1878) show people navigating between two cultures and adapting to an era of transformational change.*

traditions and identity.[5] An attempt to unite the various Māori tribes had been launched on North Island, in the form of the so-called King Movement, and there was a universal effort to ensure that Māori ancestors were remembered and revered. It was in this latter capacity that Lindauer's story became entwined with that of Māori Aotearoa.

Māori and Pākehā relations in the late nineteenth century were complex and multi-faceted; they entailed interaction and two-way appropriation, as well as opposition and conflict.[6] When Lindauer painted portraits of Māori subjects for European customers, he tended to paint them in traditional dress. When his patrons were Māori, many demanded that they be shown in a hybrid mixture of European and traditional dress, illustrating that they had the skills to move freely between the two cultures. Lindauer's portraits enabled his Māori sitters to demonstrate that they had secured a place in this complex, fast-changing, hybrid society. Such is the case in Lindauer's 1884 portrait of Te Rangiotu, a Māori chieftain and successful businessman. Te Rangiotu's portrait was painted by Lindauer on terms dictated by the chieftain and in accordance with how he wanted to be seen and remembered, and the issue of remembrance was key.

Lindauer's Māori portraits were rapidly incorporated into Māori culture and belief systems. The significance of Lindauer's work to Māori communities was noted

and recorded when the Czech writer and traveller Josef Korensky visited New Zealand in 1900. Korensky was thrilled to discover that an artist from his same ethnic-Czech background had achieved an elevated status among the little-known people of a land 11,000 miles from Europe. Korensky wrote:

> Say Lindauer's name, and every Māori chief nods their head to indicate they know the artist who painted their portrait. Visit the house of any important public figure at their funeral, and what do you see above the body on display? You see a canvas painting with a spitting image of the chieftain, decorated with ribbons and reminding the guests of the good face of the deceased. And who did the painting you might ask? Looking at the corner of the painting, you will see the artist's signature: Bohuslav Lindauer.[7]

Today Gottfried Lindauer's Māori portraits are highly valued in New Zealand, and increasingly so in the Czech Republic. A number of his portraits, including that of Te Rangiotu, have remained in the possession of the ancestors of the sitters. Such portraits are regarded as embodiments of the spirit of the subject through which a connection can be achieved. Those portraits belonging to Māori communities and families are often held in traditional meeting houses, sacred spaces that have long been the central focus of Māori

culture. Conventionally, such meeting houses were adorned with elaborately carved, semi-abstract figures and swirling patterns, each with its own symbolic meaning. After the arrival of Europeans, Māori meeting house decoration began to incorporate more literal, figurative scenes, borrowed from European art, and the new hybrid culture took solid form.

Traditionally, Māori meetings houses are guarded by elaborately carved faces which are themselves connected to another Māori art form, one that Lindauer carefully and dramatically presented in his portraits: Tā moko, facial tattoos. As we know from his own letters, Lindauer went to great lengths to depict the moko of his sitters accurately. In one, Lindauer notes: 'The Māori are extremely sensitive on the regularity of moko: they are quick to point errors when I am painting them. That is why I studied moko in-depth.'[8]

Tā moko is today a revived traditional art in modern New Zealand forming a

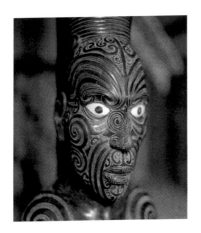

65. Lindauer won huge respect among the Māori for his skill in depicting the Tā moko (facial tattoos) of his subjects. The same markings – each one unique – appear in the carvings that decorate Marae, traditional Māori meeting houses.

66. Lindauer's portrait of Māori chief and businessman Te Rangiotu is still in the possession of his descendants. Such portraits are regarded not just as representations of ancestors but as embodiments of them and their sprits.

link, for Māori, back to their ancestors. As Tā moko was brought to New Zealand by Māori when they first settled in Aotearoa over 700 years ago, it also provides a link to the other Polynesian cultures that are spread across the Pacific and who practise different forms of tattooing. Tā moko is considered to be a mark of beauty and respect. For centuries each Tā moko carried a specific cultural meaning; they denoted social status and family connections, and no two designs are ever alike. While today, perhaps inevitably, the designs of Tā moko have been appropriated as a global fashion accessory, for many Māori they have been reclaimed as a highly visible symbol of cultural pride and identity.

THE ADVENT OF THE CAMERA

At eight o'clock one morning in either 1838 or 1839 – the time of day is known but the year uncertain – the inventor Louis-Jacques-Mandé Daguerre set a camera obscura in position at one of the windows of 4 Rue Sanson, in the 11th arrondissement in Paris. He focused the lens out over the rooftops and down into Boulevard du Temple below. A copper plate that had been coated with silver was then exposed to the light entering the camera obscura. Using mercury fumes as a developing agent, Daguerre managed to fix the resulting image on to the copper plate. The exposure time for Daguerre's primitive prototype camera was around ten minutes. This was far too slow for the people and horse-drawn carriages that travelled up and down Boulevard du Temple to register; they appear merely as indistinct blurs. But one man, who had stopped to have his shoes shined, remained static long enough for his image to appear on Daguerre's photograph. The indistinct shapes of other figures can also be made out: people who lingered long enough for their presence to be detected, just

as ghostly forms. Only the man having his shoes shined appears fully formed and fully recognisable, thus becoming the first person to appear in a photograph. His form is so distinct that some historians of photography have even wondered if he was deliberately placed there by Daguerre. Whether intentional or not, his presence illustrated the great potential of photography: its capacity to fix on to glass, and then paper, images of the human form, to make permanent and available to all images that artists had been viewing through the lenses of their camera obscura for centuries.

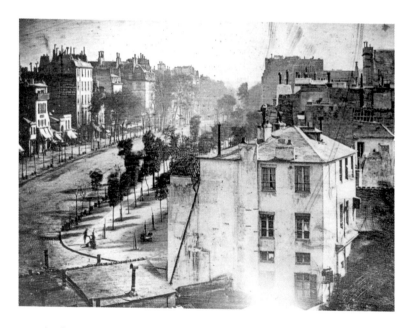

67. *The first Daguerreotype, Louis Jacques Daguerre's image of Boulevard du Temple in Paris, taken in either 1838 or 1839.*

68. The unknown man having his shoes shined on Boulevard du Temple. Perhaps the first human beings ever to appear in a photograph.

The photographic portrait was a profoundly revolutionary medium. Whereas the painted portrait had always been beyond the reach of the vast majority of people, the rapid refinement and evolution of photographic processes made the photograph, and then the camera itself, available to almost everyone. Photography made the human image not just permanent but also transmittable; it allowed living generations to look into the eyes of their ancestors and know that their descendants would be able to do likewise. But in the hands of artists the camera could do more than make a visual record.

Among the first to grasp that the photographic portrait had the capacity to capture the inner character of the sitter was Gaspard-Félix Tournachon, known to the public as Nadar, a nickname from his youth that had stuck. Nadar was a caricaturist, novelist and publisher, as well as a photographer. Perhaps above all, he was an inveterate showman, self-publicist and a figure of incredible energy and near-limitless enthusiasm. These qualities and his many

talents had made him a feature of Parisian society. His fame was such that his friend the writer Victor Hugo could write nothing but the name Nadar on letters to him and be confident that they would safely arrive at his photographer's studio on Boulevard des Capucines. Using his society contacts and the recently developed wet-plate collodion method, Nadar became one of the first true masters of portrait photography. (The collodion method reduced the exposure time to around thirty seconds, rather than the minutes required by the daguerreotype, which it rapidly supplanted.) Experimenting with lighting, backdrops and clothing, in a more relaxed and informal atmosphere, the new process enabled Nadar to capture something of the inner personality of his subjects.[1] His photo portraits of the novelists Charles Baudelaire and Alexandre Dumas and the great actress Sarah Bernhardt were among the greatest works to come out of his studio.

Having been born at the height of Europe's age of urbanisation – a phenomenon that took place later on the Continent than in Britain – the other obvious subject for the new technology was the city itself. Paris was then a city in the midst of a transformation that was radical, comprehensive and as destructive as it was creative. The camera was conscripted to record the death of one Paris and the birth of the other. In the rush towards modernity, old medieval Paris was incrementally obliterated week by

48 rue Bassano

69. *Gaspard-Félix Tournachon, an early pioneer of portrait photography, set out to capture something of the inner character of his celebrity subjects, as here in his portrait of the actress Sarah Bernhardt (c. 1864).*

70. *The photographer Charles Marville captured some of the last images of Paris before the medieval city was demolished in the vast programme of rebuilding known as Haussmannisation.*

week; from the 1850s onwards, whole neighbourhoods were demolished and replaced by a planned city. This process of creative destruction was called Haussmannisation, derived from the name of the ruthless but brilliant visionary who directed it, Baron Georges-Eugène Haussmann.

A well-connected bureaucrat, Haussmann had been an early and trusted ally of Louis-Napoleon, the nephew of Napoleon Bonaparte. Haussmann had backed the right horse. Louis-Napoleon rose to become President

of the Second Republic and then Emperor Napoleon III. He rewarded Haussmann by giving him extraordinary powers to force through his plans for the new capital. The essentially medieval city that was to be wiped off the map in the process was dank and dark, into which, so it was said, neither fresh air nor sunlight was able to penetrate.

Before that Paris faded into history, however, the photographer Charles Marville attempted to record its narrow, crooked streets and decaying buildings, the city he had known as a child (his own family home was demolished as part of the rebuilding programme). As its population had rocketed to over a million, Paris had become a city in which festered all the social problems that could be found in the slums of contemporary Manchester or New York. Although less industrial and more medieval in character, there was little romantic about the city, and there is remarkably little that is romantic about many of Marville's stunning images. His later photographs, commissioned by the Paris Department of Historic Works itself, offer a visual record of both the old capital and the mammoth building works then taking place. Many of his more memorable images are of the process of transition, the old city reduced to rubble, the new metropolis still under construction, as yet unborn.

The Paris that emerged from Haussmann's building programme was a hugely expanded city. Around 20,000 buildings had been demolished and around 30,000 new

structures erected. By some estimates the population had doubled, but the human cost of Haussmannisation had been enormous. Thousands of poor Parisians had been forced out of the city, their homes demolished and replaced by government offices or new residential districts aimed at the middle classes, and in which the apartments were beyond their financial reach. Such unfortunates were exiled to the growing suburbs. The new city was the Paris we know today, with its sweeping boulevards and elegant, uniform apartment buildings. The photographer who took the most striking images of this reborn metropolis was Nadar, who left his studio and took his camera into the skies above Paris. As well as being the great photo portraitist of his age, Nadar was also one of the most energetic promoters of aviation and a founder of the Society for the Promotion of Heavier than Air Locomotion. In 1858 he recognised the possibility of bringing two transformative technologies together: the camera and the hot-air balloon.

By the 1850s balloons were far more reliable than the primitive Montgolfier balloon that had crashed into Cairo's Ezbekiyah Square during Napoleon's occupation of Egypt. Nadar used a tethered balloon, sited near the Arc de Triomphe, raised to an altitude of 1,600 feet. From this

71. A series of aerial views of the Arc de Triomphe, Paris, taken by Nadar from a hot-air balloon sometime in the 1860s.

platform he took the first ever aerial photographs. Paris, as seen from the air, became one of the iconic images of nineteenth-century modernity, as only from above could the sheer scale of Haussmann's creation be comprehended.

AN ARTISTIC RESPONSE TO PROGRESS

The Paris we see laid out in Nadar's surviving aerial photographs was both the subject and the home of a new generation of artists. Like Haussmann, they were driven by a desire to sweep away the old. Like Nadar, they were fascinated by the new. Indeed, Nadar played a significant role in their story, as it was in his former studio on Boulevard des Capucines that their first exhibition took place in 1874.

It is difficult from the vantage point of the twenty-first century to appreciate fully how modern and radical the Impressionists were. The new visual landscape they created has been so thoroughly appropriated and so ruthlessly commercialised that we struggle to comprehend its original power to shock. Renoir's party scenes, Pissarro's Paris streetscapes, the ballet paintings of Degas now speak not of artistic innovation but of the lost elegance and faded glamour of *fin-de-siècle* Europe. The artistic revolution of which they were a part was so successful that we have lost touch with the very fact that the deliberate choice to paint

the people of their own city in their own time was, in itself, a radical and provocative act. And doing so, in the 1870s, made the Impressionists and their fellow travellers artistic outcasts, rejected by the Académie des Beaux-Arts, whose members were the great arbiters of taste, technique and style.

In subject terms it was the city, its growing suburbs and its expanding middle classes that most interested the Impressionists, but among the more radical elements of their style and philosophy was a focus on light and its effects. They emerged as an artistic movement, therefore, into a new city that had been deliberately designed by Haussmann and his planners to allow daylight to penetrate, and that was illuminated at night by thousands of street lamps, and the lights of the city's cafés, restaurants and apartments.[1]

Although Claude Monet is best remembered for his water-lilies and the paintings of the garden he built in later life at Giverny, some of his most radical works were of Paris's first railway station, the Gare St Lazare. The station, the locus of one of the great transformative technologies – which arrived later in France than it had in Britain – was a key site of modernity, a place well known to Monet. In his St Lazare series we find the station exaggeratedly filled with clouds of smoke and steam, illuminated by the daylight that pours in from the glass-panelled roof of the vast railway shed. To magnify the ever-changing effects of

light, Monet painted Gare St Lazare at various times of day. The trains themselves are subservient to the play of light through the billowing steam. Also just visible are glimpses of Haussmann's omnipresent architecture.

In Gustave Caillebotte's 1877 vision of a Paris street on a rainy day, Haussmann's grand boulevards loom oppressively, as if distorted by a camera's wide-angle lens. Pedestrians rush past, busily and privately. None of the figures makes eye contact – not even the couple walking towards the viewer. Each is cocooned from the others, not only by their umbrellas but also by the anonymity of city life.

72. One of a series of paintings of the Gare St Lazare by Claude Monet.

73. *The strange distortions in Gustave Caillebotte's* Paris Street; Rainy Day *(1887) accentuate the angles of Haussman's architecture. The cropped framing and the play with focus effects hints at the artist's fascination with photography.*

There is likewise no contact between the two figures in Edgar Degas's *L'Absinthe* (1876). Two dishevelled figures sit in a café, both of them lost in thought. Before the women is the infamous drink of the title, then the focus of public concern during one of the periodic upsurges of the French temperance movement. Although sitting in close proximity, the two are utterly disengaged, oblivious both to each other

74. *The two desperate looking figures in* L'Absinthe, *by Edgar Degas, are preoccupied with their own troubles and oblivious to one another.*

and to the world around them. Perhaps more unsettling still is Degas's peculiar sculpture *La Petite Danseuse de Quatorze Ans* (1879–81). Its subject, the juvenile Marie van Goethem, was a teenage apprentice at the Paris Opera Ballet, one of the so-called 'petits rats'. Degas's strangely cold sculpture, two-thirds life-size, speaks of his own disturbing urban detachment.

In one of Impressionism's most enigmatic works, *A Bar at the Folies-Bergère* (1882), Édouard Manet offers a glimpse into the glamorous, glittering world of Parisian high society. But Manet permits the viewer only to see that world indirectly, as a reflection in a mirror behind a bar. From the moment it appeared at the 1882 Paris Salon exhibition *A Bar at the Folies-Bergère* was controversial. At the centre of the controversy was the figure at the centre of the canvas, the barmaid. Her expression, one of the most famous and most examined in all of art, has been said to be that of neutral indifference, or perhaps defensive alienation? The fact that Manet painted her alongside an array of luxury goods – champagne, fashionable imported beer and a bowl of oranges – may have been his way of hinting that she herself was for sale. Her reflection, not where it logically should be,

75. La Petite Danseuse de Quatorze Ans, *Edgar Degas's disturbing sculpture of the teenage ballet dancer Marie van Goethemis. Contemporary critics were shocked by the dancer's unnatural pose and contorted face. Some regarded the sculpture as intentionally ugly.*

76. *Suzon, the barmaid in Édouard Manet's* Bar at the Folies-Bergère *of 1882. A study in ambiguity, the painting is loaded with coded visual messages: much of what we see is visible only in reflection through a mirror behind the bar.*

adds to the confusion. The barmaid is looking out of the canvas not, as first appears, to the viewer but at the man in a top hat who we see only in reflection. Manet's master class in ambiguity captured the atmosphere of a city that was both real and unreal, an alcohol-fuelled, consumer society.

AN EXOTIC ESCAPE

In 1889 Haussmann's Paris, rebuilt and reborn, was presented to the world when between May and November 28 million visitors from across Europe came to the Exposition Universelle, the most spectacular of the great nineteenth-century exhibitions. Held on the centenary of the French Revolution, it was a huge, state-sponsored celebration of French civilisation, and an ebullient reassertion of national pride in the face of the still lingering humiliation of defeat in the Franco-Prussian War.[1]

The Exposition's centrepiece was an enormous tower, then the tallest structure ever created. Intended as a symbol of modernity, it was a stunning feat of French industrial prowess and engineering ingenuity. It has largely been forgotten that the Eiffel Tower was conceived of as a temporary structure, scheduled to be dismantled after only ten years. So rapidly and so completely did it become a defining symbol of the age, and of the centrality of Paris in that epoch, that the plans for its demolition were permanently suspended. Subsequent generations of

French engineers have laboured incessantly to maintain and preserve the world's most enduring temporary structure. In 1889 the view from the Eiffel Tower was almost as revolutionary as the tower itself. From the upper viewing deck, 906 feet above the city, millions saw for themselves what they could previously only know from Nadar's aerial photographs: the capital city of European modernity laid out before them.

The official exhibition of French art at the Exposition Universelle was held in the Palais des Beaux-Arts and

77. *The pavilions of the Paris Exposition Universelle of 1889, as seen through the arches of the Eiffel Tower, which was itself built as a temporary structure for the Exposition.*

arranged under the auspices of the Académie des Beaux-Arts. The Impressionists, having for the most part rejected or been rejected by the Académie, were not invited. However, a small group of artists, which included Paul Gauguin, secured wall space at Café Volpini, a temporary venue situated next to the Champs de Mars, just outside the gates of the Exposition, and put on their own fringe exhibition.

The so-called 'Groupe Impressionniste et Synthéstiste' only came about because the wall hangings Monsieur Volpini had ordered for his café had not been delivered in time for the exhibition.[2] To avoid the embarrassment of opening to the public with bare walls, he offered the space to the otherwise shunned group of artists. The Volpini exhibition had two unexpected consequences. It added the name of an otherwise obscure Italian café proprietor to the annals of art history, and it placed Paul Gauguin at the centre of the Exposition Universelle. From the Café Volpini, Gauguin was within easy walking distance of the Esplanade des Invalides, where he encountered the Pavillons des Sections Coloniales.

The Exposition Universelle was a celebration not just of France's power and modernity but also of the French colonial empire – recently expanded with new territories conquered and incorporated. Prime Minister Jules Ferry, whose administration had begun the project to create the

Exposition Universelle, only to fall from office before 1889, had famously asserted his belief that it was not enough for France to be a free country, she 'must also be a great country'. France's colonial mission, as Ferry conceived it, was to 'carry everywhere its language, its customs, its flag, its genius'.[3]

Along the Esplanade des Invalides various people who now lived under that flag, and who had been specially shipped to Paris from Africa, Asia, Arabia and Oceania, were placed on public display, in mock villages built for them by French architects. These human exhibits were largely confined to those areas for the duration of the Exposition. Visitors to the Pavillons des Sections Coloniales could experience a north African market and a west African street. They could wander past reconstructed villages in which human exhibits from Senegal, Dahomey, Cambodia, Algeria, Madagascar, Tunisia, Tonkin (Vietnam), Tahiti and other distant lands re-enacted scenes from their daily lives or performed ceremonial dances. The two groups, the re-enactors and the spectators, the colonised and the coloniser, were kept apart by fences.[4]

This vast and elaborate human zoo was, in effect, a living museum that extolled the paternal benevolence of the French empire. The intention of the organisers was that visitors would revel in the exotic sight of these allegedly 'primitive' peoples being assisted towards the goal of

78. *Javanese dancers shipped to Paris to live and perform in the Pavillons des Sections Coloniales at the Exposition Universelle. Human exhibits from other parts of Asia, Africa and Oceania were also put on public display.*

civilisation by France, through her *mission civilisatrice*.[5] An inherently Enlightenment project, the mission unquestioningly presumed that French culture was superior to that of her subject peoples, while simultaneously keeping faith in the ideal of human perfectibility.[6]

What visitors to the Pavillons des Sections Coloniales were not supposed to do was to see the cultures, modes of life and art of the subject peoples on display as potential for an escape from French civilisation. Yet that was exactly the view taken by Paul Gauguin, who, over the summer of

1889, was able to wander at leisure around the miniature, condensed simulation of the French empire that had been temporarily constructed.

Despite exhibiting his work in five of the eight Impressionists' exhibitions, Gauguin's place in the story of Impressionism is sometimes overlooked. He came to art late in life, having served in the French navy and then worked as a city trader until he suffered ruin in the financial crash of 1882. Like a number of artists and writers of late nineteenth-century France, Gauguin was entranced by the idea of escaping the frenetic pace and apparent artificiality of modern European life. Constantly short of money, he was also perpetually in search of a place where he could live cheaply and paint. Although the idea of an escape to the tropics had come to him in 1888, and been discussed with fellow artists Émile Bernard and Vincent Van Gogh, it was amid the crowds at the Exposition Universelle, that the notion took form.

Gauguin convinced himself that his creative future and financial salvation lay in the colonies, although he always intended to return to Paris and sell his new works. All that remained to be determined was his destination. After trying and failing to get official permission to go to Vietnam, Gauguin set his heart on establishing his 'Studio of the Tropics' on the island of Madagascar. He had visited the Tahitian exhibition at the Pavillons des Sections Coloniales,

but it was not until after the Exposition Universelle had closed its doors in November 1889 that he began to read about the French Polynesian islands. He had also, by that time, obtained a copy of the romantic colonial novel *The Marriage of Loti* (1880), written by the French naval officer Pierre Loti and set in Tahiti. The more Gauguin read of Tahiti, the more convinced he became that there he would find a cheap place to live and work and be surrounded by an authentic and natural people whose culture and modes of life had not yet been erased by the *mission civilisatrice*. There, too, he would find the new version of himself, a liberated man, freed from the stifling conventions and artificiality of French bourgeois life; a man at one with nature and his natural 'savage' inner self. Just before sailing, he wrote to a friend of his impending rebirth: 'The European Gauguin has ceased to exist.'[7]

When the French first arrived in Tahiti in the 1760s, they encountered a people they came to regard as the most content on earth. Louis-Antoine de Bougainville, the captain of the first French ship to land there tellingly named the island Nouvelle Cythère, after the beautiful island from the waters of which, in ancient Greek mythology, the equally beautiful Aphrodite sprang fully formed. Bougainville deployed similar classical imagery when describing the women of mid-eighteenth-century Tahiti.[8] Thanks to Bougainville's descriptions, and those of the

Englishmen Joseph Banks and James Cook, the discovery of a tiny Pacific island became an event of enormous significance to Enlightenment Europe. The accounts that captivated contemporary readers described the island as a place of exquisite beauty, on which grew abundant fruits. The verdant shores were surrounded by shallow blue seas teeming with fish. The very colours of Tahiti were said to be more vibrant than those of Europe, and, critically, the island's female inhabitants were described as being extraordinarily beautiful, sexually available and free from the supposed affectation and artificiality that European manners demanded of European women. To educated middle-class Europeans these dubious accounts of the simple and carefree lives of the Tahitians appeared to reinforce some of the more utopian strands of Enlightenment thinking – the belief in a benevolent Creator and in Man's innate goodness. Here, it seemed, was proof of Rousseau's theories of Natural Man and the idea of the 'noble savage', a highly unstable Enlightenment concept about which there was never much agreement.

Although more balanced and sceptical descriptions of the island and its people did appear, the enduring image of Tahiti was that of a tropical idyll. To some later nineteenth-century observers the Tahitians seemed to be living in a state of innocence that approximated to the Arcadian or pastoral stage of civilisational development

that Thomas Cole had depicted in *The Course of Empire*. The layers of romantic exoticism that had built up around Tahiti were later accentuated by the growing belief that the Tahitians were a race of innocents who stood on the brink of extinction. Like the American wilderness and the Native Americans, their imagined disappearance rendered them and their culture yet more romantic. By the late 1880s Gauguin had imbibed a heady cocktail of such theories and preconceptions. When asked by a journalist why he had chosen to establish himself in Tahiti, he responded: 'I was captivated by that virgin land and its primitive and simple race; I went back there, and I'm going to go there again. In order to produce something new, you have to return to the original source, to the childhood of mankind.'[9]

The Tahiti that had gripped the imaginations of eighteenth-century Europeans had been largely an Enlightenment fantasy, based on fleeting encounters and superficial interactions. Tahiti of the late nineteenth century was even further removed from the myth. By the 1890s Tahiti was an assailed and decaying society, although not one doomed to extinction. While a tiny local elite had done well from the arrival of Europeans, the bulk of the Tahitian people had been devastated by disease, war and cheap alcohol. The population was a fraction of what it had once been, and missionaries of various denominations had done their best to stamp out much of their indigenous culture

and beliefs, a process that was still under way in Gauguin's time but never fully successful. Tahiti had become a classic case study of what European civilisation and colonialism could do to other societies.

Gauguin discovered that the only aspects of the old legend that remained true were the beauty of the landscape – once he got away from the capital, Pipette – and the island's reputation for the easy availability of women or, in his case, girls. Gauguin quickly found himself a local mistress and model: Tehamana, a girl of only around fourteen. She became his model as he set to work painting the island and its people. Gauguin described Tahiti as a land in which, 'everything is bare and primordial', yet he was as interested in the corrupting effects of French colonisation as he was in

what remained of pre-contact indigenous culture and modes of life.[10] Indeed, Gauguin, for all his affected bohemianism, became a feature of French colonial society in Tahiti,

79. Here Tehamana, Paul Gauguin's teenage mistress, wears a European-style dress, of the sort imposed upon Tahitians by the missionaries. But the flower in her hair and in the images in the background speak of Tahitian culture and history.

80. *Painted during Gauguin's first period in Polynesia, this scene of 1893 depicts the Tahitians as an apparently carefree people living in a pastoral paradise.*

associating with European traders and government officials and enjoying his celebrity.

Although his Tahitian paintings can seem exotic, Gauguin was too complex and too conflicted an artist to produce a standard European, fantasy vision of Tahiti as a classic island paradise. Like many, he saw the world as being divided between Europe and places such as Tahiti in which men and women remained – he believed – in a natural, savage state. He constantly wrote about his need for a

rejuvenation that could only take place away from European civilisation. In some of his letters Gauguin deployed the word 'civilisation' pejoratively. There's little question that Gauguin's Tahitian paintings were full of his own ideas and preconceptions about the tropics, sexuality, civilisation and savagery. The 'European Gauguin' did survive his relocation to Polynesia, and on occasions he painted the women of Tahiti more as native 'types' rather than as individuals; often they are turned away from the viewer in poses reminiscent of Degas.

Gauguin's own complicated background further shaped his thinking. His father had been French, but his mother Peruvian, and Gauguin convinced himself and others that his mother's ancestry was part Inca. This was probably just a family legend, but Gauguin repeated it in his letters. He was seemingly firm in the assertion that his supposedly mixed

81. *Read from right to left, Gauguin's last masterpiece, which was painted as the artist's own health was failing, is a meditation on the stages of life from birth to death.*

blood meant that both the civilised and the savage states existed within him, speaking repeatedly of the conflict within his inner nature. In 1889 he wrote to the art dealer Theo Van Gogh: 'You know I have Indian, Inca blood in me and it comes across in everything I do. It's the basis of my whole character. I'm looking for something more natural to set against the corruption of civilisation, with savagery as my starting point.'[11]

Yet, despite this, many of Gauguin's paintings of Tahitians can be seen as honest accounts of the condition in which he found them, a people in the latter stages of being overwhelmed by the Europe from which Gauguin was attempting temporarily to escape. Despite the vivid colours, there is melancholy and loss in Gauguin's Tahitian paintings. Gauguin did find an escape from the artificiality of Europe, but he found it, unexpectedly, in the Tahitian past. Studying Tahitian history, using books he could easily have procured in Paris, Gauguin encountered the island's myths and legends. He incorporated what he understood of Tahitian mythology and spirituality into his art, fusing Tahitian imagery with visual ideas taken from other parts of the tropics, often to stunning effect.

His last great masterpiece, *D'où venons-nous? Que sommes-nous? Où allons-nous?* (*Where Do We Come From? What Are We? Where Are We Going?*), was completed in late 1897. By then Gauguin had received news of the death of his daughter

Aline back in France and his own health had begun to fail. He lived in near-constant pain and was assailed by his debts. Yet, as the painting amply demonstrated, he remained ambitious and inventive. Painted on sackcloth, stretched over a frame over twelve feet wide, it portrays a line of symbolic figures, both human and animal, some staring at the viewer, others in contemplation. The human figures, all of them Polynesian women or children, range in age from a baby on the right to an old woman on the left. Like a scroll, the painting is meant to be read from right to left. The production of the painting and its intended meanings are clouded by Gauguin's deliberate myth-making, and his own accounts and reported actions have to be read with caution, but it may have been intended as a final artistic statement. In a letter of 1898, after he had allegedly attempted suicide, Gauguin wrote of the painting, 'I believe that this canvas not only surpasses all my preceding ones, but that I shall never do anything better, or even like it.'[12] Gauguin died five years later, in 1903, having relocated to the Marquesas Islands.

TRANSFORMATIONS

To the north of the Champs de Mars and the Eiffel Tower used to stand the Palais du Trocadéro, a relic of an earlier Exposition Universelle, in 1878.[1] It consisted of a large concert hall, famed for its poor acoustics, flanked by two wings. The east wing housed the Musée de Sculpture, the west wing the Musée d'Ethnographie. The latter, almost from its inception, was a troubled institution, with the curators struggling to display adequately their expanding collection of ethnographic objects from across the world. The building itself proved remarkably unsuited to its given purpose, and the museum, starved of funds by the closing years of the nineteenth century, became shabby and dilapidated. It was regarded by many as something of a national embarrassment, and few complained when it was closed down in 1937 and its collections transferred to the Musée de l'Homme.[2] The Musée d'Ethnographie du

82. *One of the African masks that Picasso might have seen during his famous visit to the Musée d'Ethnographie at the Palais du Trocadéro in 1907.*

Trocadéro would be merely a footnote in the history of Paris were it not for a single visit made by a young Spanish artist in the spring of 1907.

Pablo Picasso was as unimpressed by the Musée d'Ethnographie as most other visitors. 'When I went to the Trocadéro,' he later told the novelist and statesman André Malraux, 'it was revolting. Like a flea market. The smell. I was all by myself. I wanted to get out.' The exact date of Picasso's visit is unknown, and the whole affair is shrouded in myth, much of it of Picasso's own making. But there, as he told Malraux, 'It came to me that this was very important: something was happening to me.' [3]

What happened to Picasso at the Trocadéro in 1907 was that he encountered African art, masks and sculptures. He may well have seen examples of African art, those belonging to his rival Henri Matisse, a year earlier at the Paris apartment of the novelist Gertrude Stein. But this all matters because in the spring and summer of 1907 Picasso painted what most art historians consider the most influential and revolutionary painting of the twentieth century, *Les Demoiselles d'Avignon*. The African masks Picasso saw at the Trocadéro have long been regarded as one of the critical influences that flowed to that most radical and disruptive of paintings.

What seems certain is that at that time Picasso had no real interest in the cultural meanings or the ritual functions

of the masks that he saw at the Trocadéro or elsewhere. Although there is evidence that he later collected African sculptures, it is unknown if he ever set out to learn anything of the African societies that had produced them. What Picasso was interested in was their potential for his own art, and it may well have been at that moment at the Trocadéro that he first found – and from outside Europe – the formal inspiration and the expressive power that helped him create *Les Demoiselles d'Avignon.*

The subject of the painting, a brothel scene, was not especially radical or unusual. The title is a reference to an

83. *One of Picasso's preparatory sketch for* Les Demoiselles *showing the two male figures – a sailor and a doctor – who are absent in the finishing painting.*

infamous brothel on Carrer d'Avinyó in Barcelona, and the painting had originally been conceived as an allegory on desire, sexual disease and mortality. Preparatory sketches reveal that Picasso had initially included two male figures: a sailor and a medical student. Only the women remain in the completed painting.

84. Les Demoiselles d'Avignon (1907), *perhaps the most radical, confrontational and influential painting of the twentieth century.*

Picasso shows five naked prostitutes awaiting clients, their bodies formed from a series of broken, disjointed and often jagged planes. Crushed into a compressed space, they gaze out at the viewer with shocking intensity and palpable ferocity. While the faces of the three women to the left in *Les Demoiselles d'Avignon* are believed to have been derived from archaic Iberian sculpture, the two women on the right, their faces strikingly fractured, irregular, asymmetrical and distorted, are thought to have been influenced by the African masks. Despite the seeming clarity of his statements to André Malraux on the matter, Picasso deliberately muddied the waters around *Les Demoiselles d'Avignon* over many years, making a series of contradictory statements. If those distractions are set aside, what can be argued, and often has been, is that African art offered Picasso more than inspiration for his innovations in form and vitality. By channelling Africa into his art, Picasso, consciously and subconsciously, infused *Les Demoiselles d'Avignon* with then powerful ideas about Africa and her people. In his conversation with Malraux, Picasso stated that the masks at the Trocadéro

weren't just like any other pieces of sculpture. Not at all. They were magic things ... they were intercessors, mediators ... They were against everything – against unknown, threatening spirits ... I too believe that everything is unknown, that everything

is an enemy! Everything! Not the details – women, children, animals, tobacco, playing – but the whole of it! I understood what [they] used their sculpture for. Why sculpt like that and not some other way? ... But all the fetishes were used for the same thing. They were weapons. To help people avoid coming under the influence of spirits again, to help them become independent. They're tools. If we give spirits a form, we become independent. Spirits, the unconscious, emotion – they're all the same thing. I understood why I was a painter... *Les Demoiselles d'Avignon* must have come to me that very day, but not at all because of the forms; because it was my first exorcism – painting – yes absolutely![4]

Picasso created faces inspired by African masks that he believed were potent and threatening and then placed those faces on prostitutes, thereby creating a link between two sets of ideas: early twentieth-century colonial preconceptions about racial primitivism, savagery and civilisation, and older anxieties about female sexuality and prostitution. The impact was accentuated by the sheer scale of the canvas: *Les Demoiselles d'Avignon* is eight feet tall. When finally unveiled, the painting was too much even for the other painters of the Paris avant-garde. It was hidden away for almost a decade, yet its eventual impact on those who saw it was seismic, guiding Picasso and Georges Braque towards the revolution that was Cubism.

THE PLUNGE OF EUROPE

For the novelist Henry James the outbreak of the First World War represented not merely the breakdown of international relations but also the dawning of an event so cataclysmic that it repudiated the cult of progress that had propelled the previous century. On 5 August 1914, the day after Britain declared war on Germany and any hopes of a limited war had been brought to an end, James wrote to his friend Howard Sturgis:

> The plunge of civilisation into the abyss of blood and darkness ... is a thing that so gives away the whole long age during which we had supposed the world to be with whatever abatement gradually bettering, that to have to take it all now for what the treacherous years were all the while really making for meaning is too tragic for my words.[1]

Two days later James wrote to another friend of 'our murdered civilisation'.[2] Then, on 10 August, he penned a

sorrowful and somewhat self-pitying letter to the Welsh novelist Rhoda Broughton:

> Black and hideous to me is the tragedy that gathers, and I'm sick beyond cure to have lived on to see it. You and I, the ornaments of our generation, should have been spared this wreck of our belief that through the long years we had seen civilisation grow and the worst become impossible. The tide that bore us along was then all the while moving to this grand Niagara – yet what a blessing we didn't know it. It seems to me to undo everything, everything that was ours, in the most horrible retroactive way.[3]

Before the trenches of the Western Front had been dug, before chlorine gas and unrestricted submarine warfare, before the Somme and Verdun, the novelist understood what the politicians at that point did not: that this great war was a great rupture. Henry James was later to recover some of his optimism and even reassemble his sense of artistic purpose, but his initial assessment was prescient. Only when all predictions of easy victories and of armies returning home by Christmas had been proved wrong did a generation of European statesmen – members of one of the most educated and privileged elites in history – see what Henry James had recognised in the very first days of the war.

The barbarism of 1914 and the years that followed were a devastating rebuttal of the theory of inevitable

and irreversible progress that had infused the intellectual atmosphere of Europe in the nineteenth century. One effect of the cult of progress was that it had externalised savagery and barbarism. Africa, in particular, had become what the novelist Chinua Achebe later called 'the antithesis of Europe and therefore of civilisation.'[4] The totemic power of the African masks Picasso viewed at the Musée d'Ethnographie du Trocadéro in 1907 stemmed not just from their radical and dynamic form but also from the fact that they were symbols of the supposed inner savagery of a continent that Europeans had come to regard as the 'Heart of Darkness': Europe's mirror image. It was for such reasons that in the years leading up to 1914 African masks became objects of enormous curiosity. In 1915, on the Western Front, a new type of warfare, industrial and total, exposed the countenance of Europe's own latent barbarism. The gas mask, newly invented and rapidly evolving, became the face of that underlying inner savagery.

In the hands of the German painter Otto Dix, perhaps the greatest of the many unofficial war artists, the gas mask became a symbol for the historical rupture that his doomed generation was destined to witness. In 1914 Dix was one of the millions of young European men who enthusiastically rushed to enlist at the outbreak of war.[5] He is said to have marched into battle with the Bible and a book of Nietzsche's philosophy in his backpack. For three years he fought and

subsisted in the mud and the slime of the trenches, serving on both the Western and the Eastern Fronts. For some of his time he served in a machine-gun unit, wielding the ultimate industrial weapon – the literal fusion of the gun and the machine. It was the weapon that turned the age of the machine, which had begun in the mills and factories of England in the eighteenth century, against the bodies of its inventors' great-grandchildren. It was a weapon that, until then, had only been used on the supposedly uncivilised peoples of the colonies, returned to its home continent.

Throughout his war service Dix produced hundreds of sketches. Some were drawn directly on the many postcards he dispatched home. His images graphically recorded what the new weapons did to flesh and bone. He drew the broken faces and decaying putrid corpses. He chronicled in detail how industrial warfare transformed the soldier from warrior to victim, how it de-skilled combat, making it random and chaotic. Dix wrote of the duty he felt to 'bear witness' to the war, yet simultaneously he served with enthusiasm. During the war and afterwards he believed that, for all its horrors, the conflict delivered experiences and insights that would have remained beyond his reach in normal civilian life. In old age he admitted:

The war was a horrible thing but there was something tremendous about it, too. I didn't want to miss it at any price.

You have to have seen human beings in this unleashed state to know what human nature is. I need to experience all the depths of life for myself, that's why I go out, and that's why I volunteered.[6]

Although his work was used by anti-war campaigners, Dix himself was never a pacifist.

In 1924, during a year of anniversaries and international remembrance, Dix produced his print cycle *Der Krieg*, a series of fifty-one images that offer a fragmentary narrative

85. One of the fifty prints from Otto Dix's portfolio Der Krieg showing storm troopers advancing on an enemy position. Although Dix sketched while the trenches, Der Krieg was based on the memories of war that haunted him in the years after.

of the lives of the front-line soldiers and that has been compared to Goya's great series *The Disasters of War*. In Dix's work isolated traumatic incidents were set alongside moments of everyday drudgery. In the most famous, *Sturmtruppe geht unter Gas vor* (*Storm Troops Advance under Gas Attack*), five German soldiers are depicted in the moment of a frontal attack on an enemy trench. Their faces are concealed by the primitive gas masks of the earlier war years. The landscape through which they emerge is otherworldly, rendered opaque by smoke and toxic gas; only the blasted stumps of trees are visible through the gloom.

Dix presented the barbarism of the front in stark and brutal honesty, but without judgement or political intent. His was the artistic voice of a man who remained proud to have been a soldier and determined that the sufferings of his comrades be remembered. But, for all his Nietzschean lust for experience, he was also a man who wrote of his art as a form of exorcism of the war from his dreams and visions.[7] Critically, *Der Krieg* was based not on the sketches Dix had drawn during the war but largely on the memories that had troubled him in the years since.

His ultimate statement on his years in the trenches was the painting known as *Triptychon Der Krieg*. It was begun in 1929 and slowly refined until its completion in 1932, with multiple alterations being made and certain visual elements abandoned as the work become ever simpler and ever more

stark. It was inspired by the extraordinarily rich tradition of the triptych in German Renaissance art and is loaded with religious iconography. The narrative plays out from daybreak to dusk, and the action moves from left to right. In the left-hand panel German soldiers march through the smoke, under a blood-red morning sky, towards the battlefield. Their steel helmets glint as they catch the light. The central panel, the most powerful and the most laden with allegory, presents the wasteland of the Western Front, and makes reference to an earlier work, *The Trench* (1923).

The front line, and the war-torn land around it, appear as a great putrid scar of mud and decaying flesh, cut across the face of Europe. The figures of the dead dominate the panel. The skeletal form of a dead soldier leers over the battlefield. Another, caught on the barbed wire, is a nod to the Crucifixion, except his body is inverted. The ghastly, bullet-riddled legs, a visual quotation of the Christ figure in Matthias Grünewald's *Isenheim Altarpiece* (1516), point upwards. An outstretched hand has a bullet hole through his palm.

In 1917 the *Isenheim Altarpiece* had been transported from the formerly French province of Alsace-Lorraine to Munich and there became the subject of enormous levels of fascination and nationalistic passion. Its return to France by a defeated Germany in 1919 added to the sacred aura that surrounded Grünewald's masterpiece, symbolic both

86. *The monumental triptych* The War
(Der Krieg), *held at Galerie Neue
Meister in Dix's home town of Dresden,
is the artist's ultimate statement on
the war. Three years in the making,
it recalls and subverts the Medieval
German tradition of triptychs and
altarpieces.*

of the human cost of the war and of Germany's defeat.[8] The living figures in the central panel of Dix's triptych lurk anonymously at the back of the trench or huddle under corrugated iron sheeting wearing gas masks, the war's first prosthesis. In the right-hand panel the results of battle are made manifest. A soldier drags a wounded comrade from the battlefield. His face is that of Dix himself, a self-portrait fixed with a traumatised and haunted expression. At his own feet Dix painted another survivor, who crawls over the torn and broken bodies of his dead comrades.

The triptych was exhibited in 1932 to little comment, and then placed in storage. A year later, after the passing of the infamous Enabling Act in March 1933, the Nazis began their assault on what they regarded as 'degenerate art'. Otto Dix, despite his war service and his enormous talent, was dismissed from his teaching post at the Dresden Academy of Fine Arts. Paintings by Dix were among those later destroyed by the Nazis.

The enemies of Otto Dix, the soldiers of the victorious Entente powers, whom he had faced across no man's land for three years, were awarded a service medal at the end of the war. The soldiers, sailors and airmen who survived the carnage each received the Inter-Allied Victory Medal, almost 6 million of which were struck in bronze. On the front was the winged figure of Victory, an allusion to classical mythology. On the reverse was a simple inscription

encircled by laurels. Despite the mechanised slaughter that had killed 22 million people, brought down ancient empires and bankrupted nations, the inscription read, with no sense of irony: 'The Great War for Civilisation 1914–1918'.

AFTERWORD

During the summers of the 1970s and 80s my mother would take me and my siblings to the British Museum. There we would explore the whole array of cultural treasures on display but as a family we made a particular point of going to see the Benin Bronzes, which at that time were installed on a large landing of a main staircase. My mother's ambition was to ensure that her mixed-race, half-Nigerian children had access to the art and culture of both sides of their background and there, in front of the masterpieces of sixteenth- and seventeenth-century Benin, we felt kinship with our African forefathers, with the craftsmen who had created these incredible plaques that once decorated the royal palace of the Oba. Photographs of Benin art hung in frames on the walls of our council house and the knowledge that our African ancestors, as well as our European ones, had created great art and formed sophisticated civilisations was a truth that I cannot recall ever not knowing.

My appreciation and love for the art and culture of Europe was primarily acquired not through visits to museums and

galleries, however, but was gifted to me by another medium – television. My personal epiphany came on 12 February 1986 when my mother made me watch a documentary on BBC 2 called *Artists and Models*. Over the space of sixty minutes I consumed the art and the incredible life of Jacques-Louis David, the master of French Neo-Classicism. I was enthralled. With the fanaticism of a new convert, I began to borrow books on art from the nearby library. As *Artists and Models* had been as much about history as art my passion for both was ignited, and my youthful and all too boyish obsession with World War Two waned.

Two years later, having worked in shops at weekends and during school holidays, I had saved up enough money to go travelling across Europe. As well as lying on beaches and meeting up with friends, I visited the great art galleries in all the cities I passed through. At eighteen I stood in the Louvre in front of the paintings I had seen on the BBC. On *Artists and Models* a contemporary writer had said the paintings of Jacques-Louis David's were so austere that a cold wind could almost be felt blowing out from his canvases. I recall standing in front of David's *Oath of the Horatii* hoping to feel that icy blast on my cheeks. The idea that art was going to be part of my life was new and exciting, a wonderful gift bestowed by my mother's careful efforts to inspire. After Paris I went to Amsterdam and to the Rijksmuseum where I saw for the first time the works of Rembrandt, Vermeer,

Frans Hals and the other Dutch Masters. Next came Madrid and the Museo del Prado where I was exposed to Titian, El Greco, Picasso, Velázquez and Hieronymus Bosch. In the gift shop at the Prado I bought a reproduction of Bosch's *The Garden of Earthly Delights*. It was an object I could ill afford, and I treasured it for many years, hanging it on the wall of every student room.

The spark that changed my life had reached me through the thick screen of our boxy, rented television, more than thirty years ago. Not that I knew it at the time, the television documentaries that I watched were part of a tradition that had been given shape and momentum by a series broadcast the year before my birth. Kenneth Clark's thirteen-part series *Civilisation* is part of television legend, both in Britain and the United States. The series changed lives for many of the millions who watched it, just as *Artists and Models* later did for me. Colour television had been introduced in Britain just two years earlier and the colour sets needed to truly appreciate the series were rare. Households wealthy enough to have been able to afford one threw '*Civilisation* parties', inviting friends who would otherwise have had to contemplate the wonders of European art in black and white. For thirteen consecutive weeks, with Kenneth Clark as their guide, audiences were transported to 117 locations. During those three months, curators of art galleries and museums reported an increase in visitor numbers. Later,

during the summer of 1969, there were reports of a boom in tourist numbers, as thousands of people travelled to France, Italy and elsewhere to visit galleries and see for themselves the masterpieces of art and architecture that Kenneth Clark had brought to their living rooms.

This book accompanies a television series inspired by *Civilisation*. Almost fifty years after it was broadcast Kenneth Clark's series remains famous, and rightly so. Yet *Civilisation* is famous not just for the unprecedented impact it had on those who watched it but also for the narrowness of its focus. It told the story only of European art and culture, predominantly that of Italy and France. Filming took place in a mere eleven countries. Germany played a supporting role in the narrative. Britain had only a bit part. The art of Spain was omitted completely, causing genuine offence in Madrid. Kenneth Clark should, of course, not be judged on one series alone. In his expansive writings he displayed a world view that was far broader; he was a lifelong champion of Japanese art for example. Yet even on the page, art for Clark remained a mostly male pursuit. The lack of female artists in *Civilisation* is striking to modern viewers.

Clark was inspired to take part in the series when the word 'civilisation' was used at the BBC meeting to which he had been invited. It was that word, above all other considerations, that fired his imagination and inspired him to become the presenter and author of the project. In the

very first scene of the series Clark famously toyed with the meaning of the word. Stood in front of the Notre-Dame Cathedral he playfully asked 'What is civilisation? I don't know ... but I think I can recognise it when I see it.'

Clark could be less hesitant when making judgements about the various civilisations of the world or the cultural imaginations of the peoples who had forged them. In the book he wrote to accompany the series a passage appears that is not in the broadcast script of the programme. Comparing an African mask that had belonged to critic and Bloomsbury artist Roger Fry to the head of the Apollo Belvedere, Clark wrote,

> Whatever its merits as a work of art, I don't think there's any doubt that it [the Apollo Belvedere] embodies a higher state of civilisation than the mask. They both represent spirits, messengers from another world – that is to say, from a world of our own imagining. To the Negro imagination it is a world of fear and darkness, ready to inflict horrible punishment for the smallest infringement of a taboo. To the Hellenistic imagination, it is a world of light and confidence, in which Gods are like ourselves, only more beautiful, and descend to earth to teach men reason and the laws of harmony.

It might be said that Clark's phrase the 'Negro imagination' was a throwaway line used by a man born in the Edwardian age. That might well be so. But it was because she understood how the idea of civilisation had

been used against their father's ancestors that my mother took her half-African children to stand in front of the Benin Bronzes so many summers ago. It was because the concept of the 'Negro imagination', supposedly impoverished and primitive when compared to that of Europeans, was still prevalent in the Britain I grew up in that we, as children, were armed and armoured against such concepts, through visits to the British Museum and exposure to the writings of African authors.

In this short book and in the two films it accompanies, I have attempted to explore the role art played in the moments of contact, interaction and conflict that I believe have been defining features of the past half millennium. I have done so not in riposte to Kenneth Clark, an enormously significant cultural figure whom I admire, but to remind myself and those who might be interested, that there is a single human imagination, of which all art is a product.

NOTES

Victorian Disbelief

1 Quoted in Robert Home, *City of Blood Revisited: A New Look at the Benin Expedition of 1897* (1982), p. 100.
2 Quoted in Tiffany Jenkins, *Keeping Their Marbles: How the Treasures of the Past Ended Up in Museums –and Why They Should Stay There* (2016), p. 141.
3 Hans-Joachim Koloss, *Art of Central Africa: Masterpieces from the Berlin Museum für Völkerkunde* (1990), p. 21.
4 Annie E. Coombes, *Reinventing Africa: Museums, Material Culture, and Popular Imagination in Late Victorian and Edwardian England* (1994), p. 46.
5 Ibid., p. 38.
6 Kate Ezra, *Royal Art of Benin: The Perls Collection in the Metropolitan Museum of Art* (1992), p. 117.
7 There may originally have been four masks of Queen Mother Idia.

A Mariner Nation

1 Jerry Brotton, *The Renaissance Bazaar: From the Silk Road to Michelangelo* (2002), p. 168.
2 Juan Pimentel, *The Rhinoceros and the Megatherium: An Essay in Natural History* (2017), p. 88.
3 T. H. Clarke, *The Rhinoceros from Dürer to Stubbs, 1515–1799* (1986), p. 20.
4 L. C. Rookmaaker and Marvin L. Jones, *The Rhinoceros in Captivity: A list of 2439 Rhinoceroses Kept from Roman Times to 1994* (1998), p. 80.
5 Annemarie Jordan Gschwend and K. J. P. Lowe (eds.), *The Global City: On the Streets of Renaissance Lisbon* (2015), p. 61. Some estimates put this figure at 20 per cent.

6 T. F. Earle and K. J. P. Lowe (eds.), *Black Africans in Renaissance Europe* (2005).

7 Gschwend and Lowe, *The Global City*, p. 23.

8 Ibid., p. 73.

9 Ibid., p. 72.

10 Ibid., p. 164.

Invaders and Looting

1 Michale W. Cole and Rebecca Zorach (eds.), *The Idol in the Age of Art: Objects, Devotions and the Early Modern World* (2009), p. 21.

2 The Nahua tribes of the Mexico Valley did not refer to themselves as the Aztec, but for ease I have used that term here to describe them and their civilisation.

3 Hugh Thomas, *Rivers of Gold: The Rise of the Spanish Empire* (2003), p. 417.

4 Susan E. Alcock et al (eds.), *Empires: Perspectives from Archaeology and History* (2001), p. 284.

5 Quoted in Donald R. Hopkins, *The Greatest Killer: Smallpox in History* (2002), p. 206.

6 Wolfgang Stechow (ed.), *Northern Renaissance Art, 1400–1600: Sources and Documents* (1966), p. 100.

7 Colin McEwan et al., *Turquoise Mosaics from Mexico* (2006), p. 58.

8 See Colin McEwan, *Ancient American Art in Detail* (2009).

9 Jonathan Israel, *Race, Class and Politics in Colonial Mexico 1610–1670* (1975), p. 8.

10. Serge Gruzinski, *Painting the Conquest: The Mexican Indians and the European Renaissance* (1992), p. 24.

Keeping an Eye on Culture

1 Olof G. Lidin, *Tanegashima: The Arrival of Europe in Japan* (2002), p. 1.

2 Sometimes spelled *harquebuse*.

3 Donald F. Lach, *Asia in the Making of Europe, Volume I: The Century of Discovery* (1965), p. 655.

4 Holden Furber, 'Asia and the West as Partners before "Empire" and After', in *Journal of Asian Studies*, Vol. 28, No. 4 (Aug 1969), pp. 711–21.

5 James L. McClain, *Japan: A Modern History* (2002), p. 44.

6 Ross E. Dunn, Laura J. Mitchell and Kerry Ward (eds.), *The New World History: A Field Guide for Teachers and Researchers* (2016), p. 508.

7 Kwame Anthony Appiah and Henry Louis Gates (eds.), *Africana: The Encyclopedia of the African and African American Experience* (2005), p. 497.

8 Kotaro Yamafune, *Portuguese Ships on Japanese Namban Screens*, unpublished MA thesis (Texas A&M University) (2012), p. 7.

9 Ibid., p. 96.

10 Charles Ralph Boxer, *The Christian Century in Japan: 1549–1650* (1974), p. 29.

11 Ibid., p. 1.

12 McClain, *Japan*, p. 43.

13 Michael Sullivan, *The Meeting of Eastern and Western Art: From the Sixteenth Century to the Present Day* (1973), p. 14.

14 Adam Clulow, *The Company and The Shogun: The Dutch Encounter with Tokugawa Japan* (2014), p. 262.

15 Ibid., p. 260.

16 Timon Screech, *The Lens within the Heart: The Western Scientific Gaze and Popular Imagery in Later Edo Japan* (2002), p. 119.

Embracing the New

1 Anthony Bailey, *A View of Delft: Vermeer Then and Now* (2001), p. 26.

2 The original seventeen provinces that rebelled in 1568 also included what are today Belgium and Luxembourg, as well as regions of northern France and western Germany. Only the seven northern provinces won their independence from Habsburg Spain.

3 Letter to Guez de Balzac, 5 May 1631, quoted in Fernand Braudel, *Civilization and Capitalism, 15th–18th century, Vol. III: The Perspective of the World* (1984), p. 30.

4 Timothy Brook, *Vermeer's Hat: The Seventeenth Century and the Dawn of the Global World* (2010), p. 8.

5 Simon Schama, *The Embarrassment of Riches: An Interpretation of Dutch Culture in the Golden Age* (1987), p. 160.

6 For a description of Willem Kalf's *Still-Life with a Nautilus Cup* (1644), see Norman Bryson, 'Chardin and the Text of Still Life', in *Critical Inquiry*, Vol. 15, No. 2 (Winter, 1989), pp. 227–35.

7 Quoted in Charles Ralph Boxer, *The Dutch Seaborne Empire, 1600–1800* (1965), p. 42.

8 James C. Boyajian, *Portuguese Trade in Asia under the Habsburgs, 1580–1640* (2008), p. 150.

9 Brook, *Vermeer's Hat*, p. 42.

10 Ibid., p. 55.

11 J. L. Price, *The Dutch Republic in the Seventeenth Century* (1998), p. 5.

12 Londa Schiebinger, *Plants and Empire: Colonial Bioprospecting in the Atlantic World* (2004), p. 107.

Acts of Empire

1 Joseph Farington, *The Farington Diary*, Vol. 3, 15 December 1804 (1924), p. 34.

2 Kathrin Wagner, Jessica David and Matej Klemenčič (eds.), *Artists and Migration 1400–1850: Britain, Europe and Beyond* (2017), p. 150.

3 Toby Falk, 'The Fraser Company Drawings', *RSA Journal*, Vol. 137, No. 5389 (December 1988), pp. 27–37.

4 Durba Ghosh, *Sex and the Family in Colonial India: The Making of Empire* (2006), p. 40.

5 William Dalrymple, *White Mughals: Love and Betrayal in Eighteenth-century India* (2002), p. 32.

6 Griselda Pollock, 'Cockfights and Other Parades: Gesture, Difference and the Staging of Meaning in Three Paintings by Zoffany, Pollock, and Krasner', *Oxford Art Journal*, Vol. 26, No. 2 (2003), p. 155.

7 Maya Jasanoff, 'A Passage through India: Zoffany in Calcutta and Lucknow', in *Johan Zoffany, RA: Society Observed*, Martin Postle (ed.) (2011), p. 137.

8 Ibid., p. 137.

9 Dalrymple, *White Mughals*, p. 268.

10 Ghosh, *Sex and the Family in Colonial India*, p. 40.

11 Zareer Masani, *Macaulay: Britain's Liberal Imperialist* (2013), p. 99.

The Lure of the Pharaohs

1 Richard Wellesley landed in Calcutta on 17 May; the Toulon fleet embarked in the early hours of 9 May.

2 John Bagot Glubb, *Soldiers of Fortune: The Story of the Mamlukes* (1973), p. 480.

3 Darius A. Spieth, *Napoleon's Sorcerers: The Sophisians* (2007), p. 41.

4 A phrase used by Professor Kwame Anthony Appiah in his 2016 BBC Reith Lectures.

5 Spieth, *Napoleon's Sorcerers* (2007), p. 47.

6 Quoted in Juan Cole, *Napoleon's Egypt: Invading the Middle East* (2007), p. 16.

7 Edward W. Said, *Orientalism* (1978), p. 81.

8 Paul Strathern, *Napoleon in Egypt: 'The Greatest Glory'* (2007), p. 258.

9 Said, *Orientalism*, p. 81.

10 Michael Curtis, *Orientalism and Islam: European Thinkers on Oriental Despotism in the Middle East and India* (2009), p. 12.

11 Darcy Grimaldo Grigsby, *Extremities: Painting Empire in Post-Revolutionary France* (2002), p. 66.

Revolution in the Midlands

1 P. M. G. Harris *The History of Human Populations, Vol 2: Migration, Urbanization, and Structural Change* (2003), p. 226.
2 Ibid.
3 Quoted in Ann Bermingham, *Landscape and Ideology: The English Rustic Tradition, 1740–1860* (1986), p. 80.

The City and the Slum

1 Alfred Russel Wallace, *The Wonderful Century: Its Successes and Its Failures* (1898), p. 338.
2 Quoted in Franny Moyle, *The Extraordinary Life and Momentous Times of J. M. W. Turner* (2016), pp. 631–2.
3 Charles Dickens, *The Old Curiosity Shop* (1841), p. 242.
4 John Ruskin, *Notes by John Ruskin on His Drawings by J. M. W. Turner, R.A., Exhibited at the Fine Art Society's Galleries, 1878 & 1900* (1900), p. 34.
5 John Lucas, *The Literature of Change: Studies in the Nineteenth Century Provincial Novel* (2016), p. 40.
6 Shirley Foster, *Elizabeth Gaskell: A Literary Life* (2002), p. 35.
7 Elizabeth Gaskell, *Mary Barton: A Tale of Manchester Life* (1848), vol. 1, p. 90.

The American Wilderness

1 While the works of the male painters are proudly on display in national and state galleries, the works of the female members of the school are largely forgotten, lost or in private collections. The paintings of Harriet Cany Peale, Mary Blood Mellen, Laura Woodward, Josephine Walter and Sarah Cole, Thomas's sister, proved of little interest to their contemporaries.

2 Carrie Rebora Barratt in *Art and the Empire City: New York, 1825–1861* (2000), pp. 60–61.

The Course of Empire

1 David Schuyler, *Sanctified Landscape: Writers, Artists, and the Hudson River Valley, 1820–1909* (2012), p. 40.
2 Louis Legrand Noble, Elliot S. Vesell (eds.), *The Life and Works of Thomas Cole* (1997), p. xii.
3 John Hay, *Post-apocalyptic Fantasies in Antebellum American Literature* (2017), p. 103.
4 Schuyler, *Sanctified Landscape*, p. 39.

The Theft of Identity

1 Stephanie Pratt and Joan Carpenter Troccoli, *George Catlin: American Indian Portraits* (2013), pp. 18–21.
2 H. Glenn Penny, *Kindred by Choice: Germans and American Indians since 1800* (2013), pp. 49–50.
3 George Catlin, *Letters and Nates on the Manners, Customs, and Conditions of the North American Indians* (1841), p. 3.

Portraits for Posterity

1 Edward Markham, *New Zealand, or Recollections of It* (1963), p. 83.
2 Michael King, *The Penguin History of New Zealand* (2003), p. 272.
3 Ngahiraka Mason and Zara Stanhope (eds.), *Gottfried Lindauer's New Zealand: The Māori Portraits* (2016), p. 41.
4 Ngahiraka Mason, *Gottfried Lindauer's New Zealand: The Māori Portraits* (2016), p. 35.
5 Ibid, p. 33.
6 Dominique de Font-Réaulx, *Painting and Photography: 1839–1914* (2012), pp. 157–8.
7 Robert L. Herbert *Impressionism: Art, Leisure, and Parisian Society* (1988), p. 28.

8 Elizabeth Anne Maxwell, *Colonial Photography and Exhibitions: Representations of the Native and the Making of European Identities* (2000), p. 1.

The Advent of the Camera
1 Some sources suggest it was a set of ornate mirrors that had failed to find their way to Café Volpini.

An Artistic Response to Progress
1 James Patrick Daughton, *An Empire Divided: Religion, Republicanism, and the Making of French Colonialism, 1880–1914* (2008), p. 3.

An Exotic Escape
1 Elizabeth Anne Maxwell, *Colonial Photography and Exhibitions: Representations of the Native and the Making of European Identities* (2000), p. 1.
2 It was also hoped that the colonial pavilions would encourage an increase in French emigration to the colonies.
3 By the 1880s the rise of forms of social Darwinian racism had added darker strands to French thinking about its empire and the futures of its colonial subjects.
4 Elazar Barka and Ronald Bush (eds.), *Prehistories of the Future: The Primitivist Project and the Culture of Modernism* (1996), p. 226.
5 Robert Wokler, *Enlightenment and Modernity* (1999), p. 11.
6 Quoted in Stephen F. Eisenman, *Gauguin's Skirt* (1997), p. 201, and Ronnie Mather, 'Narcissistic Personality Disorder and Creative Art – The Case of Paul Gauguin', *PSYART Journal* (2007).
7 Elazar Barkan and Ronald Bush (eds.), *Prehistories of the Future: The Primitivist Project and the Culture of Modernism* (1996), p. 226.
8 Claire Moran, *Staging the Artist: Performance and the Self-Portrait from Realism to Expressionism* (2016), pp. 42–3.

9 Albert Boime, *Revelation of Modernism: Responses to Cultural Crises in Fin-de-Siècle Painting* (2008), p. 143.

10 Five such events were held in Paris between 1855 and 1900.

11 The collection has since moved again to the Musée du Quai Branly.

12 Wayne Andersen, *Picasso's Brothel* (2002), p. 62.

Transformations

1 Wayne Andersen, *Picasso's Brothel* (2002), p. 62.

2 L. C. Knights, *Selected Essays in Criticism* (1981), p. 181.

3 Ibid, p. 181.

4 Dietmar Schloss, *Culture and Criticism in Henry James* (1992), p. 122.

The Plunge of Europe

1 Lionel Charles Knights, *Selected Essays in Criticism* (1981), .p. 181.

2 Ibid., p.181.

3 Dietmar Schloss, *Culture and Criticism in Henry James* (1992), p. 122.

4 Chinua Achebe, *An Image of Africa: Racism in Conrad's* Heart of Darkness (1977), p. 3.

5 The sources are contradictory on this.

6 Otto Dix, interview, December 1963, quoted in Bernd-Rüdiger Hüppauf, *War, Violence, and the Modern Condition* (1997), p. 242.

7 Linda F. McGreevy, *Bitter Witness: Otto Dix and the Great War* (2001), p. 201.

8 See Ann Stieglitz, 'The Reproduction of Agony: Toward a Reception-History of Grünewald's Isenheim Altar after the First World War', *Oxford Art Journal*, vol. 12, no. 2 (1989), p. 93.

9. Eva Karcher, *Dix* (1987), p. 1.

CE

| 1450 | 1500 | 1600 | 1700 |

Britain

East India
Company
established
(1600)

Calcutta
Founded
(1686)

France

Rest of the World

Vasco de Gama
reaches India
(1498)

Columbus
reaches America
(1492)

Dürer's
Rhinoceros
(1515)

Cortés destroys
Tenochtitlán (1521)

Portuguese
reach Japan
(1543)

"Florentine Codex"
(1579)

El Greco's
Disrobing of Christ
(1579)

Dutch East India
Company established
(1602)

Japanese
"Seclusion Edicts"
(1633–39)

Johannes Vermeer
(1632–1675)

Maria Merian
travels to Surinam
(1699)

1700	1800	1900	1950

Johan Zoffany in India (1783–1789)

Turner visits Dudley (1830)

Government House Calcutta (1803)

Treaty of Waitangi (1840)

Tipu Sultan killed in battle (1799)

Elizabeth Gaskell's *Mary Barton* (1848)

Benin Expedition (1897)

Industrial Revolution (*c.* 1750–1850)

⟵—————⟶

Description De L'Égypte (1809–1820)

Exposition Universelle Paris (1889)

First Daguerreotype photograph (1838/9)

Gauguin moves to Tahiti (1895)

French Revolution (1789)

Hausmann begins renovation of Paris (1853)

Picasso's *Les Desmoiselles D'Avignon* (1907)

Napoleon invades Egypt (1798)

Manet's *Bar at the Folies-Bergère* (1882)

Lisbon earthquake (1755)

Thomas Cole (1801–1848)

Otto Dix *Der Krieg* (1924)

Maruyama Ōkyo *Cracked Ice* (*c.* 1780)

Indian Removal Act (1830)

ACKNOWLEDGEMENTS

Every creative endeavour I have ever embarked upon has drawn upon the talents of many people. In their own different ways both television documentaries and books are products of collaboration and discussion. On a project of such a scale and ambition of *Civilisations* that truism has been amplified and accentuated. I'd therefore like to thank my fellow presenters Simon Schama and Mary Beard. From the BBC I would like to give special thanks to Janice Hadlow and offer my sincere gratitude to Mark Bell and Jonty Claypole.

The remarkable team at Nutopia who realised this ambitious project was led by Denys Blakeway, Michael Jackson and Mel Fall. I would also like to thank Jane Root. The producer whose endless hard work and insight made my films possible was Ian Leese who worked with talented colleagues Ewan Roxburgh, Isabel Sutton, Joanna Marshall, Jenny Wolf and Laura Stevens. I am also grateful to Matt Hill. Thanks too to the brilliant series consultants Julian Bell and Jonathan Jones, from whom I have learned much. The visual impact of the television series was the work of camera operators Johann Perry, Duane McLunie, Dirk Nel, Rewa Harré and Richard Numeroff. The finished films also owe much to the composing talents of Tandis Jenhudson.

Further thanks go to everyone at Profile Books: Penny Daniel for her patience and belief, Andrew Franklin for making this project possible, and my publicist Valentina Zanca; and to designer James Alexander at Jade Design and Lesley Hodgson for great picture research.

I am grateful, as always, to my agent Charles Walker. Finally, I would like to thank my family for tolerating absences and giving support.

LIST OF ILLUSTRATIONS

1. First Contact: 1. Benin relief plaque © The Trustees of The British Museum; 2. Oba Ovonramwen © The Trustees of The British Museum; 3. Photograph of Benin Expedition © The Trustees of The British Museum; 4. David Olusoga at the British Museum © BBC/Nutopia; 5. Portuguese soldier figure, Edo © The Trustees of The British Museum; 6. Carved ivory mask © The Trustees of The British Museum; 7. *The Rhinoceros* (1515), by Albrecht Dürer © Sterling and Francine Clark Art Institute, Williamstown, Massachusetts, USA / Bridgeman Images; 8. *The King's Fountain* (*Chafariz d'el Rey*) *c.*1570–80, artist unknown © akg-images; 9. Carved ivory salt cellar © Lebrecht Music and Arts Photo Library / Alamy Stock Photo; 10. Drawing from the Florentine Codex, Book XII by Bernardino de Sahagún *c.*1540–85 © Granger, NYC/TopFoto; 11. *The Taking of Tenochtitlán by Cortes*, seventeenth century, artist unknown © Spanish School/Getty Images; 12. Aztec calendar stone © Universal History Archive/UIG / Bridgeman Images; 13. Mosaic of a double-headed serpent © The Trustees of The British Museum; 14. Ms Palat. 218–220 Book IX Aztec musicians from the Florentine Codex by Bernardino de Sahagún *c.*1540–85 © Biblioteca Medicea-Laurenziana, Florence, Italy / Bridgeman Images; 15. Ms Palat. 218–220 Book IX Aztecs from the Florentine Codex by Bernardino de Sahagún *c.*1540–85 © Biblioteca Medicea-Laurenziana, Florence, Italy / Bridgeman Images; 16. Still from *Spectre*, 2015 © Columbia Pictures/ Jonathan Olley/ Courtesy Everett Collection/Alamy Stock Photo; 17. *The Crucified Christ with Toledo in the Background* (1613), by El Greco © akg-images; 18. *View of Toledo* (1597–9), by El Greco © H. O. Havemeyer Collection, Bequest of Mrs. H. O. Havemeyer, 1929 / Metropolitan Museum of Art, New York, USA 29.100.6; 19. Namban screen, School of Kanō Naizen, *c.*1606 © Museu Nacional de Arte Antiga / Luisa Oliveira / José Paulo Ruas, 2015 / Direção-Geral

do Património Cultural / Arquivo de Documentação Fotográfica (DGPC/ADF); 20. Detail of Japanese namban screen, *c*.1600 © Granger Historical Picture Archive / Alamy Stock Photo; 21. Two young women with a picture viewer, *c*.1750 by Suzuki Harunobu: Courtesy Wikimedia Foundation; 22. Hanging Scroll (pair of pheasants), *c*.1750–95 by Maruyama Ōkyo © Archivart / Alamy Stock Photo; 23. *Cracked Ice* (*c*.1750–95), by Maruyama Ōkyo © The Trustees of The British Museum; 24. Fantasy Interior with Jan Steen and the Family of Gerrit Schouten, *c*.1659–60 by Jan Steen: Courtesy Wikimedia Foundation; 25. *The Night Watch* (1642), by Rembrandt can Rijn © On loan from the City of Amsterdam/Rijksmuseum, Amsterdam; 26. *Banquet Still Life* (1644), by Adriaen van Utrecht © On loan from the City of Amsterdam (A. van der Hoop Bequest)/ Rijksmuseum, Amsterdam; 27. Delft blue tiles © Peter Horree / Alamy Stock Photo; 28. *Officer and Laughing Girl* (1660), by Johannes Vermeer © akg-images; 29. *Girl Reading a Letter by an Open Window* (1659), by Johannes Vermeer © Painting / Alamy Stock Photo; 30. *Insects of Surinam* (1705), by Maria Sibylla Merian © The Natural History Museum / Alamy Stock Photo; 31. Market scene, Patna, 1850, Shiva Dayal Lal © Victoria and Albert Museum, London; 32. *Colonel Mordaunt's Cock Match* (*c*.1784–6) by Johan Zoffany © Tate, London 2017; 33. An artist, thought to be Ghulam Ali Khan (1825) © akg-images / Pictures From History; 34. *The Last Supper* (1787), by Johann Zoffany © ephotocorp / Alamy Stock Photo; 35. South West View of Government House, Calcutta © Gilman Collection, Purchase, Cynthia Hazen Polsky Gift, 2005 /Metropolitan Museum of Art, New York, USA 2005.100.491.1 (15b).

2. Cult of Progress: 36. David Olusoga in Egypt © BBC/Nutopia; 37. *The Slave Market* (1866), by Jean Leon Gerome © Sterling and Francine Clark Art Institute, Williamstown, Massachusetts, USA / Bridgeman Images; 38. Interior of a Weaver's Workshop, from Volume II Arts and Trades of *Description of Egypt* © Private Collection /

The Stapleton Collection / Bridgeman Images; 39. Temple Portico of Esna, engraving from *Description of Egypt* © De Agostini Picture Library / G. Dagli Orti / Bridgeman Images; 40. *Napoleon Bonaparte visiting the Plague Victims of Jaffa, 11 March 1799* (1804), by Antoine Jean Gros © Leemage/Corbis via Getty Images; 41. *The Women Of Algiers In Their Apartment* (1834), by Eugène Delacroix © Fine Art Images/Heritage Images/Getty Images; 42. *The Iron Forge* (1772), by Joseph Wright of Derby © Broadlands Trust, Hampshire, UK / Bridgeman Images; 43. *Arkwright's Cotton Mills by Day* (1795–6), by Joseph Wright of Derby © Derby Museum and Art Gallery, UK / Purchased with assistance from the Heritage Lottery Fund, the Art Fund (with a contribution from The Wolfson Foundation), the V&A Purchase Grant Fund, and the Friends of Derby Museums / Bridgeman Images; 44. *An Experiment on a Bird in the Air Pump* (1768), by Joseph Wright of Derby © Photo12/UIG via Getty Images; 45. Descriptive map of London Poverty (1889), by Charles Booth © Museum of London, UK / Bridgeman Images; 46. *Dudley, Worcestershire* (1832), by Joseph Mallord William Turner © Lady Lever Art Gallery, National Museums Liverpool / Bridgeman Images; 47. *Manchester from Kersal Moor* (1852), by William Wyld: Royal Collection Trust © Her Majesty Queen Elizabeth II, 2018 / Bridgeman Images; 48. *Kaaterskill Falls* (1826), by Thomas Cole © Private Collection / Bridgeman Images; 49. *Niagara Falls* (1857), by Frederic Edwin Church © Corcoran Collection, National Gallery of Art, Washington D.C., USA / Museum Purchase, Gallery Fund / Bridgeman Images; 50. *The Course of Empire: The Savage State* (1834), by Thomas Cole © New York Historical Society/Getty Images; 51. *The Course of Empire: The Arcadian or Pastoral State* (1834), by Thomas Cole © New York Historical Society/Getty Images; 52. *The Course of Empire: The Consummation of Empire* (1835–6), by Thomas Cole © New York Historical Society/Getty Images; 53. *The Course of Empire: Destruction* (1836), by Thomas Cole © New York Historical Society/Getty Images; 54. *The Course of Empire: Desolation* (1836),

by Thomas Cole © New York Historical Society/Getty Images; 55. *The Oregon Trail* (1869), by Albert Bierstadt © Universal History Archive/UIG via Getty Images; 56. *George Catlin* (1849), by William Fisk © FineArt / Alamy Stock Photo; 57. Top left: *Stu-mick-o-súcks Buffalo Bull's Back Fat, Head Chief, Blood Tribe* (1832), by George Catlin © FineArt / Alamy Stock Photo; 58. Top Right: *Shon-ta-yi-ga, Little Wolf, a Famous Warrior* (1844), by George Catlin © Photo 12 / Alamy Stock Photo; 59. Bottom Left: *Kah-beck-a* (1832), by George Catlin © Niday Picture Library / Alamy Stock Photo; 60. Bottom Right: Sioux mother and baby, *c.*1830 by George Catlin © Private Collection / Peter Newark Western Americana / Bridgeman Images; 61. Painted Deer Hide © National Museum of the American Indian, Smithsonian Institution (18/4323). Photo by NMAI Photo Services; 62. *Self portrait* (1862), by Gottfried Bohumir Lindauer © Courtesy of the West-Bohemian Museum in Pilsen, Czech Republic Inv No NMP 71672; 63. *Māori Chief Tamati Waka Nene* (1890), by Gottfried Lindauer © VCG Wilson/Corbis via Getty Images; 64. *Heeni Hirini and Child* (1878), by Gottfried Lindauer © Christie's Images / Bridgeman Images; 65. Carved figure on main pole at marae meeting house © LOOK Die Bildagentur der Fotografen GmbH / Alamy Stock Photo; 66. David Olusoga and portrait of Te Rangiotu by Gottfried Lindauer © BBC/Nutopia; 67. *View of a Paris Street* (1838), a daguerreotype by Louis-Jacques-Mandé Daguerre © GraphicaArtis/Getty Images; 68. Detail of above; 69. *Sarah Bernhardt* (1864), by Nadar © Artokoloro Quint Lox Limited / Alamy Stock Photo; 70. Top of the rue Champlain (view to the right) (20th arrondissement), 1877–8, by Charles Marville © Musee de la Ville de Paris, Musee Carnavalet, Paris, France / Bridgeman Images; 71. Aerial views of the Arc de Triomphe, *c.*1860s by Nadar © SSPL/ Getty Images; 72. *Gare St Lazare* (1877), by Claude Monet, Musee D'Orsay © Peter Barritt / Alamy Stock Photo; 73. *Paris Street; Rainy Day* (1877), by Gustave Caillebotte, Art Institute of Chicago © VCG Wilson/Corbis via Getty Images; 74. *In a Cafe, or L'Absinthe*, 1875–6

by Edgar Degas © Musee d'Orsay, Paris, France / Bridgeman Images; 75. *La Petite Danseuse de Quartorze Ans* (1881), by Edgar Degas, Musee d'Orsay © Christophel Fine Art/UIG via Getty Images; 76. *A Bar at the Folies-Bergère* (1882), by Edouard Manet © Samuel Courtauld Trust, The Courtauld Gallery, London, UK / Bridgeman Images; 77. Under the Eiffel Tower, from L'Album de l'Exposition 1889 by Glucq © The Stapleton Collection / Bridgeman Images; 78. Javanese dancers © ND/Roger Viollet/Getty Images; 79. *The Ancestors of Tehamana* (1893), by Paul Gauguin, Art Institute of Chicago © VCG Wilson/Corbis via Getty Images; 80. *Pastorales Tahitiennes* (1893), by Paul Gauguin © State Hermitage Museum, St. Petersburg, Russia / Bridgeman Images; 81. *Where Do We Come From? What Are We? Where Are We Going?* (1897–8), by Paul Gauguin © Museum of Fine Arts, Boston, Massachusetts, USA / Tompkins Collection / Bridgeman Images; 82. Mask © Musée du Quai Branly – Jacques Chirac, Dist. RMN-Grand Palais/Patrick Gries/Bruno Descoings; 83. Study for the painting *Les Demoiselles d'Avignon* (1907), by Pablo Picasso © Succession Picasso/DACS, London 2018/ Courtesy akg-images; 84. *Les Demoiselles d'Avignon* (1907), (oil on canvas) by Pablo Picasso © Succession Picasso/DACS, London 2018/Courtesy of Museum of Modern Art, New York, USA / Bridgeman Images; 85. *Sturmtruppe geht unter Gas vor* (1924), by Otto Dix © DACS 2018/ Courtesy akg-images; 86. *War* (1932), (mixed media on panel) by Otto Dix © DACS 2018/Courtesy of Staatliche Kunstsammlungen Dresden / Bridgeman Images.

While every effort has been made to contact copyright-holders of illustrations, the author and publishers would be grateful for information about any illustrations where they have been unable to trace them, and would be glad to make amendments in further editions.

INDEX